Figuring Out
Figurative Art

Also by Damien Freeman
Art's Emotions: Ethics, Expression and Aesthetic Experience (Acumen)

Also by Derek Matravers
Introducing Philosophy of Art in Eight Case Studies (Acumen)

Figuring Out Figurative Art

Contemporary Philosophers on Contemporary Paintings

Edited by Damien Freeman
and Derek Matravers

Routledge
Taylor & Francis Group

LONDON AND NEW YORK

BREESE LITTLE

First published 2015
by Routledge
2 Park Square, Milton Park, Abingdon, Oxon OX14 4RN

and by Routledge
711 Third Avenue, New York, NY 10017

Routledge is an imprint of the Taylor & Francis Group, an informa business

British Library Cataloguing in Publication Data
A catalogue record for this book is available from the British Library

Library of Congress Cataloguing in Publication Data
A catalog record for this title has been requested

ISBN: 978-1-844-65802-2 (hbk)
ISBN: 978-1-844-65803-9 (pbk)

Typeset in Warnock Pro by Kate Williams, www.skettyprepress.co.uk

"What is called Philosophy of Art usually lacks one of two things: either the philosophy, or the art."

(Friedrich Schlegel, 1797)

| Contents

| Acknowledgements

This book owes its genesis to Steven Gerrard, whose enthusiasm for the project, together with the dedication of his team at Acumen, in particular Kate Williams and Hamish Ironside, set it on its way. Following Acumen's acquisition by the Taylor and Francis Group, we are delighted that it is now published under the Routledge imprint.

This book has been a collaborative endeavour between Routledge and the commercial art gallery Breese Little. Its directors, Henry Little and Josephine Breese, have been involved from the project's inception, when they curated a portfolio of contemporary art, through the production process, in managing relations with other art galleries representing the artists discussed in this book, and finally hosting a reception in their London gallery to launch the book. Needless to say, the final product bears the mark of their guidance in so many ways.

Together with Routledge and Breese Little, we appreciate the assistance of the following commercial art galleries in obtaining permission to reproduce works of art by artists that they represent: Gagosian Gallery (John Currin, Dexter Dalwood and Paul Noble), Marlborough Gallery (Paula Rego), Pace Gallery (Adrian Ghenie and Yue Minjun), Stephen Friedman

Gallery (Ged Quinn), Victoria Miro Gallery (Chantal Joffe) and Wilkinson Gallery (George Shaw), as well as Breese Little Gallery (Tom de Freston).

This volume represents a new direction in philosophical writing, and we are grateful to the contributors for their enthusiasm in exploring the new possibilities presented by this project. As the volume has been completed within an eighteen-month time frame, we are also indebted to them for committing to write thoughtful contributions in a short space of time.

DTF
DCM

| The artists

John Currin (b. 1962, Boulder, Colorado; lives and works in New York) paints subjects that range from the domestic to the overtly erotic. These exceptionally refined and gloriously engaging paintings continue the intense debate within Currin's work that combines art-historical technique with contemporary reference. While some of Currin's new paintings are of flowers and exquisite china, most are depictions of hardcore eroticism taken from European pornography. Pornography is functional and, almost by definition, an unembellished celluloid or digital idiom. Indeed, one of the primary uses of photography is pornography, and a painting would struggle to claim to be as immediate – or undeniably in the moment – as a photograph. Currin's use of pornographic subject matter is both a challenge to these conventions and an acknowledgement of the spectral presence of photography for the contemporary painter.

Dexter Dalwood (b. 1960, Bristol; lives and works in London) seeks, in his paintings, to render historical events as unpopulated spaces constructed through literal visual quotation from the works of other artists. Events from recent history (e.g. Hurricane Katrina or the Poll Tax riots in London) are

imagined and represented as moments in time. Dalwood investigates how an event in time may subsequently achieve a visual existence or a place in the mind's eye, and presents this for subjective reconsideration – the bombing of Margaret Thatcher's hotel room in Brighton, in October 1984, for example, or the infamous Yalta conference of February 1945. Dalwood's works begin as small, precise collages, constructed by cutting up reproductions from magazines, catalogues and books. This process is central to Dalwood's conception of each painting as an image whose representation of a moment in art history is balanced by the more literal subject announced by the title of each work. References might be immediately apparent – a Picasso skull, a Richter abstraction – or more opaque – a still from the opening scene of Walt Disney's *Bambi*. The familiar, the vaguely recognized and the unattributable, in Dalwood's work, combine with authority to represent the cultural landscape of recent history, exploring visual language and the function of the imagination in understanding history.

Tom de Freston (b. 1983, London; lives and works in Oxford) creates narrative paintings that tend to take a particular theatrical, literary or art-historical source as a starting point. Recent projects have involved collaborations with theatre companies and poets. Literary and theatrical sources often act as a start point, before de Freston employs a wider range of image-making strategies and processes (photography, performance and collage) to develop ideas. His paintings often consist of domestic spaces, theatrical stages and barren landscapes populated with masked, animalistic or caricatured figures, dealing with dystopian narratives, mutated mythology and appropriated art-historical imagery. The scenes are frequently in danger of being engulfed by thick pools of paint, threatening the order with chaos. The paintings provide windows onto stages littered with uncanny signifiers, providing the viewers with access to worlds which are unknown but familiar.

Adrian Ghenie (b. 1977, Baia Mare, Romania; lives and works in Cluj, Romania and Berlin) investigates the darker currents of modern European history in his paintings, combining sources from historical books, archives, film stills and his imagination, to create simultaneously figurative and abstract images that address issues of personal and collective memory.

Exposing the horror and complexity of some of the most historically charged moments of the twentieth century, Ghenie's painterly and expressionistic canvases force the viewer to confront and bear witness to the past.

Chantal Joffe (b. 1969, London, where she continues to live and work) possesses a humorous eye for everyday awkwardness and an enlivening facility with paint, bringing a combination of insight and integrity to the genre of figurative art. Hers is a deceptively casual brushstroke. Whether in images a few inches square or ten feet high, fluidity combined with a pragmatic approach to representation seduces and disarms simultaneously. Almost always depicting women or girls, sometimes in groups but recently in iconic portraits, the paintings only waveringly adhere to their photographic source, instead reminding us that distortions of the brush or pencil can often make a subject seem more real. Joffe's paintings always alert us to how appearances are carefully constructed and codified, whether in a fashion magazine or the family album, and to the choreography of display. And yet, throughout her career, there is witty neutrality in a line-up that has given equal billing to catwalk models, porn actresses, mothers and children. Joffe questions assumptions about what makes a noble subject for art, and challenges what our expectations of feminist art might be. She ennobles the people she paints by rehabilitating the photographic image but, crucially, recognizes that it is paint itself, rather than attendant socio-political ideas, that gives her paintings complexity and keeps us looking.

Paul Noble (b. 1963, Dilston, England; lives and works in London) offers the viewer intricate graphite drawings that describe Nobson Newtown, a fictional place composed of labyrinthine edifices and deserted topography embedded with modules of dense detail. Employing cavalier projection – a cartographical method characterized by a high viewpoint – Noble meticulously delineates a wealth of elaborate architecture and open urban spaces. These phantasmagorical landscapes allude to sources as diverse as ancient Chinese scrolls, Fabergé eggs, Henry Moore's sculptures and paintings by Hieronymus Bosch. The encrypted fictions of Nobson Newtown are dizzyingly complex – visual articulations of the tensions between disorder, perversion and logical schema.

Ged Quinn (b. 1963, Liverpool; lives and works in Cornwall) creates work that, like Freud's notion of the uncanny, is both familiar and unfamiliar. Utilizing art-historical tropes to subtly introduce spirituality, temporality and myth into a larger framework of cultural and political discourses. The work is radical in its use of juxtapositions, not least those of romantic and modernist thought and imagery.

Paula Rego (b. 1935, Lisbon; lives and works in London) first won acclaim in Portugal with semi-abstract paintings that sometimes included collage elements culled from her own drawings. Their satiric wit and verve of line, sometimes applied to violent or political subjects, revealed gifts for story-telling that had been awakened in her as a child by folk-tales related by a great-aunt. In the late 1970s, Rego turned from collage to drawing directly in acrylic on paper. Using an essentially graphic style reminiscent of comic strips, she continued to produce figurative pictures that were spontaneous narratives rather than illustrations to literary texts. Her characters often took the form of animals for satirical effect. She developed a greater freedom and range of colour in her drawings, which inclined them more towards painting. In 1986, she turned to a naturalistic idiom with strongly modelled figures and a consistent light source, often in interior settings.

George Shaw (b. 1966, Coventry; lives and works in Devon) paints in Humbrol enamels, more usually associated with boyhood model-making, and bases his works on photographs which revisit landmarks remembered from his youth. Meticulously painted houses, pubs, underpasses and parks become autobiographical notes, frozen in time. Conflating memory and present-day reality, Shaw's works take on an uncanny quality, alluding to a murkier side of contemporary society and collective subconscious.

Yue Minjun (b. 1962, Heilongjiang, China; lives and works in Beijing) has been quoted as saying, "I always found laughter irresistible." Best known for his oil paintings depicting himself with his trademark smile, Yue is a leading figure in the Chinese contemporary art scene. He has exhibited widely and is recognized as one of the breakout stars of his generation. In his earlier work, surrealism had an especially strong influence on him. His self-portraits from the 1990s were the first to depict his easy, automatic

smile, but the figures' warmth masked underlying emotions. Yue has also been continuing his *Landscape with No One* series in which he removes figures from historical Chinese socialist paintings and well-known Western paintings. He states, "Those typical socialist paintings in China looked very realistic but were indeed surreal. They served for heroic fantasies, and the images of great people or the heroes in the paintings could well justify the fabricated scenes."

| **List of plates**

Paula Rego, *War* (2003). Pastel on paper on aluminium, 160 × 120 cm.

John Currin, *The Dane* (2006). Oil on canvas, 122 × 81 cm.

Dexter Dalwood, *A View From A Window* (2006). Oil on canvas, 165 × 109 cm.

Tom de Freston, *Quartet – Stage One* (2012). Oil on canvas, 200 × 150 cm.

Tom de Freston, *Quartet – Stage Two* (2012). Oil on canvas, 200 × 150 cm.

Tom de Freston, *Quartet – Stage Four* (2012). Oil on canvas, 200 × 150 cm.

Chantal Joffe, *The Black Camisole* (2004). Oil on board, 300 × 120 cm.

Ged Quinn, *Hegel's Happy End* (2012). Oil on linen, 200 × 148 cm.

Dexter Dalwood, *Room 100 Chelsea Hotel* (1999). Oil on canvas, 182 × 213 cm.

Dexter Dalwood, *Hendrix's Last Basement* (2001). Oil on canvas, 203.2 × 213 cm.

Adrian Ghenie, *Dada is Dead* (2009). Oil on canvas, 200 × 220 cm.

Adrian Ghenie, *Nickelodeon* (2008). Oil and acrylic on canvas, 230 × 420 cm.

Paul Noble, *Heaven* (2009). Pencil on paper, 114 × 286.5 cm.

Ged Quinn, *The Fall* (2007). Oil on canvas, 188 × 250 cm.

George Shaw, *No Returns* (2009). Humbrol enamel on board, 147.5 × 198 cm.

George Shaw, *This Sporting Life* (2009). Humbrol enamel on board, 43 × 53 cm.

Yue Minjun, *Untitled* (2005). Watercolour on paper, 78.5 × 109 cm.

INTRODUCTION | Figurative art and figurative philosophy

Damien Freeman

Life's but a walking shadow, a poor player
That struts and frets his hour upon the stage,
And then is heard no more. It is a tale
Told by an idiot, full of sound and fury,
Signifying nothing.

(*Macbeth*, act V, scene 5)

What is a Picasso-like horse-person doing on the cover of this book, clutching a broken dagger in his left hand; his feet poised at the edge of a chessboard suspended over the abyss of eternity; and his right eye staring desperately at the viewer? The image is taken from Tom de Freston's painting *A Poor Player that Struts and Frets his Hour*. The painting's title is taken from act V, scene 5, of *Macbeth*. In that scene, Macbeth receives the news that his wife is dead. Immediately, he responds to news of his misfortune by becoming philosophical.[1] He is struck by the futility of life, and captures this through the metaphor of a fretful actor whose performance is quickly forgotten. In the painting, de Freston achieves a thick impasto texture in the background that moves between sombre and fiery tones, and which evokes

the feeling of an atmosphere that is too thick to cut with a knife — hence the broken dagger. Such an atmosphere is de Freston's attempt at capturing the feeling of what it is like to be in the moment when one realizes that, even after the monumental act of regicide, the loss of one's wife is enough to consign one to a shadowy life of nothingness: the dagger that cuts so effortlessly through royal flesh is useless when standing at the edge of life's chessboard, seemingly poised over the meaningless abyss of eternity.

So we might understand the horse-person as philosophizing in the painting, or we might understand the picture as the end product of some philosophical speculation that de Freston was engaged in when painting the figure of the horse-person at the edge of the chessboard over the abyss. Similarly, we might understand Macbeth as being engaged in some philosophical activity in the scene that inspired de Freston, or we might understand Shakespeare as using the character to explore some deep philosophical problem.

The painting led me to revisit the play, and to retrieve the battered copy of the Challis Shakespeare edition, published by Sydney University Press, and which I read as a schoolboy, from the top of my bookcase (on the shelf just beneath the oboe case). In A. P. Riemer's introduction to that edition of the play, he discusses the significance that critics have attached to Shakespeare's presentation of Macbeth as a person whose actions are an exercise of free will, before Riemer questions such an interpretation of the play:

> Yet the hypothesis that *Macbeth* is based on the presumption of its hero's exercising free will is by no means inevitable; it may be a disservice to Shakespeare's art to consider the play in such absolutely philosophical or even theological terms. This is not to suggest that too high a valuation may have been placed on the tragedy by previous critics; it is rather to stress that the greatness of *Macbeth* does not necessarily rely on its concern with such issues. Free will is not a theme of paramount importance in the play; to consider it is to speculate about the implications of the play's material rather than to comment on its actual concerns or preoccupations. Like many of Shakespeare's plays, *Macbeth* is significantly open-ended: it raises possibilities more

than it determines issues. The hero may be responsible for his crimes or he may be a victim of fate – the emphasis falls not so much on an adjudication between these claims as on the vivid, dramatic, moving and ultimately terror-filled presentation of Macbeth's decline into barbarous tyranny. He is surrounded by images and personalities that highlight this process ... The poetic and imaginative complexity of the tragedy is revealed through such parallels by the subtle use of images and motifs ...[2]

Free will is undoubtedly an important philosophical concept. However, the centrality of free will to *Macbeth* does not mean that Shakespeare takes a philosophical interest in the concept. T. S. Eliot famously denounced Shakespeare's "philosophy" in his essay "Shakespeare and the Stoicism of Seneca", while nevertheless affirming the poetical value of Shakespeare's work, on the basis that the poet's task is to use the philosophy of the age to give expression to the poet's own emotions.[3] Whatever one makes of Eliot's approach, he is manifestly correct in pointing out that there is something valuable about an artist engaging with philosophical ideas without claiming to be engaged in academic philosophy. The predicament is not limited to poets. The American art critic Harold Rosenberg, in his influential essay "The American Action Painters", denied that painters – even that arch anti-figurative painter Barnett Newman (who sounds rather philosophical in his denunciation of the "props and crutches that evoke associations with outmoded images" when using paint to express "absolute emotions", in his manifesto, "The Sublime is Now")[4] – were interested in philosophy: "Philosophy is not popular among American painters. For most, thinking consists of the various arguments that to paint is something different from, say, to write or to criticize: a mystique of the particular activity."[5]

So it would hardly be surprising if something similar might be said about de Freston's figurative painting, in which he uses the "props and crutches" of the images of the horse-person, chessboard and dagger, to explore absolute emotions.

If artists are not philosophers, or are not interested in academic philosophy, many of them are, nevertheless, finding ways of engaging with philosophical problems. This leaves an irresistible opening for philosophers

when they engage with art, either by taking up the baton of the artist interested in philosophical concepts, or exploring philosophical ways of engaging with art, whether or not the art in question is explicitly concerned with philosophical ideas.

Philosophers are no more artists than artists are philosophers. Philosophers are theorists. But, as theorists, they are no more art critics or art historians, than they are artists. Whereas the art critic seeks to persuade us of the value that a work has for the critic, by drawing our attention to details of the work that enable him to provide reasons for his judgement, and the art historian uses historical methods to understand facts about individual paintings, philosophers of art are concerned with the fundamental nature or value of art generally, rather than with understanding or appreciating a specific work of art. Philosophy of art is not necessarily the same as aesthetics. Where philosophers of art are concerned with the nature and value of a cultural phenomenon – "art", or "the arts", or one or more of the several art forms – aestheticians might cast their net further afield, in order to understand what is entailed by the peculiar mode of aesthetic appreciation that attends as readily to the sublime, the beautiful, or the picturesque in the natural world as it does to objects created by human agents in pursuit of some cultural phenomenon. And, whereas an *aesthetician* is concerned with the analysis of the nature and value of aesthetic appreciation, an *aesthete* professes to possess a peculiarly keen sense of aesthetic appreciation, whether or not he has any understanding of what he possesses. But what a philosopher of art – or an aesthetician – hopefully has in common with an art critic or an art historian – or, indeed, an artist – is that any of these might also be an aesthete. Those who theorize about art and those who are practitioners of art share a conviction about the centrality of art to their lives, and any of them might profess a special sensibility to experiences of beauty in works of art or in the natural world. These shared commitments suggest that the opportunity to write essays that recruit the insights of philosophy, history and connoisseurship might go some way towards affirming the shared conviction of the centrality of art to life.

This collection contains essays by aestheticians (some of whom might also be aesthetes) and philosophers who do not specialize in aesthetics. They are all contemporary philosophers who were philosophizing during

the period in which the works of art that they discuss were created. Most work in the Anglo-American tradition of analytic philosophy; some work in the German tradition of continental philosophy, or as classicists studying ancient Greek philosophy. One of the contributors has a second life as an artist; another as an art historian. The only condition imposed upon them, in writing these essays, was that they had to choose a work of art to write about, and, in doing so, they had to make a connection between that work and some philosophical issue. No guidance was given as to how they should forge this connection.

A portfolio from which the philosophers were able to select works to write about was assembled by Henry Little and Josephine Breese, the directors of Breese Little. Breese Little is a commercial art gallery in London that specializes in contemporary art, with a significant offsite educational programme, including the Breese Little Prize for Art Criticism and a lecture series at the London School of Economics and Political Science (LSE) in collaboration with LSE Arts. The directors of the gallery have taken an active interest in this publication from its inception. The portfolio they put together contained works of figurative art by artists who have exhibited in the last decade. The catalogue of plates in this book contains the works that the contributors chose to write about, from the original portfolio of 116 works. So we have thirteen essays by contemporary philosophers discussing seventeen works by ten contemporary figurative artists.

Figurative art can be defined in various ways. In its narrowest sense, it is art that takes as its subject the human form (perhaps even more narrowly, the accurate representation of the human form). More broadly, however, it is art that is intended to look like *something* in reality. At its most general level, it might be taken to include all non-abstract art. The nineteenth century saw the rise of a new era in Western art history, with the advent of abstract art, and the creation of paintings and sculptures in which form, colour and line were used to create compositions that did not include any visual references to the world. In contradistinction to abstract art, figurative art has come to include any form of modern art that includes links to the real world. In 2007–9, Tate Liverpool held an exhibition, *The Twentieth Century: How it Looked and How it Felt.* On the first floor was one exhibition, *The Twentieth Century: Figuration*, which was concerned with "art that retains strong references to the real world", and on the second floor

was *The Twentieth Century: Abstraction*, which contained art "that may appear to be without a recognisable subject".[6]

This collection of essays gains a measure of unity from the fact that each is concerned with an example of contemporary figurative art. But why should the philosophers have been invited to select from a portfolio of *figurative* art, let alone *contemporary* figurative art?

In the nineteenth century, Hegel thought he heard the death knell of art: human spirit had evolved to such a point that art could no longer perform its vocation as an expression of spirit, and so it had come to an end. The death of art, it was claimed in the twentieth century, came in 1917 with Marcel Duchamp's *Fountain*, or almost half a century later, in 1964, with Andy Warhol's *Brillo Boxes*. But even if art did not die in the nineteenth century, it still seemed, to some, that painting as an art would die, with the advent of photography: on one reading of the history of the art of painting, in the West, the whole tradition had been in pursuit of the quest for mastery of perspective, and now, even though it had finally been mastered, photography would supersede painting as a means of achieving accurate visual representations. And even if painting as an art did not die, it seemed that figurative painting would die in the twentieth century: Dadaism, abstraction and action painting all suggested that art was no longer concerned with visual representation of the world, and, even if visual representation of the world was still important in painting, impressionism, expressionism, surrealism, cubism and pop art suggested that the accurate or realistic representation of the world was not what mattered. And yet, despite the vicissitudes of the last century, this catalogue demonstrates that contemporary painters remain engaged in the figurative tradition. And, if the catalogue of contemporary figurative art demonstrates that the figurative tradition is still alive, then the collection of essays demonstrates that contemporary figurative art still speaks to the intellectually curious in a multitude of different ways. These contemporary artists' visual references to the world around them can inspire philosophers in their quest to understand that same world.

How ought one to talk about a catalogue of works of art? One might talk about the artists represented in the catalogue, and point out that they are all living artists, born between 1935 and 1983 in America (Colorado), England (Bristol, London, Dilston, Liverpool and Coventry), continental

Europe (one Portuguese artist from Lisbon; one Romanian artist from Baia Mare) or China (Heilongjiang), who now live and work in major centres of art, such as New York, London, Berlin and Beijing, or more remote places, such as Oxfordshire, Cornwall and Devon in England, and Cluj in Romania. Or one might talk about the works themselves: the media used to execute the works – enamel paint on board, pastel on paper on aluminium, graphite on paper or oil (occasionally with acrylic) paint on canvas, board or linen – or the dimensions of the completed works (ranging from 43 × 53 centimetres to 4.2 × 2.4 metres), or the fact that they were all executed between 1999 and 2012. Or one might talk about the subject matter depicted in the paintings: a still life, a semi-clad woman in repose, a wolf haunting an art gallery, a donkey-person nursing a wounded rabbit-person, an architectural study, deserted urban landscapes, abandoned domestic rooms, and groups of human figures engaged in activities ranging from pie-throwing to masturbation. Or one might simply note that one work is untitled, and list the titles that the artists gave the other works: *This Sporting Life*, *Nickelodeon*, *Dada is Dead*, *The Black Camisole*, *Quartet – Stage One*, *Quartet – Stage Two*, *Quartet – Stage Four*, *No Returns*, *The Fall*, *Heaven*, *War*, *The Dane*, *Hegel's Happy End*, *Hendrix's Last Basement*, *A View From A Window* and *Room 100 Chelsea Hotel*. Or one might talk about the value of these works of art: an oil painting by John Currin has fetched $5,458,500 at auction, whereas it is still possible to pick up an oil painting by Tom de Freston for $9,400.

This is not an auction catalogue, however, and the essays are not concerned with the monetary value of the works reproduced in the catalogue. That they are concerned with value, but not the monetary value of the works, is to say that they are concerned with the *artistic* value of the works.

In his, *Values of Art*, Malcolm Budd begins with the bald assertion:

> The central question in the philosophy of art is, What is the value of art? Philosophical reflection on art would be idle unless art were valuable to us, and the significance of any question that arises in philosophical reflection on art derives directly or ultimately from the light that its answer throws upon the value of art.[7]

Artistic value lies in "the experience a work of art offers", Budd explains, which is "an experience of the work in which it is understood": it is not any person's actual experience of the work that matters here, but how the work ought to be experienced if its meaning is to be understood. Budd then distinguishes intrinsic value of art from instrumental value of art:

> the value of a work of art as a work of art is intrinsic to the work in the sense that it is (determined by) the intrinsic value of the experience the work offers (so that if it offers more than one experience, it has more than one artistic value or an artistic value composed of these different artistic values). It should be remembered that the experience a work of art offers is an experience *of the work itself*, and the valuable qualities of a work are qualities *of the work*, not of the experience it offers. It is the nature of the work that endows the work with whatever artistic value it possesses; this nature is what is experienced in undergoing the experience the work offers; and the work's artistic value is the intrinsic value of this experience. So a work of art is valuable as art if it is such that the experience it offers is intrinsically valuable; and it is valuable to the degree that this experience is intrinsically valuable.
>
> By the intrinsic value of an item I do not mean a value that depends solely on the intrinsic nature of the item – a value that depends solely on its internal properties (its qualities and inner relations) – as contrasted with as extrinsic value – a value that depends, wholly or in part, on its external properties (its relations to other things). My conception of intrinsic value opposes it, not to extrinsic value, but to instrumental value, and I do not assume that something's intrinsic value is dependent solely on its intrinsic nature. By the instrumental value of a work of art I mean the value, from whatever point of view, of the actual effects of the experience of the work on people or the effects that would be produced if people were to experience the work ... My claim therefore implies that the instrumental value of a work of art, its beneficial or harmful, short- or long-term effects or influence, either on a given person or people in general ... is not the value of art *as* a work of art.[8]

So, all philosophy of art is concerned with artistic value, and artistic value is the intrinsic value of the experience a work of art offers, but artistic values are as multifarious as the experiences offered by works of art.

Each of these essays takes, as its departure point, the experience of a particular work of art, and some value that a particular philosopher finds in that experience. Mostly, the essays are concerned with intrinsic value, although some are explicitly concerned with the instrumental value of a work of art. But even if each philosopher finds intrinsic value in the experience of the work of art, we should not expect each to find the works rewarding in the same way. It is central to Budd's thesis that, although artistic value is concerned with the intrinsic value of a work of art, there are different ways in which a work of art can be intrinsically valuable, because there are different ways in which the experience offered by a work of art can be rewarding. So it is a strength of the collection if the various contributions respond to the variety of values of art.

Not all contemporary philosophers were equally inspired by the invitation to choose a work from the Breese Little portfolio of contemporary art as the basis for a philosophical essay. Some indicated that, had we not confined them to contemporary paintings, they would have been strongly tempted to accept the invitation, especially if they could have chosen the painting to write about, but, as the invitation stood, they declined to view the portfolio. Others viewed the portfolio, but came to the conclusion that they did not really have anything of interest to say, finding some of the pictures obscene, but nevertheless fairly representative of British art and culture today. Occasionally, there was a lament that a promising philosophical project was foiled by images that seemed like pathetic colourbursts, swirlingly anxious, intertextual, but nevertheless lifeless. So what was it that other philosophers saw in the portfolio that inspired them to write about the works?

Some works spoke to the contributors through a dialogue with earlier works of art. Sometimes, it is to ponder a contrast, such as that seen between Lowry's cheerful depictions of the industrial north of England and Shaw's seemingly bleak and desolate treatment of the industrial north. Sometimes, it is to demonstrate how a contemporary artist, such as Rego, alludes to the work of a master, such as Goya's *Los Caprichos*, in order to convey shared concerns about their common subject – in this case, power

used to kill, rather than to save. Contemporary art might also allow the opportunity to revisit the aims of earlier art, so that, in Ghenie's paintings, we have the opportunity to reflect upon the manifestos of the Dadaists, and their ambitions. We also find efforts to connect up the discussion of contemporary figurative artists' work with the treatment of similar themes in non-visual art forms, such as the poetry of Philip Larkin and the prose of Elie Wiesel and Aleksandr Solzhenitsyn, and in the performing arts, including ancient tragedy (Sophocles' *Antigone*), modern theatre (Meyrink's *The Golem*), film (Michael Powell's *Peeping Tom*) and popular music (Leonard Cohen's "Chelsea Hotel").

No doubt, a large part of the appeal of writing an essay for this collection is the opportunity to engage in a "mixed" activity. The contributors cannot limit themselves to a "pure" disciplinary approach such as the abstract speculation of philosophy, the connoisseurship of art criticism, or the historical method of art history. Necessarily, they are forced to cross boundaries in writing these essays, and it is in doing so that they offer us something original and precious. So it is not surprising that they have drawn especial inspiration from the work of interdisciplinary theorists including the German aspirant Hypsistarian writer–scientist–statesman Johann Wolfgang von Goethe (1749–1832), the English "unconverted" Evangelical writer–art–critic–draughtsman–watercolourist–philanthropist–social theorist John Ruskin (1819–1900), Viennese Jewish neurologist–psychoanalyst Sigmund Freud (1856–1939), New Yorker Marxist–essayist–art critic Clement Greenberg (1909–94), and the English Anglican archaeologist–historian–Waynflete Professor of Metaphysical Philosophy R. G. Collingwood (1889–1943).

On the whole, these essays are not intended to be scholarly contributions to academic philosophy. Predictably, however, the contributors find connections in the works of art with the writings of other philosophers, or believe that the insights of such philosophers can be recruited to shed light on the works of art. We find the canon of Western philosophy plucked for its riches: the ancients (Plato and Aristotle), the mediaeval scholastics (Saint Thomas Aquinas), the early moderns (Adam Smith, Rousseau, Kant and Hegel) and twentieth-century philosophers (Sartre, Wittgenstein, Benjamin, Goodman and Danto), as well as more recent work by philosophers such as Gregory Currie, and scholars such as Andrea Dworkin and

Catherine MacKinnon, working in related fields. Perhaps the works of art also offer contemporary philosophers new possibilities for engaging with the philosophical canon.

The essays address a number of standard philosophical problems in aesthetics, including expression, depiction, style, and the ontology of art. They also discuss a number of other artistic issues ranging from the significance of the titles that artists give their work, to the relationship between photography and older art forms, and from historically important approaches to art, such as vanitas painting, to more recent developments such as the role of the "artworld". There are also discussions of aesthetics beyond art, such as the beauty of the natural world.

They also address a range of topics that transcend art and aesthetics. Some of these essays can rightfully be characterized as engaging in social and political commentary, while others examine ethical, religious and legal concepts. Experiences of war, over the century from the First World War to Abu Ghraib, feature prominently, as do the political movements of that century, ranging from Bolshevism and Marx-inspired political movements to Thatcherism, and the plethora of new scourges encountered during that century: the Soviet gulag, television, internet pornography, News Corp. Then there are discussions of concepts such as irony, disgust, apathy, inequality and physiognomic expression, and even the sense of wonder that is at the core of philosophical responses to the world. Together with religion, art and philosophy were the manifestations of human spirit in Hegelian idealism. The dialogue between art and philosophy in these essays admirably gives expression to a range of concerns that are central to life in the West at the dawn of the twenty-first century, and, in one case, addresses concerns of those living in contemporary China, which in turn cast further light on problems encountered in the West.

At the end of the preface to his *Principles of Art*, R. G. Collingwood preemptively asks of the theory that he is yet to expound in his book:

> Is this so-called philosophy of art a mere intellectual exercise, or has it practical consequences bearing on the way in which we ought to approach the practice of art (whether as artists or as audience) and hence, because a philosophy of art is a theory as to the place of art in life as a whole, the practice of life?[9]

The first page of his book commences, "The business of this book is to answer the question: What is art?" It is no part of the business of *this* book to answer that question. However, it is to be hoped that the treatment of the non-aesthetic concepts enumerated above will speak for itself in demonstrating how these essays are exercises in approaching the practice of art (as audience, if not as artists) as affirming the central place of art in life as a whole, and philosophizing about art as forming part of the practice of life.

In a review of the Greater Philadelphia Philosophy Consortium's recent volume *Narrative, Emotion, and Insight* (edited by Noël Carroll and John Gibson), for the *Philosophical Quarterly*, I observed:

> The collection is significant for analytic aesthetics in the shift that it signals from thinking about "fiction" as a central concept, to thinking about "narrative" as a central concept, and the fruit that this shift might yet bear. More generally, it demonstrates the developments that are possible in philosophy when its practitioners cooperate to identify a new concept in need of investigation.[10]

I hope that, in a similar way, the current collection demonstrates something not just for aesthetics, but for general philosophy, about developments that are possible in philosophy when its practitioners open their minds to philosophical activities through which philosophy and philosophers might engage with the wider world. If figurative art has come to comprise any form of modern art that includes links to the real world, perhaps there is also a place for "figurative philosophy", comprising any form of modern philosophy that includes links to the big wide world beyond the academy.

1 | The pornography of Western art

John Currin
The Dane
(2006) | *Jesse Prinz*

Fine art has long had a complex relationship with pornography. Some artists in the Western canon were pornographers. Countless others created works that are clearly designed for titillation, if not masturbation. The majority of Renaissance masters created works that exemplify the objectifying male gaze. Over the last two decades, the link between art and pornography has become a topic of considerable interest, with some A-list artists quoting pornographic imagery in works made for gallery exhibitions. No figure is more associated with this trend than John Currin. His sexually themed paintings have been in equal measure controversial and celebrated. They have helped to secure his place as one of the leading painters of our time, while also being described as flagrantly misogynistic. Currin's work offers a welcome opportunity to reflect on the relationship between art and pornography. His painting, *The Dane*, derives directly from pornographic sources, yet also challenges current standards of beauty, and can, for that reason, be regarded as a transgression against the prevailing porn culture. Here I shall use this work to interrogate the "artification" of pornography and the "pornification" of art. Currin manages to stay on the art side of the divide in this work, but this doesn't get him off the hook. Creating offensive

images under the mantel of art would hardly qualify as ennobling. Currin fans the flames of contempt by defiantly embracing the charge that he objectifies women in his work. While devotees might hope to interpret his work as ironic, he insists that it is motivated by his own sexual desires.

My goal is not to assassinate Currin's character here. Neither is this an apologia, and much less an apotheosis. Rather, I want to read *The Dane* as a culminating point in art history. It draws on pornography as a source, but it is also informed by Currin's reverent knowledge of past masters. The painting serves as a diagnostic tool. In deciding whether Currin is a pornographer, one is also confronted with the fact that his work is continuous with art history, and that fact allows us to see pornographic elements nascent in the Western canon. We are confronted, in other words, with the possibility that, if Currin's work is pornography, then the same might be said about much Western art.

Looking at (looking in) *The Dane*

John Currin studied art in the 1980s, when neo-expressionism was all the rage. Julian Schnabel was on a rapid ascent, and art schools, like Yale, placed emphasis on various forms of abstraction. Figurative postmodernist painters, like David Salle, were also in the spotlight, and Currin admired Salle's work, but his own experiments were initially more abstract, drawing on the likes of de Kooning for inspiration. Then, at the end of the decade, he grew weary of abstraction and turned to portraiture. One early effort, *Mary O'Connel* (1989), was based on a yearbook photo. Two years later, while commuting to New Jersey,[1] he got the idea to paint the silver-haired TV actress, Bea Arthur, topless. Set against a mustard background, Arthur stares at the viewer with slightly raised eyebrows and pendulous breasts, in a lifeless pose that is both too frank to be sexual and too sexual to be frank. *Bea Arthur Naked* sold at Christies this year for nearly $2,000,000.

In the ensuring years, Currin's fame and infamy rose like floodwaters. Needing to exceed the shock of his geriatric nude, he turned to schlock, painting maidens with twisting bodies, coquettish expressions and grotesquely large breasts, who look like centrefold girls on growth hormones. Examples from this period include *The Wizard* (1994), in which an older

Madison Avenue woman in black gloves clutches the enormous naked breasts of a young blonde. The anatomical oddity of the nude in this picture is nothing in comparison with paintings that would appear in the following years. For example, *The Bra Shop* (1997) shows two young women in miniskirts and spray-on blouses, which reveal oversized breasts. The breasts are centred on the canvas, each one larger than a human head and as spherical as a beach ball. One woman in the painting is tenderly measuring the chest of the other, who glances demurely downward holding a pink brassiere that is manifestly too small, as if Currin needed these extra narrative elements to draw further attention to the canvas's most conspicuous elements. Currin was praised for the craftsmanship of his paintings from this period, but academically trained painters would surely scoff. Technically, the works are amateurish, perhaps intentionally. Currin uses impasto paint for the faces in *The Bra Shop*, alluding to de Kooning or other macho mid-century expressionists in Clement Greenberg's pantheon.

Within a couple of years, Currin's technique began to show signs of improvement. Already regarded as a champion of traditional painting skills, Currin's work was now living up to that reputation. Paintings like *The Pink Tree* (1999) show the studious influence of Northern Renaissance masters. Currin uses a stark black background with a twisting tree as the setting for two serpentine female nudes. The appearance strongly echoes paintings of Adam and Eve by Albrecht Dürer, Hans Memling and especially Lucas Cranach the Elder. The allusion to these classic works is amplified by the fact that one of Currin's nudes appears to have short reddish curly hair and she stands taller than a long-haired blonde, which is precisely the hair-style differentiation used in some of Cranach's paintings of the Fall. Of course, Currin's Adam is a woman, who smiles broadly while glancing sideways at the nimble Eve, whose crouching posture resembles the gait found in traditional Expulsion scenes. Currin's anatomical choices are more constrained here than in earlier work. The bodies are still idealized, but the upper bodies of these women have been dramatically downsized, and their broad hips and spindly legs place them just outside prevailing norms of anatomical perfection. The latter features strongly evoke Memling.

These examples set the stage for *The Dane*. Currin's paintings of the 1990s often present sexualized and distorted female bodies. They bring to mind pin-up girls and cartoons found in *Playboy* magazine. They are the kinds of

images that might best be viewed while wearing a smoking jacket in a bachelor pad, while sipping a whisky sour. They hark back to a time when misogynist imagery still seemed like innocent fun. We now recognize the playful iconography of that era to be condescending and infantilizing. Currin spent a decade decontextualizing these images and his efforts were ambiguous enough to engage critics: was this a spoof of pin-up sexuality? An exercise in irony? A winking jab at artworld prudishness? No one was really sure.

By the turn of the millennium, Currin was an A-list artist with major museum shows and paintings selling in the high six figures. By this point, he had also followed a formula of progressively pushing the sexual explicitness of his work, while also pursuing greater mastery of traditional painting techniques. His work of the 2000s can be seen as an ineluctable extension of this trajectory. In these recent years, Currin began to draw on pornographic sources more overtly, and with increasing skill (for instance, one can track the increasing retinal realism of his fabrics and hair). Turning from the back pages of *Playboy*, he started to seek out vintage hard-core pornography. He was particularly inspired by Scandinavian pornography from the 1970s, discovered on the Internet. *The Dane* (2006) is appropriated from one of these images.

Like *The Wizard*, *The Bra Shop* and *The Pink Tree*, this painting captures two women in an intimate moment. Like the latter three, there is a blonde and a redhead. There also appears to be an age differential, as in many of Currin's works, but, unlike *The Bra Shop*, *The Dane* presents the older woman as the object of desire. She stands tall, and smiles, wearing nothing but a slinky necklace, a hair comb and lace-topped black stockings which have been pulled down to reveal her genitals. The younger woman is fully clothed, and wearing costume jewellery and blue eye-shadow. She stares in lustful meditation, with parted lips, at the standing woman's hidden treasure. She is seated subordinately, with one hand pressing firmly against her partner's naked thigh. The two women contrast anatomically. The standing woman is disturbingly thin, almost anorexic, but also evoking the spindly contours of figures in Flemish primitive painting, or the angular nudes of Austrian and German expressionists. She also resembles Picasso's *Woman Ironing*, who has somehow struck it rich and is now living the good life as a dominatrix. The seated woman is not rotund, but she is curvilinear in comparison. Her breasts swell roundly beneath her blouse and she has a

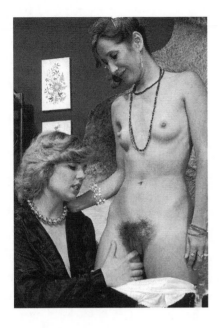

Figure 1.1 Still from *Blue Climax*, Issue 20 (1982) © Color Climax Corp., Copenhagen.

fleshy, dimpled chin. Even her hair curves, flipped back 1970s-style in a crowning S-shape. She is too slight to please Rubens, but could serve as a stand-in for Picasso's mistress, Marie-Thérèse Walter.

In many of Currin's earlier paintings, figures stand against an empty field of colour or other minimal backgrounds. Here, the figures still float in the foreground, but there is a greater sense of place. Behind the standing figure hangs an enormous animal skin. Behind the seated figure there is a moss-coloured antique china cabinet lined with glistening plates. On top of the cabinet, there is a lit – but lightless – candlestick, which rises up against a rose-red wall, which Currin has patterned with a lavish gold brocade.

The background differs from the source material in various ways. In the original photograph, there is a hanging animal skin, but it appears to be a grey cow hide, rather than the plush brown bear skin of Currin's picture. There is also some kind of shelving unit or perhaps a bedpost, but the porcelain plates are Currin's addition. In several exhibitions, Currin has interspersed still lifes with such items among his lascivious nudes. Here, they seem to convey a kind of hominess that adds domestic intimacy to the *mise en-scène*. The china cabinet also brings old-world class to this smutty scene. In the 1970s, Americans regarded Scandinavia as a libertine

paradise where beautiful blonds engaged in guiltless casual sex. Denmark was seen as both forward-looking and quaint, almost provincially innocent. Danish free love was not progressive or political, but rather Edenic and blissfully naive, according to this stereotype. Currin's china cabinet makes this exoticizing ideal more evident than the original photo. He also replaces the seated figure's black satin shirt with a striped-pink variant, which seems more disarming and benign.

The most dramatic change is the wall décor. The original is slate grey, with two hanging floral prints. Currin's gold brocade adds opulence to this interior. It may also be a quotation from Renaissance paintings again. Gold brocades were a popular motif in fifteenth-century Flemish paintings. For example, there is a painting of the Virgin and Child by Rogier van der Weyden in Vienna's Kunsthistorisches Museum, which includes a similar pattern on Mary's throne. As in Rogier's painting, the brocade on Currin's wall in strangely flat, violating the angled geometry of the room. The Rogier painting has a second panel, which shows Saint Catherine holding a sword (Saint Catherine was a martyr who was first broken on a wheel and then decapitated). Curiously, Saint Catherine's posture in that panel is very similar to the standing nude in Currin's painting, which is based on the pornographic photograph. The similarity is surely coincidental, but one can't help thinking that Currin's attraction to the Danish image was informed by his deep affection for Northern Renaissance painting.

The foregoing is little more than a clinical description of *The Dane*. Commentary will follow. I shall be most interested in asking whether Currin's appropriation of a pornographic image results in a work that qualifies as pornography itself. This question will help us explore the nature of pornography, art and their relation. Before getting there, I want to say a bit about other artists who operate at the boundary between art and pornography. Some of these others will help us put Currin's project in context.

Pornography and contemporary art

Many important figures in the Western canon (and elsewhere, of course,) produced works with overtly sexual content. I shall postpone the question of whether such work is pornographic. Sometimes the sexual themes

are implicit, as with Botticelli's *Venus and Mars*, and sometimes more obviously intended to titillate, as with Cranach's many paintings of the *Judgement of Paris* or *The Golden Age*. There is also a long tradition of reclining nudes who are, no doubt, intended to exemplify and excite male desire: Giorgione's *Sleeping Venus*, Correggio's *Danae*, Goya's *Naked Maja*, Boucher's *L'Odalisque* and Manet's *Olympia* are canonical examples. Explicit sexuality was pushed even further when Courbet unveiled his *The Origin of the World*, a cropped close-up of a woman's naked crotch. Many of Courbet's risqué precursors had avoided pubic hair, and any sign of a vulva, as if to preserve the juvenile purity and virginity of their female subjects. It was recently discovered that Courbet's painting originally included the head of his model, a favourite muse, which he or some collector evidently cut off, making the picture more objectifying, despite a title that seems to flatter women. Also relevant for analysing Currin is Courbet's *The Sleepers*, which, like *The Dane*, offers a male perspective on lesbian desire.

Courbet's brazen excesses paved the way for further excursions into sexually explicit art. Ingres, Degas, Lautrec and Rodin all made sexually themed images. Klimt made pictures of women masturbating and heterosexual intercourse with visible penetration. Schiele served a jail term for producing pornography. Georg Grosz and Hans Bellmer drew pictures of penetration and fellatio. Picasso etched erotic minotaurs. Duchamp cast a woman's vagina in bronze. Balthus made a career of sexualizing children. Man Ray took photographs of himself engaged in sexual acts with his muse, Kiki of Montparnasse, who was also a gifted painter. These images are as graphic as today's hardcore pornography.

Quoting from pornographic sources continued after the Second World War. In the 1940s, Francis Picabia was making paintings inspired by pin-ups. In the 1960s, Warhol made a film of a man being fellated (*Blow Job*, 1964). In the early 1970s, Betty Tompkins made enormous paintings of sexual close-ups. The 1970s also saw the rise of feminist art, and female nudity figured prominently in the work of feminists. Hannah Wilke stripped in front of Duchamp's *Large Glass*. Valie Export posed for a photograph carrying a gun and exposing her crotch; while, in another piece, she invited people to feel her breasts. Carolee Schneeman created a performance piece in which she removed a long scroll of text from her vagina. Other female performance artists with a more ambiguous relationship to feminism were

also working with sexual themes: Yoko Ono had fans cut off her clothes; Marina Abramovic asked gallery visitors to abuse her naked flesh; and Annie Sprinkle invited people to peer deeply into her anatomy.

In the 1980s, when Currin was in art school, mainstream artists continued to draw on pornographic imagery. David Salle painted naked women spreading their legs, contorting and bending over in suggestive ways. Eric Fischl painted a teenage boy staring at the naked crotch of a reclining nude woman as he steals something from her purse (*Bad Boy*, 1981). Also highly visible in this period were the lounging nudes of Philip Pearstein and Lucian Freud. The homoerotic photos of Robert Mapplethorpe had also attained considerable notoriety, and art enthusiasts learned about Nan Goldin's harrowing world of drugs, sex and illness.

By the 1990s, internet pornography had become a major cultural phenomenon, and explicit imagery was more accessible than ever before. This had a noticeable impact on visual culture. Advertising, film, music videos and fashion (especially for young women) seemed more sexualized than ever. It is no surprise that artists' fascination with pornography became even more prevalent during this period than in prior generations. In 1990, Jeff Koons made a series of gaudy photos of himself having sex with a porn star named La Cicciolina (*Made in Heaven*). They later married and divorced, and she was elected to the Italian parliament. Video artist Pipilotti Rist also filmed sex acts using her hypnagogic style (e.g. *Pickelporno*, 1992). Later in the decade, Vanessa Beecroft began photographing large groups of idealized nude women with shaved genitals, which by the 1990s had become the standard in pornography, and, by extension, outside of pornography. Young British artists also began producing sexually themed work. Tracey Emin created a tent listing all the people she had slept with, and the Chapman brothers made child mannequins with phallus noses or sex-doll orifices in place of mouths. In this period, the United States and western Europe began taking an interest in works created by artists from other parts of the world. Museums began to collect works by Marlene Dumas, a South African who was making ethereal paintings that often draw on sexual source material, such as *Fingers* (1999), which shows a woman spreading open her vulva from behind. Japan's Takashi Murakami also attained celebrity status, bolstered by his sculptural quotations of sexually themed manga cartoons (*hentai*). In one piece, a blue-haired nymphette squirts a

giant ribbon of milk from balloon-sized breasts (*Hiropon*, 1997). Fame also came to the Egyptian artist Ghada Amer, who made gorgeous colourful patterns using needlepoint depictions of sexually explicit acts.

John Currin's forays into sexually themed art must be understood against the background of these developments. One might even describe the 1990s as the pornography decade in art. It was also a time when the neo-expressionist efforts of the 1980s gave way to a new interest in shock value. Saatchi's *Sensation* exhibit was a seminal manifestation of this trend, and art galleries began mounting risqué shows, with parental advisory warnings at their entranceways. When Currin abandoned abstraction, it is hardly surprising that he was drawn to prurient themes. His work co-evolved with his Yale friend Lisa Yuskavage, who makes kitschy paintings of curvy female nudes, which evoke Precious Moments figurines after ingesting aphrodisiacs or cutesy Keane's girls post-pubescence. Both artists present sexual imagery using styles that seem innocent and cartoonish. Both paint nostalgically, with Yuskavage drawing on vintage fantasy art, and Currin drawing on vintage porn. My point is not that Currin's creations were derivative or inevitable. Rather, I am suggesting that they were timely. It is sometimes said that we have moved past the age of "isms" in art, but it might be said that there is an evident "pornism" in art from the last two decades, which is unified thematically and sometimes even stylistically (Richard Prince, Patricia Cronin and Wei Dong are among other possible practitioners).

Several things distinguish Currin from this cohort. First, he is particularly drawn to 1970s pornography, with all its pasty colours, seedy settings and unpolished performances. This introduces an element that is not always present in other porn-inspired art. Currin is revisiting a time when hardcore pornography first became mainstream, with films like *Deep Throat* and *Behind the Green Door*. His choice of Scandinavian source material reminds viewers that many mainstream filmgoers in the United States saw unsimulated sex for the first time in the Swedish films, *I am Curious Yellow* (1967) and *Language of Love* (1969), which was the film that Robert de Niro's character chose for a first date in Scorcese's hit, *Taxi Driver* (1976). Denmark legalized hardcore pornography in 1969, before any other country, establishing its reputation as a land of sexual promiscuity in the American imagination. This was the landscape of Currin's adolescence.

Another distinguishing feature of Currin's work is his use of anatomical distortions. Other recent artists, such as Yuskavage and Murakami, exaggerate the female form, but Currin's distortions are more extreme. His subjects often look disfigured. One thinks here of Otto Dix and other New Objectivists, who shrank and stretched bodies for biting satirical effect. The standing figure in *The Dane* is strikingly reminiscent of a standing nude in Dix's *Three Wives* (1926).

A third mark of distinction is Currin's overt use of classical painting techniques. It is difficult to view his work without thinking of past masters. I shall consider the significance of this again below.

All three of these features are in evidence in *The Dane*: it is an homage to 1970s pornography; it distorts anatomy beyond the source material; and it shows off skills that Currin acquired when aping Renaissance art. I shall try to suggest that these features hang together in an important way, and deliver a message that is somewhat different from what we find in the work of equally explicit peers. Before we get there, I want to address the question that most immediately confronts viewers of his work: Is it pornography? In addressing this question, we may gain further insights into the status of what I called "pornism" more broadly. When artists draw on pornographic material, do they create pornography? If no, why not? If so, what can we learn from that?

Is *The Dane* pornographic?

In 1964, Supreme Court Justice Potter Steward famously said of pornography, "I know it when I see it."[2] This effort to skirt a definition is decidedly unhelpful, especially when dealing with sexual imagery in art. "I know it when I see it" implies that pornography is a visual category, something that can be identified by appearance alone. But that is just what's at issue here. If an artist copies an image from a pornographic magazine, the result will look like pornography, but we can still ask whether it is pornography. To answer that question, we need some account of what pornography is.

Definitions of pornography are legion, and I cannot attempt a complete review here, much less argue for which definition is correct. Rather, I shall mention several representative definitions, and we can keep them all on the

table when thinking about Currin's work. Dictionaries define pornography as representations (e.g. pictures, films or writings) designed to produce sexual excitement. Most philosophers have noticed that definitions like this are too inclusive. For example, a pathetic come-on line might be designed to produce sexual excitement, but few would regard it as pornographic. The philosopher Michael Rae specifies a number of further conditions.[3] Notably, he adds that if something is porn, it is reasonable to believe that it will be used to pursue arousal by most of the intended audience. On this definition, it is not enough that something be intended for arousal; it must be the kind of thing that would be used for this purpose by its intended audience.

Other scholars define pornography in ways that try to restrict its scope to materials that are offensive in some way. Such definitions tend to treat "pornography" as akin to "obscenity" – a term that is usually reserved for sexual material that is morally (and often legally) problematic. The most influential definition of this kind comes from the work of Andrea Dworkin and Catherine MacKinnon, who were interested in formulating a criterion that could be used to advance legal challenges against pornographers. In *Pornography and Civil Rights*, they define pornography as "the graphic sexually explicit subordination of women through pictures and/or words".[4] To be more inclusive, they later add "men, children, or transsexuals" along with women. They then explicitly spell out the kinds of things that qualify as subordination. These include presenting people as enjoying pain or humiliation; as experiencing pleasure in being raped; as sexual objects tied up, cut up, mutilated, bruised or physically hurt; as reduced to their sexual anatomy; and, as people who are whores by nature. This list, which I have only reproduced in part, aims to be inclusive, so that sexual material without these features can be defined as non-pornographic. A more succinct definition with a similar spirit comes from Helen Longino.[5] She restricts the category to material that represents sexual behaviour that is degrading or abusive to someone, which also explicitly or implicitly endorses that behaviour. Sexual imagery that is not degrading or abusive would not qualify as pornography on this definition.

A related concept in the scholarship on pornography is objectification. This refers to materials that treat persons as mere objects. Pornography can be distinguished from erotica by the fact that it objectifies the sexual

subject. Some scholars have worried that objectification is not always a bad thing. For example, Linda LeMoncheck notes that some medical procedures are objectifying.[6] She prefers the term "dehumanization", which is a form of objectification that fails to treat a person as a moral equal. Dehumanization is related to the term "humiliation", which figures in the Dworkin/MacKinnon definition of porn. Pornographic representations sometimes fail to represent their subjects as fully consenting individuals, and this deprives them of dignity and moral agency. These are forms of dehumanization.

Of course, some sexual imagery does present subjects as consenting, dignified agents. With this in mind, some authors try to distinguish "pornography" and "erotica". In a classic essay, "The Uses of the Erotic", poet Audre Lorde notes that the word "erotica" derives from Eros, the god of love.[7] She says that pornography and erotica are polar opposites, since pornographic depictions show contempt for their subjects. Citing similar ideas in Gloria Steinem's work, Alisa Carse has criticized this notion of the erotic, saying that "love" is too strong a demand for erotic art.[8] Rather, erotica is sexually themed work that conveys respect. In the same article, Carse notes that the word "pornography" derives from a Greek phrase meaning a graphic depiction of sex slaves. The notion of subordination and implied ownership of bodies demarcates the porn/erotic contrast on her account.

A different approach to the distinction can be found in Jerrold Levinson's "Erotic Art and Pornographic Pictures".[9] He echoes dictionary definitions in saying that pornography is aimed at sexual arousal, and then defines arousal as "the physiological state that is prelude and prerequisite to sexual release". Erotic, in contrast, is aimed at "sexual stimulation", which includes, "sexual thoughts, feelings, imaginings, or desires that would generally be regarded as pleasant in themselves".[10]

With these definitions in hand, we can begin to think more systematically about whether a given work of art is pornographic. There is no simple algorithm for settling the question, but the definitions can be used when trying to articulate reasons for applying that label. For example, one might note that Klimt's sexual drawings were intended to produce arousal, and thus qualify as pornographic on Levinson's definition. Or one might regard Mapplethorpe's photos of a man getting urinated on as pornographic because they are degrading. Someone who wanted to resist this

interpretation might argue that the depicted men retain agency and dignity in a way that blocks this inference. This is not an easy debate to settle, but the definitions lay out ground rules for how to proceed. They help us see what such debates turn on.

This brings us to *The Dane*. Working through the definitions, we can first ask: is it intended to produce sexual excitement? The source material certainly was, but what about the painting? This raises questions about Currin's intentions. In an interview, he says, "If I paint women, half the time it's just out of lust." We might infer that he hopes this image would arouse at least some of his viewers.[11] On the other hand, Currin made the picture less arousing in some ways than its source. He exaggerated the bony angularity of the standing woman, and she is no longer being vaginally penetrated by the finger of the seated woman, as she was in the original. However, if Currin didn't want to arouse viewers at all, he could have done more to de-sexualize the image. We could settle what he intended to do by asking him. Following Rae, we can then ask whether most viewers would recognize *The Dane* as a tool for excitement. This is trickier, since few viewers would actually consider masturbating in an art gallery, but, given the similarity between *The Dane* and conventional pornography, we can say, at least, that most viewers would recognize it as having features conducive to that function.

Moving on to Dworkin and MacKinnon, we can ask whether Currin's painting is a sexually explicit depiction of subordination. This too is a somewhat difficult interpretive matter, since the characters depicted have an ambiguous relationship. The standing figure appears dominant, but she is naked while the other is clothed. So it's hard to settle whether one is subordinate to the other. Dworkin and MacKinnon would say this misses the point. The very fact that viewers may take pleasure in viewing these women, who may have been coerced into the original photo-shoot, could make viewing the picture qualify as an act of complicity with sexual violence. With respect to the viewer, these real persons, whom Currin did not consult, may be humiliated. Also, the fact that the source image was (presumably) a paid photo-shoot may imply that the women in the picture are "whores by nature".

There may also be a sense in which Currin's work is sexually degrading for some of those who view it. Currin presents a world of male heterosexual desire. Even though he presents two women in an intimate setting,

he is portraying a male fantasy. There is no effort to capture accurately the attraction that exists between some women. The source image was made for male consumption. By transforming this into a work of art, Currin is effectively turning exhibition spaces into playgrounds for male sexual enjoyment. He may be able to get away with this because men continue to exercise disproportionate control over the artworld. Men own more important galleries than women, have more money to invest as collectors, and count among the most influential critics. Currin's success means that he is able to show in the world's most prestigious museums, and women who care about art will inevitably encounter his work. Such encounters may be degrading. Heterosexual women become a captive audience to paintings that pander to desires other than their own, rendering their own sexual agency invisible or irrelevant

Some of Currin's other paintings, such as *The Bra Shop*, could be accused of reducing women to their body parts – another clause in the Dworkin/ McKinnon definition. Such images may qualify as degrading too, a key term in Longino's definition, and objectifying in a dehumanizing way. Currin seems to recognize that his work is objectifying. In a 1990s interview, Kim Morgan asks him, "Are you objectifying women? Is [your work] a critique of that?" Currin is quick to reply, "No, it's not a critique of that. It's just objectifying women (laughs) … I don't think art is about critiquing anything." Though commendable for his candour, this suggests that Currin's work can be interpreted as an exercise in objectification.[12]

To argue against these interpretations, one would have to look for signs of respect in the work. One might argue that *The Dane*, in contrast to some earlier works, seems to impart some dignity to its subjects. The women appear to be acting freely in a well-appointed interior. It would be interesting if it turned out that *The Dane* qualifies as a less pornographic work than some of the less explicit paintings in Currin's *oeuvre*. That said, one could argue that *The Dane* is dehumanizing. Notice that the women do not look at each other in the eye. The standing woman stares down at the other with a mocking smile, and the seated woman stares at the other's vagina, as if this bit of anatomy summed up her worth as a person. Currin's women rarely make eye-contact with each other or with the viewer. This doesn't establish that his paintings are dehumanizing, but he misses out on a powerful tool for seeing his subjects empathetically.

Let's turn finally to the pornographic/erotic distinction. For Carse, erotic art conveys respect, whereas pornography conveys subordination. Here again, viewers may differ in how they see *The Dane*. The fact that the two women appear willing may be seen as a sign of respect. On the other hand, we can ask, does Currin respect these women? Is Currin inviting viewers to regard them respectfully? I had occasion to ask the artist about *The Dane* at a recent public appearance,[13] and he had this to say: "The pornographic source is pretty extraordinary itself. This emaciated and I think very moving, I think, face on the woman. Very tragic in a way that's not even the normal porn tragic. There is something about her face that I thought was very moving."

Currin's remark about the source material for *The Dane* reveals his compassion for one of the models. It also indicates that he sees a degree of tragedy in pornography. Presumably he is referring to a kind of expressive malaise, which indicates that many of the models in that industry are not happy to be posing for pictures. Here, we might begin to see a way in which Currin's work is not merely objectifying is also motivated by a sensitivity to the feelings and hardships of the women who appear in the images he is quoting. On the other hand, even if Currin feels compassion for these women, the paintings themselves may be more subordinating than respectful. Indeed, the fact that these women were reproduced without consultation may qualify as a kind of subordination.

Applying Levinson's definition is also non-trivial. It is highly unlikely that these images were intended by Currin for "release", which operates as a euphemism for ejaculation in Levinson's wording (a focus that may strike some readers as androcentric). But Levinson requires only that works put viewers into a state that is a precursor to release. It seems plausible that Currin's picture affords arousal, since the original was surely designed for that purpose. Perhaps a poll of viewers would help settle the question.

None of this settles the question of whether Currin's paintings are pornographic. It is controversial whether the foregoing criteria apply. The definitions provide strategies for defending an affirmative answer, but they could also be used in an effort to argue that Currin's work fails to qualify. Moreover, in defence of the critics who helped Currin rise to fame, it is often remarked that his paintings are ambiguous in just this way. I agree. One reason why it is rewarding to engage with his work is that it forces us

to ask these questions about the nature of pornography and its relation to art. However the verdict is brought down on Currin, the discomfort and controversy surrounding his work is not gratuitous. He is not a charlatan seeking to shock. Rather, he presents his work as an unapologetic window into the pornographizing gaze of the heterosexual male. In so doing, he doesn't simply recreate pornographic images. His stylistic choices and distortions block any simple equation between Currin and the pornographer. The resulting uncertainty raises important questions, and, in answering these questions, we may discover the ultimate value of his work.

The Dane as diagnosis

I have not settled the question about whether Currin's work is pornographic. I said that it might qualify on some prevailing definitions, but I also tried to suggest that the answer to this question is less important than answering a question about the relationship between art and pornography more broadly. I want to end by suggesting that Currin's work can lead to insights about the nature of Western art.

To bring this out, I want to come back to the three ways in which Currin distinguishes himself from other contemporary artists who quote from pornographic sources. First, I said he draws attention to a moment in time when pornography was becoming mainstream. Second, his figures are distorted in various ways. Third, he uses techniques that have deep art historical roots. These three features may seem unrelated. They may even seem to be in tension with each other. How can Currin commemorate the Renaissance while also adopting a 1970s aesthetic? How can he focus on technical mastery while distorting anatomy? One might think he has simply adopted incompatible ambitions resulting in pictures that are incoherent or unresolved.

I think these three features collectively contribute to the success of the work. First, consider what happens when one redeploys traditional techniques with a 1970s sensibility. This unexpected amalgam invites an analogy. It says, in effect, that 1970s kitsch is not so far off from previous periods, and, more specifically, that certain moments in Western art history can be compared with the time when pornography became mainstream. Why?

Perhaps because there has always been something sleazy about Western art. Perhaps Western art has always been a kind of popular pornography. And why the distortions? Perhaps these thwart the effort to treat Currin's work as just more of the same. His work may qualify as pornography, but it also goes "meta": it draws attention to our habit of unwittingly using art in this way. It subverts the easy enjoyment we normally seek out in pictures, and thereby reveals that viewing art is often a kind of leering. Currin's work helps us see that museums are places where we can gain cultural capital by viewing naked subordinated bodies. I don't mean to suggest that Currin operates with this political message in mind. Rather, his work draws attention to the problem by instantiating it. Currin's work is symptom, not censure. But as a symptom, it is revelatory. Currin blurs the boundary between art and pornography so overtly that it makes subtler blurrings of that boundary more apparent.

In suggesting that Western art has traditionally been a kind of mainstream pornography, I mean to suggest that prevailing definitions of pornography have some applicability to some of the most famous work in the canon. This point can be made by illustration. Consider Titian's *Pastoral Concert* (sometimes attributed to Giorgione) – a painting in the Louvre, which hangs directly behind the *Mona Lisa*. It depicts two nude women with two dressed men in a public setting. Someone could try to argue that this is pornographic because public nudity, or nudity in the presence of clothed men, would be humiliating for the women in the picture. This theme recurs in Manet's *Le déjeuner sur l'herbe*. Less obviously, it recurs in any of the thousands of paintings showing naked female bodies arrayed on the canvas for the pleasure of clothed male viewers. This exploitative aspect of art is not restricted to nudes. Even the *Mona Lisa*, who would hardly excite male viewers today, is presented as a beautiful woman in a low-cut top. We must remember that she was the legal property of her husband and that her portrait would have been used to enhance or express his power, not hers. This may not seem like pornography now, but it can be seen as a sexualizing image symptomatic of systematic subordination.

A proponent of Levinson's definition might resist these characterizations, saying the Renaissance pictures were not intended to produce arousal. That is a question for art historians to settle. For me, it doesn't so much matter that such works strictly satisfy any definition of pornography,

but rather that they are candidates. The fact that features characteristic of pornography can be found throughout Western art underscores the implicitly recognized fact that art production is not isolated from the phenomenon of sexual dominance and humiliation, but is often a manifestation of it.

Once recognized, museums begin to look a bit different. They begin to look like places where women who had no autonomy are put on display for the pleasure of viewers. In the twentieth century, this has become more evident, as art has become more explicit. As I suggested with my survey above, parallels between art and conventional pornography have become more and more apparent. But Currin's work helps us see that this is not discontinuous with history. Consider, for example, the gold brocade that adorns the wall in *The Dane*. This, I said, resembles Mary's throne in a painting by Rogier van der Weyden, among others. That painting adopts the convention of showing the baby Jesus suckling at the breast of his mother. We now see such iconography as quaint and innocent. But, in a world where female anatomy was well concealed, these pictures may have been a rare opportunity for heterosexual male viewers to enjoy the female form. Mary is presented as young, attractive, subordinate and exposed.

At the outset, I described how *The Dane* followed naturally upon Currin's earlier work, as if he was leading incrementally up to its creation. Here I am suggesting that his work is a natural continuation of the Western history of art. Centuries of sexual images, dating back to the Renaissance, which itself drew on classical sources, have been channelled into Currin's canvases, and his allusions to the past allow us to view his work as a culmination of what's come before, rather than a vulgar departure from it. When we find ourselves wondering whether Currin's paintings are pornographic, we quickly realize that similar questions arise for many of his predecessors' works. Borderline cases of pornography pervade every Western museum, and Currin helps us see that. We may end up concluding that classical nudes are erotic rather than pornographic, but forcing the question, as Currin does, is worthwhile because any answer would be illuminating. My own suspicion is that the erotic/pornographic distinction will be difficult to maintain for works created in a time when women enjoyed no equality with men.

I don't want to suggest that we needed Currin to see this. Feminist artists and art critics have pointed this out for decades. The posters made by

the Guerrilla Girls make much the same point more directly. I also don't want to suggest that Currin is a great feminist. His work is an instance of the phenomenon that it so successfully encapsulates. I do think, however, that, by making the pornographic leanings of art manifest, he manages to do something of considerable value. Currin's work is apolitical, so it cannot be dismissed as sermonizing. Rather, it puts us in the awkward position of enjoying images that are politically problematic. Standing before his paintings, we can confront our own culpability as viewers. Currin's tendency to quote from other eras allows us to extend this political realization backward in time; viewing Currin, we discover that every catalogue of masterpieces overflows with works that pander to male desire.

This might seem like an incredible downer. I am using Currin as a lens to turn every museum trip into an act of sexual violence. I am suggesting that the value of his work consists in its self-immolating indictment of Western art. But this anxiety can be to some degree allayed. Art can be enjoyed in many ways for many reasons, and the pornographic dimension of art (if that is the best description) is not the sole fact, nor even the primary fact, that keeps us going to the galleries. Furthermore, among art's many values is social critique. It should be no surprise that art itself can be brought under critical scrutiny, but, in the same gesture, we can applaud its capacity to serve as a mirror of our world. I've presented Currin as an unwitting critic. Perhaps these aspects of his work are intentional; perhaps not. Either way, he holds up a mirror to the pornography-obsessed world we live in, and his stylistic predilections allow us to see the present as an enduring echo of the past. This last aspect sets his work apart from some of the other artists who draw on pornography. *The Dane* is not a simple throwback to the 1970s; it embodies centuries of artistic practice, and, in viewing it, we catch sight of our own role and responsibility as viewers.

2 | A moment of capture

Dexter Dalwood
A View From A Window
(2006) | *Barry C. Smith*

Like many successful art works, Dexter Dalwood's *A View From A Window* (2006) works on several levels at once. The arrangement of contrasting colours is striking. The appeal is instant. And yet, as one begins to contemplate its subject matter, things become dark, disturbing and even menacing. The window frame with vases of flowers on the sill reminds one of the hedonistic paintings Raoul Dufy produced on the Côte d'Azur. The bright piecing light of the Riviera, the blue painted wood of the window casing is there, and yet, the landscape beyond is not a pretty scene of promenading couples and sailing boats, but a part-urban, part-industrial landscape with a sinister tower of grey smoke, almost animate in its sturdy thrusting form. The sky is blackened but filled with dots of white, at first like a simple and touching snow scene that is somehow incongruous with the sunny window frame and the vases of flowers, but in the company of brightly lit buildings and the smokestack, it now appears to be a polluted mass of drifting ash.

Like the work itself, the title works on different levels. In figurative art we are used to painted views from a window that represent particular places and times. But here we have the indefinite article. It is *a* view from *a* window, not the painting of a view from a particular window. It is simply

not anywhere in particular; somewhere more detached and abstracted from the here and now. Something more evocative: a worry lurking in the recesses of the mind.

What is happening here? What is it telling us? The collaged painted pieces do not fit perfectly together, and as the eye scans these imperfect joints this increases the sense of unease. Our fears and anxieties are readily projected into the painting. But once again, they are diffuse, uncertain, more reminiscent of an unfocused anxiety. And yet, at the same time, the ambiguities are intriguing: the composition simultaneously unnerves and appeals. Look at the two figures, barely noticeable at first, outside the window and painted in green. They are close, conspiratorial. The man's face is in view, and if *we* can see him then surely *he* can see us.

And what of the other glowing, tapering tower, which points menacingly skywards but doesn't seem to belong to the collection of buildings below? These odd details unsettle the eye's gaze; but not the eye alone. Were you to provide background sounds as part of the scene, what would they be? Not the lapping of water and the quiet chatter of promenaders in Dufy's paintings. Instead, I imagine a low, perpetual groan of machinery.

What is one to make of this work? What is generating this sense of unease in such a visually engaging display? I think a clue to Dalwood's vision can be found in an interview he gave to Cherry Smith where he tells her:

> My father was a bookseller and I remember finding a book with pictures of Belsen. It's one of those things you can't really explain – any sort of innocence is lost. You can't fathom it as a child, although you can have an inkling of it when you're an adult. We used to watch the news a lot. My mother was fascinated by the Nixon trial. I remember watching that and thinking it was a really big thing. I was always thinking that there's this dark underbelly of the world; everything isn't quite as it seems.[1]

In many ways this is a philosophical response: to wonder about the difference between appearance and reality: to feel that something is going on behind the appearances; that everything is not as it seems. Many philosophers remember episodes in childhood when they are struck by a gap

between appearance and reality, and this leads them in later life to explore this gap with increasing sophistication. It often starts with perception, which presents us with an experience of how things around us look, feel or sound, and this leads to an inquiry about what the things we are perceiving are like in themselves. Are there really colours in nature, or is this just a matter of what happens in us when light strikes the rods and cones in the eye? Are objects really rough or smooth, or is this just an effect of the interaction of their surfaces with our sensing touch. How could the felt quality belong to a piece of wood or metal were there no one around to feel it? We find some foods disgusting and it appears to us as though the disgustingness were part of the food itself, leaving us astonished that others can enjoy them. But how can it be that the disgustingness, as we see it, is part of the sea urchin itself? And does it even have a taste without tasters to consume it? Bertrand Russell famously said that the world independent of the mind is a world without colour, sounds, smells or tastes, heat or cold. All of these are what we subjectively contribute to our surroundings; ways that we gild and stain the world with our internal impressions, as David Hume put it. Today, many philosophers disagree with this envisaged gap between reality and our experience of it, but even if one supposes that the everyday objects we encounter are as they appear to us in perception, it takes work and effort to make out the case for such direct realism about perception, and the sceptic is always lurking in the background warning us that things in our experience could be just as they appear to be and yet this not be how things are in mind-independent reality. These challenges to what is so familiar and intimate about our perceptual contact with our surroundings force us to go on figuring out what is really going on and what we can be sure of. It is something about the unending nature of this exploration that the artist Dalwood shares with the philosopher.

For a child, the sight of images from the Bergen-Belsen concentration camp would be fascinating and repelling all at once. Something odd, capturing one's attention immediately, but not comprehended at first, and only gradually or much latter recognized as scenes of horror. That delayed shock suggests something potent about that first look that conveyed to the uncomprehending fascination of the child a feeling that something wasn't right, that there was something unsettling here.

It would be simplistic to read into this work straightforwardly an image of the death camps, but that's not the idea. Instead, one can see many of Dalwood's works as capturing the moment of looking and the duality of feeling about what intrigues and disturbs all at once. The brightly painted and collaged images are immediately compelling, and then, little by little, as one's eye settles into the details of the composition, they give rise to a growing sense of unease, hard to pin down but readily felt. Here one sees the fascination of Dalwood's working through of appearances and what lies beyond: unfathomable and yet palpably present. The more one looks and the more one dwells on the painted scene, the more one is aware of the levels on which this piece works and how well it fuses the precise arrangement of colour and form with our unarticulated feelings. These paintings are about looking and feeling, and not necessarily knowing; they are also about how we feel when we look: about an urge to figure something out, something that haunts us and lies just beyond our understanding. They invite us to look and to dwell on the feelings that come to light: a moment of capture that Dalwood knows well and returns to again and again. It is his signature and he communicates it well.

3 | Uncanny absence and imaginative presence in Dalwood's paintings

Dexter Dalwood
Room 100 Chelsea Hotel
(1999)
Hendrix's Last Basement
(2001)

Edward Winters

The Chelsea Hotel is famous for its famous residents. Bob Dylan, Dylan Thomas, Arthur Miller, Eugene O'Neill and Jack Kerouac are a handful of names that come to mind. Leonard Cohen wrote "Chelsea Hotel" to commemorate an evening spent with Janis Joplin there in room 419. Its bed, with its rumpled, strewn sheets, the place where oral sex took precedence over the waxed Lincolns and Cadillacs, waiting – subservient drivers in their grey livery at the ready – in the street outside. The image brought up by Cohen's song, one of human intimacy in a slovenly hotel room set against the everyday street scene outside, brings a neat distinction between privacy and publicity. Rooms are interior, as are private lives. Limousines and the trappings of stardom are there to be caught on photograph and belong to the trashy culture of the tabloid and the glossy magazine.

Dexter Dalwood's painting is of an imagined room in the Chelsea Hotel; counterpart to the one in which Nancy Spungen was murdered: room 100. The prime suspect at the time was her lover, Sid Vicious, although he was subsequently acquitted due to lack of evidence. In the early hours of 12 October 1978 there had been complaints of noise coming from the

room. Both were high on the sedative Tuinal, and Spungen died from a stab wound. The couple had been moved to room 100 after having set light to the mattress in their original room.[1]

In the painting, the room is trashed. The bed is broken, its dishevelled bedding leaning toward bottom right. There are candles lit on the floor, emblematic of courtly romance and also of the paraphernalia of hard drugs. The television has fallen on its side, still transmitting news or some other programmed "talking heads". The lights are on but there's no one at home. Both violence and silence pervade the picture. It's over. We have the feeling, as in so many of Dalwood's paintings, that we are intruders. We are uninvited guests in a room where the proper occupants are either off-scene or are otherwise mysteriously absent. "Uncanny" is the usual English translation of the German "*unheimlich*". However, it can be translated as "unhomely", which I take to capture the slightly nauseous feeling of being out of place. The painting itself is a composite picture "driven" by a collage, as are all of Dalwood's paintings.

Luck saw me loaf about Málaga in September, 2010. That luck extended to my viewing the major exhibition of work by Dexter Dalwood at the Centro de Arte Contemporáneo. The work had already been exhibited at Tate St Ives and at FRAC Champagne Ardenne earlier in the year; and the shared venture afforded a lavish catalogue including an interview with the artist and two essays on his work. It was an excellent show and I returned to it over several days, each time absorbed increasingly into the range of work by this interesting and thoughtful painter. The work is, I could see straight off, beautiful; and beauty, in painting, counts.

In the artworld that is no small claim. In this essay I shall look at *Room 100 Chelsea Hotel* and *Hendrix's Last Basement* as foci for thinking about the nature of representational painting in contemporary culture. Contrary to the received view that painting is merely a small part of a larger spread of media best dealt with by visual culture, I shall argue that representational painting has a privileged status and that painting should be studied and its works appreciated in terms that sustain this discrete position. The word "privileged" in this context is likely to set teeth on edge. It shouldn't. I mean it only in the sense that painting, ultimately, requires a different set of considerations than does the courtroom sketch

of the defendant or pictorial pornography, or any other pictorial practice for that matter.

A general theory of depiction stops short of delineating the specific conditions pertaining to each of what I shall call the pictorial economies. It is when we have arrived at such a general theory that each of these economies needs to be looked at in its own terms. Once we know what pictures are, we can go on to discuss the work that they do and the arenas in which that work gets done. A general theory, however, provides a foundation upon which we can better see the intricacies of a particular pictorial practice. And so to the general theory.

On depiction

The view of depiction to which I subscribe focuses on the peculiar nature of the experience undergone when looking at pictures. Pictorial experience is complex and consists in a perception of a marked surface that is present to us. In addition, the experience is saturated by imagery *in absentia*. To understand this complex experience it is necessary to draw a distinction between perception and imagination. The distinction dates back to antiquity. In *De Anima*, Aristotle writes:

> That imagination is not the same as perception is clear from the following arguments.
> (i) Perception is either a potentiality or an activity, as, for instance, are sight and seeing, yet there are appearances in the absence of either of these, such as the appearances in sleep.
> (ii) Perception is, but imagination is not, always present ...
> (iii) While perceivings are always veridical, imaginings are for the most part false ...
> (v) Visions appear even to those whose eyes are shut.[2]

We see what is in front of us because we are sighted creatures blessed with visual perceptual apparatus. However, when we form mental images we do so without recourse to such apparatus. We see, as it were, in the mind's

eye. Seeing pictorial content is something like having a mental image *as of* that content projected onto the variously marked surface we see in front of us.

In his philosophy of psychology, Wittgenstein writes on aspect seeing. He considers the occasion of looking at a black linear triangular figure on a white ground. Apart from seeing the triangular shape we can *further* "see that shape as" an object hanging from its apex, or as a pyramid, a rhombus cut in half, a triangular object having fallen over, as an arrow head pointing left, or right, and so on. As I move from one descriptive content to the next, so too, the aspectual experience changes – the experience, at least in part, being constituted by the descriptive content.

The concept of an aspect is akin to the concept of a [mental] image. In other words: the concept "I am now seeing it as ..." is akin to "I am now having *this* image".[3]

But I don't want to say that an aspect is a mental image. Rather that "seeing an aspect" and "imaging something" are related concepts.[4]

It is as if an *image* came into contact, and for a time remained in contact, with the visual impression.[5]

In these remarks, Wittgenstein points up the kinship between having a mental image – seeing in the mind's eye – with aspect seeing, as when I see the triangular figure as a pyramid sitting at the edge of the Sahara Desert. It is not that I look at a picture and I thereby have a mental image. But rather that the concepts of mental image and aspect are related. I return to this later.

Wittgenstein relates the ability we have to see aspects with our ability to see pictorial content:

How would the following account do: "What I can see some-thing as, is what it can be a picture of"?

What this means is: the aspects in change of aspects are those ones which the figure might sometimes have *permanently* in a picture.[6]

These collected remarks afford a schematic view of how pictures, in general, might be conceived. The logic of depiction, so to speak, asks generally what it is for the perception of a present, relatively flat expanse of patterned surface to afford an experience *as of* an absent three-dimensional world. In providing an answer to that question, the logic of depiction is required to be broad enough to explain the photographic image, the technical drawing and the diagram, as well as the cartoon, the illustration and the painting; since each of these objects is a picture.

While we remain in the broad discussion of pictures, consider looking at a high-contrast black and white photographic portrait. Now imagine that the contrast weakens, the whites and light greys moving toward mid-grey as the blacks and dark greys do likewise. Eventually, the fading resolves into a uniform mid-grey rectangle where once the photographic image had obtained. At the point of attenuation, the point at which the image disappears, there remains, for the briefest of moments the image of the sitter faintly hovering above the undifferentiated rectangle.[7]

Entertaining that thought urges us to see the difference between mental images and aspects. For the faintest of aspects remains located on the picture surface. Whereas, once the rectangle has uniformly greyed, the mental image which is the residue of the aspect is no longer located in the space of our environment. We can no longer point to regions of the rectangle and say, "Look at this as the eyebrow, this as the line of the nose", and so on.

But the aspect, while located across the differentiated surface in the space we occupy, belongs to another realm: the imaginative. You can accurately measure points across the picture surface, but it is not possible to accurately measure the aspectual content. Of course, in most pictorial images, the size of the assembled items will be determined relative to each other as standardized, but accurate measurement within the pictorial remains beyond the reach of the viewer. The picture space, as it

were, is hermetically sealed, while the picture surface remains in touching distance.

Voluntary experience

One way in which mental images and aspects converge is that they are each subject to the will. We voluntarily undergo these experiences. Forming an image is something I can do and I can call upon others to do likewise. Moreover, I can temporally measure these experiences and after a certain amount of time I can give up the image at will. This is equally true of aspects. Consider the famous duck–rabbit ambiguous figure:

I can choose to see the duck aspect for exactly ten seconds before choosing to switch aspects, thereafter seeing the rabbit aspect. It is possible to reject both aspects preferring the simple perceptual state of seeing the serpentine line surrounding a small dot. Now the relation between the aspect and the black line is an internal relation. I see the relation between the duck aspect and the line and I see the relation between the rabbit aspect and the line. And when I switch from seeing the one to the other my experience changes. "By noticing the aspect one perceives an internal relation, and yet noticing the aspect is related to *forming an image*."[8]

Imagination is subject to the will while, ordinarily speaking, perception is not. When we look up into the fluffy clouds on a summer's day, we can see in them ferocious monsters or great catastrophes; or we can see charming faces or some heavenly environment. We are unconstrained as to what we might see in the cloud, just provided we can somehow fit our imaginative content to the patterned outline the cloud affords. In the case of depiction, what holds our attention to the surface and what dictates the content of the picture is an additional ingredient. We are constrained by the thought

that the pattern of the surface in front of us is the result of some process by which the current picture was fabricated. In the case of the clouds we freely consider our perception to be "gappy" with respect to content. The left eye, in the face we "see" therein, has to be supplied by us to complete the recognitional aspect; or some redundant feature of the configuration has to be masked out of our experience in order to sustain the "content".

On seeing surfaces, we are able to provide additional content by way of "marking in". Consider this passage from Jean-Paul Sartre, in which he considers looking at a patch of patterned wallpaper and using his perception of the lines that form the pattern to imagine representational content:

> Here ... the form is only outlined: for hardly have forehead and eye appeared when we already know it is a Negro. We complete the process ourselves by effecting a harmony between the real data of perception (the lines of the arabesques) and the creative spontaneity of our movements: that is, we supply the nose, mouth and chin ourselves.[9]

(We can also "mask out" of our perception features that might otherwise intrude upon the pictorial experience. The subscriber to the pornographic periodical, as he gazes longingly at the glamorous model disported across the centre pages, masks out of his experience the staple that holds the magazine together; and which might otherwise appear as the large metallic pincers of some alien escaping from her navel region.)

With pictures, the surface is not "gappy" in this way. It was prepared for our looking; and if it does require other additions or subtractions, it is because we understand these gaps or additions as intentionally motivated. In looking at a picture *as a picture*, we are predisposed to consider why its surface looks as it does. We think of it as the trace of some causal chain; or we think of it as having been fabricated within some pictorial context to look as it does.

There is more to be said about the nature of the aspectual content as that rests upon, or soaks into, the perceived surface. One way of approaching that puzzle is to list the features of the perception of the world – the picture surface – and to list those features of the imaginative fold that inhere there. Colin McGinn makes a start:

> We may have a simple percept of the picture, with no imagination involved, and then we have the consciousness of what it represents – and this requires an exercise of imagination ... As with seeing aspects, this kind of seeing involves a move away from the simple percept, though the percept is what makes this transcendence possible: the imaginative seeing is *based on* the percept, triggered by it.[10]

And a little further on he adds:

> we have a percept being invaded by an act of imagination: instead of the image remaining in its own "space," a representation of an absent object, it locates its object in the current visual field. Compare forming an image of a duck and seeing lines on paper *as* a duck: the duck image seems to have made a trip from imaginative space to real space.[11]

And to this last quote there is added a telling endnote:

> This joining of imagistic and perceptual space is particularly perplexing ... The intentional object of the image fuses with the object located by the percept, as if the objects of imagination have come down to earth temporarily – jumped spaces, as it were.[12]

Thinking about pictures leads us to regard them as imaginative perceptions of surfaces. While picture surfaces are held in the world we occupy, imaginative aspectual content lies beyond our grasp. Seeing the content of a picture is voluntary and is thereby subject to adjustment by the spectator. I can come to see pictorial content under descriptions previously unavailable to me. I can be persuaded in and out of experiences comprising imaginative content.

On pictorial economies and aesthetic pictures

Pictorial economies arise from the uses to which we put pictures. Our purposes are diverse. In foreign climes, maps assist in the negotiation of an unfamiliar environment. At home, technical diagrams explain the way a piece of furniture delivered in a flat pack is to be assembled. At the frontier, passport photographs help to identify the traveller at his point of crossing. At the track, photographs establish the order in which horses pass the post and determine who shall collect on their bets. When suffering from loneliness pictorial pornography puts us in mind of those for whom we long. In saloon bars, Wild West "wanted" posters announce the reward money and show us the grim faces of those sought "dead or alive". At the gallery, a painting quickens our affection for ideas given visual form by the painter's hand. It is because there are such diverse purposes that there is such varied commerce providing pictures tailored to the pursuit of these ends.

However mysterious, however puzzling, all this talk of percept and image – it nevertheless strikes me that some such description best captures the phenomenology of looking at pictures; and seeing in those pictures the content they might bear. And even if only partially characterized, the view is strong enough to provide resources out of which we can fashion an account of why painting is an *aesthetic* endeavour. When we look at paintings, our understanding of the imaginative perception affords us an insight into what it is that the artist does when he makes a picture. He exploits his mastery over the (perceptual) material in order to provide us with an occasion upon which we can see its manipulation create life in the imaginative light we project onto the canvas. However, given that is his project, we recognize that we are to see the surface as complete. Missing detail is taken as deliberate omission. Additional detail can be seen as breaking into the narrative or interrupting or intervening. This again is regarded as something the artist has done to further his project. Aesthetic representations – works of art – use the conduit between the aspectual content and the surface material, in which the content is secured, to exercise the imagination in ways that we find both pleasurable and meaningful. Painting as an art thrives on the ingenuity of the artist as he pushes the material around in order that the spectator

sees new and innovatory combinations of marks that conscript images into their space.

Dexter Dalwood

In her foreword to the 2013 catalogue of the CentrePasquArt Biel, Felicity Lunn writes:

> It is no coincidence that the subjects of his paintings are always physically absent ... Their invisibility heightens the mystery and artifice of the scene but also removes the most recognisable aspect of figuration from works that ultimately communicate something that goes beyond depiction or language. Much more than the sum of their very disparate parts, Dexter Dalwood's paintings make an uncompromising claim for the continuing tradition of the medium.[13]

In the earlier discussion of depiction the imaginative content that infuses the special perception pertinent to pictures, requires a descriptive content that transfigures the perception. The transfiguration transforms the perception of alizarin, lavender, Paynes grey and warm titanium white into a maroon-carpeted room with colour-coordinated walls and a white-sheeted unmade bed. It transforms whites, pale blues and yellows into sources of light – wall lights, candles, a vestibule-ceiling light and a television set. The room is the scene of a crime. The crime is committed and we look upon the aftermath. Paint on canvas has to contain all that.

In the interview from the Málaga catalogue, Dalwood says, "I became obsessed with making paintings of odd bits of rooms, bits of ceilings – the kind of thing you look at when you're lying on a bed, feeling slightly depressed."[14] When I first looked at *Room 100 Chelsea Hotel*, I thought of Leonard Cohen's song "Chelsea Hotel", and then thought of an aesthetic "argument" found in one of Cohen's novels.[15] The form of the argument simply lays out two conceptions of what might be a proper response to staying in a cheap room. Breavman, the narrator and the autobiographical voice of Leonard Cohen, is at university with Shell, whom he sleeps

with but does not love. They have been driving all day and they put up in a cheap rooming house. Shell wants to move the bed in their rented room.

> Breavman was furious. He didn't want to move the bed.
> "What does it matter where the damn bed is? We'll be out of here by eight in the morning."
> "We'll be able to see the trees when we wake up."
> "I don't want to see the trees when we wake up. I want to look at the dirty ceiling and get pieces of dirty plaster grapevine in my eye."

Shell proceeds to move the bed without Breavman's help: "The ugly brass bed resisted her. For generations of sleepers it had not changed its position. He imagined a grey froth of dust on the underside."[16]

Just as the novel can make arguments about the nature of an appropriate aesthetic response, so can a painting; and Dalwood's paintings are full of such arguments presented *visually*. Indeed, I hope that enough has been said about descriptive content to permit something like the Cohen quote to enter into our experience as an imaginative presence. The feeling attendant upon looking at these pictures derives from our watching the dust settling upon a particular piece of actual cultural history. The television and the lights are still on. The candles flicker. Nancy Spungen is present, but not seen, and she is no longer alive.

In painting, the transcendental movement calls for attention to be distributed between the surface and the aspectual content in such a way that the spectator appreciates the painter's *making* of the painted picture as a ground for imaginative perception. Collage is a technique developed in the twentieth century. The foot of the bed frame is a cut-out shape that locks the bed-knobs into a space of their own. So, even as the room is set up in some strange distorted perspective, the cut-out shape serves to flatten the aspectual image – to take it back down to the surface upon which that image rests. The foot of the bed in perspectival space is experienced as such; but it is also experienced as "glued" flat across the picture surface; and so our experience oscillates between the flatness of the canvas and the pictorial space it supports.

Dalwood, here as elsewhere, borrows from others' work.[17] Patrick Caulfield's late work juxtaposed realist passages with highly schematic line drawing blocked in with flat colour. They were, in effect, different techniques of painting collaged together into a composite image. It might seem odd to think of Caulfield as indebted to cubism but that claim seems less strange after having looked at Dalwood's paintings. In one of Bloomberg's TateShots, *Nick Serota and Dexter Dalwood on Patrick Caulfield*,[18] Serota talks about the use of various "modes" of making pictures that get put together in Caulfield's *Interior with a Picture* (1985–6). This pulling together of different historical and culturally diverse means and methods of depiction is extraordinary in Caulfield's work. From this Dalwood borrows method and exploits that method to an aesthetic end.

In mentioning "borrowing", I am careful to avoid using the more usual linguistic term "referring". My reluctance to comply with this orthodoxy is grounded on the belief that too much has been made of the linguistic nature of visual art. The twentieth century has distorted contemporary art with its obsession with meaning and interpretation, where this has drawn us away from the aesthetic experience of painting in favour of a more intellectual deciphering of works. Dalwood speaks of his practice as "sampling", which I much prefer. However, sampling sounds more like merely lifting from the work of others, whereas I see Dalwood as *borrowing* to effect. Picasso does this and I think of his paintings that borrow from Ingres and his variations on Velázquez's *Las Meninas*. In one of these last, Picasso places the ceiling hooks as if they are side by side. When looking at the Velázquez original, the two hooks are in a line receding perspectivally into the picture. Picasso thereby "yanks" the space around in his variation. If the spectator was unacquainted with the original, she would not be able to see how Picasso had played with the space to such effect. So, the borrowing from Velázquez is used in the formation of an experience for the spectator.

Dalwood, in another of Bloomberg's TateShots, *Meet the Artist: Dexter Dalwood*, says: "I have people come to the studio and say, 'Oh yeah, I see you've got a bit of Edward Hopper there, and you've got, who's that over there, is that Bacon?' as if the painting isn't in front of them."[19] Earlier in the same clip, pointing to his own painting, *Hendrix's Last Basement* (2001), he remarks, "And here there's a Morris Louis painting in the bottom half of the canvas."[20]

It is interesting that Dalwood resists the idea that looking at the paintings is somehow an intellectual game whereby players compile a checklist of "references" to artists of the past. The painting's being in front of them calls upon spectators to *experience* the art of the past made present in the work in their imaginative perception – as Picasso did with Velázquez. Indeed, Picasso, with the irrepressible confidence for which he was known, writes:

> I would say to myself: suppose I were to move this figure a little to the right or a little to the left? ... Almost certainly I would be tempted to modify the light or arrange it differently in view of the changed position of the figure. Gradually I would create a painting ... sure to horrify the specialist in the copying of old masters. It would not be [*Las Meninas*] he saw when he looked at Velázquez's picture; it would be *my* [*Las Meninas*].[21]

Interesting also that Dalwood locates the Louis on the canvas and not across the floor of Hendrix's basement.

In the 2010 catalogue interview, Dalwood mentions a specific period in the history of art schools. The reluctance of the late modernists to surrender abstraction brought about two reactions from within. The first was pop art, led by Warhol, in which figuration and borrowing from visual media beyond fine art found itself breathing in an atmosphere lighter and fresher than the heavy, stale air of abstract expressionism. The other reaction was from the more intellectual conceptualists. Concerned with Clement Greenberg's formalist aesthetics, and the demand that art should be a matter for refined taste, John Latham called upon students to turn away from aesthetics and instead look to the social consequences of the work they undertook as artists. Greenberg and the Conceptualist rejection of his pure aesthetic has seen a decline in the search for beauty and the emergence of theoretically based works that would reject any aesthetic dimension.

However, if we are concerned with experiencing paintings and with the artistic value to be found therein, we might resist Greenberg's formalism and search for an alternative aesthetic – one capable of embracing contemporary social and cultural issues. After all, poetry, the novel, theatre, and song all seem to have such capacity. Moreover, these other arts are enjoyed

for their aesthetic qualities and their practitioners do not have the same hesitance when it comes to the aesthetic dimension.

In discussing pictorial content and its relation to the surface of paintings, we looked at the presence of the surface in the experience as worked within a tradition. The artist's work in contriving a surface is held to be beautiful in virtue of the representational properties to which it gives rise. So we look at the worked surface and see in it the pictorial content the painter intended. That content, it should be clear, can contain as much or as little social attitude as the artist cares to convey.

There is, however, another dimension across which a painting can gain access to aspectual content. Wittgenstein considers looking at a face and seeing it in light of another face, not present to the viewer. I notice a likeness between two faces, even though only one of the faces is present. Now the absent face is not the content of the present face. And this phenomenon has its counterpart in painting. For, when I look at Picasso's variations, I see the young princess with a dog lying at her feet and two nuns standing behind her. I see the back of a canvas and I see the artist peering out from behind that canvas. But I also see the likeness and the difference between each variation and Velázquez's original. This experience of variation – as when I notice the likeness between Rodrigo's *Concierto de Aranjuez* in Miles Davis's variation in his *Sketches of Spain*; or when I hear Gershwin's *Summertime* in Albert Ayler's darker variation – is one that builds upon the identification of the content of the picture. So I see Morris Louis's stain paintings in Dalwood's *Hendrix's Last Basement*.

The experience of variation is more central than often supposed. For the connectedness of art might be thought to be what binds art within a tradition. Now, there is some considerable force in this claim for the status of art history. In T. S. Eliot's famous essay "Tradition and the Individual Talent",[22] he claims that artists have the ability to change our perception of the art of earlier periods. So, according to Eliot, there is a two-way traffic with the history of art. The artist, with his creative talent, can guide our attention and point us in entirely new directions, but only so long as he is immersed in a tradition. Innovation, on this view, is only available from within a tradition. Perhaps painting has always sought to represent the visual world. Perhaps our concerns with, and appreciation of, the formal aspects of painting, the trace of the activity, and the surface (in which that

trace shows up) can only be made sense of when considered from within the tradition of making pictures.

An artist, according to Eliot, makes a place for himself within the existing framework of the tradition. That tradition is to be seen as a complex network of relationships between works of art. By inserting his work into that complex network of relationships, the existing set of relationships changes in its accommodation of the new. In Michael Archer's Biel catalogue essay "The Figure in Painting", he writes:

> Balancing the ostensible licence to play with historical propriety that postmodernism enjoyed is a strong reckoning with what persists as a sense of history. What we repeatedly witness in [Dalwood's] paintings is the connection made with past work such that it is released into a renewed currency of the moment.[23]

Indeed so.

The longevity of painting

Dalwood pulls together two strands of painting that were picked apart by both Greenbergian formalists and their conceptualist adversaries. At least part of the beauty is to be found in the way in which he is able to draw upon tradition, and at the same time work critically within that tradition. After all, we might ask what it is that Morris Louis was doing as a serious artist when he made those stained canvases. Certainly, he was concerned with the physical nature of the painting and the surface upon which it was supported. Did he want the flatness that Greenberg demanded?

Richard Wollheim writes on Morris Louis's *Alpha Phi* (1961), one of his late "unfurled" paintings:

> Louis ... wanted to introduce colour into the content of his paintings ... but ... he wanted consideration of the spatial relations between the coloured elements, or the bearers of colour to recede ... He seeks a form of representation where representation of space or of anything spatial is at a minimum. And to

achieve this effect, he uses the surface in such a way that so long
as we look centrally at one of the patches we see it representa-
tionally. But, as our eyes move toward the edge of the patch,
the representational element diminishes, and we become domi-
nantly, then exclusively, aware of the canvas ... The overall effect
is that, in looking at Louis's patches, we seem aware of them as
though they were embedded in, or pressed down upon, the sur-
face – an effect, which, incidentally, we find, in a highly figurative
context, in some of Goya's paintings.[24]

This passage shows us that the technicalities of painting were at the fore-
front of Louis's practice; and that the spatial properties of making a paint-
ing and on calling attention to the surface were of the utmost importance
to him. Now, given that Dalwood is a serious painter, concerned with the
longevity of painting, irritated by the continual proclamation that painting
is dead, it makes sense to see him as working in a tradition that calls upon
the technical abilities and the *artistic* concerns of his forebears when mak-
ing contemporary paintings about contemporary culture.

Dalwood's borrowed Louis sees the patches spread across a floor as some
kind of carpet. It is not, however, as crude as that might first seem. For the
constant calling attention to the Louis unfurled paintings has us look at the
patches as they shimmer between the flatness Louis gave them when looking
at the edges and the sense of them representationally in the receding plane
of the basement floor. And this shimmering feeling is similar to that feeling
we get when we hear Gershwin's *Summertime* in the Ayler variation. We
keep being drawn back to the original and in being so returned to it, we hear
anew the work being played, or we see anew the painting that is in front of us.

It is for this reason that I am convinced that borrowing is what artists
do when they want to call attention to the tradition and to add to it in the
manner in which Eliot has argued.

Coda

It often occurs to me that painting has been oppressed by Greenberg's
particular conception of beauty, so that the conceptualists were moved to

turn away from aesthetics as a form of "bad faith" or "false consciousness". Pop art's turning to visual culture more broadly – noticing the packaging and the televisual trash that surrounds us – has fuelled a movement in art history that reduces painting to a mere component in the broader visual culture. I believe that artists working now in post-conceptualist and post-modernist practices are working in an optimistic reviving way that will ensure the longevity of painting as an aesthetic endeavour. The beauty of painting, however, is not to be pursued along purely formalist lines. Beauty in painting will be hard won and it will not be the trees through the window, rather than the crumbling plaster vine on the bedroom ceiling. I recommend Dexter Dalwood's deeply thoughtful, socially contextualized works as examples of beautiful painting in contemporary culture.

4 | At the still point of the turning world

Two Quartets by Tom de Freston

Tom de Freston
Quartet – Stage One
(2012)
Quartet – Stage Two
(2012)

Lydia Goehr

Circling the square

Given established historical precedents, one could produce a square of criticism and claim, first, that the correct condition under which to judge an artwork is when the mind and the senses have become accustomed to the work, when the contemplation has settled, when something like a harmony between subject and object has been established. David Hume thought that a critic ought to be of sound and sober mind even if he suspected that few ever came really close to achieving this state. Still, he stuck to the harmonious ideal – and to the "standard of taste" – to justify his view that there is a correct state of mind in which critics should issue their judgements.[1] This view can then be added to by the claim that there is a singularly best or correct place from which to view an artwork, where this authoritative place of viewing corresponds to the perspective formed within, and framed by, the work itself. If one looks straight on at Holbein's *Ambassadors* on the wall in London's National Gallery, one won't see what one is meant to see, the work from its deliberately skewed or angled perspective, from literally and metaphorically its *right side*. Added to these two views is a third,

according to which an artwork, a painting or a sculpture, must capture the right emotional moment in its depicted action or drama, the "pregnant moment" to use Lessing's phrase, when the temporal unfolding of a state or of an action is perfectly stilled. And finally, to complete the square of criticism, it has been held that there is a singularly correct historical moment for a contemporary artwork to be judged, as the artwork moves from being entirely new for the public to its settling down into a history to be remembered or forgotten in the great stockpile of artworks produced.[2]

Needless to say, few anymore endorse this square of criticism, especially if the square has the effect of setting artworks into straight, static, essentialist, or overly authoritative frames of interpretation. Most now encourage a more variable, fluid or hermeneutical approach to art criticism. According to this approach, artworks call not for singular judgements, but for ongoing viewings and readings that allow those who engage with the works to find something new or different each time, as though, as in great works of philosophy or literature, they were always somehow viewing the works for the first time. Or the square is circled when artworks are read as essentially open, as allowing the works to explode into changing and even competing meanings as contexts and horizons of interpretation alter what one sees as embodied within them. Hence, that one judges works good or beautiful, or, better in contemporary terms, that one deems the works worth engaging with, doesn't imply that a given judgement holds for all time or that the value of the artworks is exhausted by one's singular view or perspective, by a singular viewing under a singular condition, by an isolated emotion or a singular expressive state. Rather, works submit to changing assessments as they engage preferably not too sober viewers in altered states of movement, ambiguity and tension.

When viewing Holbein's *Ambassadors*, one may reasonably claim that one point of the painting is to move from the wrong, naive or head-on, Testadura-like perspective to the correct perspective, given some sort of proof that the painting was originally hung in a certain way on the wall, so that the first viewers would have seen the painting from the correct perspective straightaway. But with more theatre in mind, one may say that Holbein was playing, through techniques of *ekphrasis*,[3] with breaking down any naive idea of a painting's perspective and medium within the painting itself. Given its content, colouring and spatial design, framed by a staged

curtain and a circular mosaic-floor that supports a movement between figures and objects who live and those whose lives have been stilled, the painting compels its viewers to move not only with their eyes but also with their bodies. Or, by forming on its two-dimensional surface three walls of a space that is both completed by but also opened up to a fourth wall, viewers are compelled to walk around the painting as one would a sculpture – to view and even touch it from its different sides, and all to the sound of a music moving between a harmony and disharmony that is silently evoked by the placement of the partially broken pipes and lute within the painted scene. More than this theatrical reading issuing a definitive meaning of the work, it encourages viewers to pay attention to painting as an art, to how paintings draw or fail to draw their viewers into a space in which meanings emerge in the interaction between works and viewers. This interactive view could be theorized in terms that still rather boringly either essentialize or relativize meaning. But the same view could also break down this traditional dichotomy by drawing our attention away from how meaning is *either* found *or* made to how meanings emerge between finding and making, between the two ambassadors of representation, between the theatrical interaction of the different arts.

In his novella dedicated to exploring the chemical movement between the four lovers of a dynamic quartet, Goethe pursued this theatrical or dramatic space when articulating his idea of elective affinities. For he gave to his idea a content and choreography pertaining also to the arts, made evident the moment he allowed one of his characters to describe how one must place something, be it an artwork or a lover, before one's eyes, and see how, although they appear to be lifeless (at first), they are in fact perpetually ready to spring into activity; one has to watch sympathetically how they seek one another out, attract, seize, destroy, devour, consume one another, and then emerge again from this most intimate union in renewed, novel and unexpected shape.[4]

Only after this did Goethe think that one could credit an artwork, a human life or a relationship as making sense, as pointing to something beyond itself, perhaps to something "eternal" or as "possessing mind and reason".[5] However, even at this moment of accreditation, his point was not that the person should stop looking or listening or moving. Even when a painting makes sense, it does not make a final sense, as though one had

completely contained its meaning in the act of making it explicit to oneself in a particular viewing. With the next viewing, sense and reason might be reached by different springs of activity. For the idea of something's coming to make sense for someone is also to acknowledge a limitation, an inadequacy or a necessary rupture between an aesthetic or passionate engagement and the conceptual demands of our understanding. For Goethe, as for many of his contemporaries, the enlightened-romantic point of not conceptually fixing or defining any *standard* of taste, sense, reason, beauty, meaning or value was to open up the space for art criticism, and for a fundamental question to be posed: whether, like a lover, a work of art – a quartet – draws one into its space, literally and metaphorically. Does it draw one's eye in, one's ear or one's hand, one's mind, interest, sensibility and even one's heart? To this question was then added another, whether, if one is drawn in, one is drawn in productively, so that one's subjectivity is drawn out beyond one's private space into a social, common or public space – often a struggling human community. In this space, as Goethe showed in his novella, one might find oneself drawn in through an admirable artfulness of the artwork or lover in which case one would think that the engagement had been worth one's time and attention. Or one might find oneself drawn into the space through the work or lover's cheap tactics, so that one would resent the waste of one's time, the spending of one's energies – but only of course if one thought that the value of one's life was never to waste one's time. By the same token, however, one might engage the work or lover with the wrong sort of attention, so that the lack of satisfaction in this dynamic theatre of engagement would be due not to the object of one's attention, but to one's self.

In this hermeneutical and critical approach to art and love, it takes at least two, if not also three or even four, to tango – to bring a quartet to life or, as sometimes, to death. In this dance, I am reminded also of T. S. Eliot's perfect lines from the "Burnt Norton" of his *Four Quartets*, lines that could well serve to sum up the present essay as a whole: "Neither flesh nor fleshless; / Neither from nor towards; at the still point, there the dance is, / But neither arrest nor movement. And do not call it fixity, / Where past and future are gathered. Neither movement from nor towards, / Neither ascent nor decline."[6]

When the editors of this book asked me as a philosopher to write on paintings of my choice, given a hundred contemporary paintings from

which to choose, I was pressed for time and more or less picked randomly, less I admit by looking at the paintings than at the titles, assuming that the titles would give me something to write about even before I confronted the paintings as a viewer. Since I'd thought before about the figure of four, and given my own far more musical than painterly background, I selected two paintings of 2012 (*Quartet – Stage One* and *Quartet – Stage Two*), without even thinking that there ought to be four paintings in the set – which I eventually learnt that there were. When more months had passed, and I turned to my task, to write about these two paintings, I did what I suspect many do when writing about contemporary painting: I read what others had written. This, I knew, would provide me with a safe context from which to assess the works, safe because it was given by others more in the know than I.

Soon after, I contacted the painter, which one can't always do, and arranged to meet him for a cocktail at the fancy, old-fashioned bar at the newly renovated station at St Pancras in London. It was a delightful and productive couple of hours in which I interviewed the artist, asking him about his work from every conceivable angle. These were hours of attracting, seizing, destroying, devouring and consuming a painter whose name – Tom de Freston – now began to take on meaning for me. Tom was in a good mood; he was celebrating an anniversary with his partner, a talented young poet, who turned up so that my conversation with Tom could end and theirs, far more romantic, could begin. To my many questions, Tom's answers were encouragingly precise and thoughtful. I returned to New York feeling secure that I had done my homework. Yet I still hadn't spent real time looking at his paintings. Were they good or bad? I did not, and still don't, know. But were they worth engaging with? They were and are. I learnt by looking that what mattered deeply to this painter mattered also and as much to me as a philosopher. He was interested in *ekphrasis* and in the engagement between different arts, and so was I; he was interested in the history of the arts as informing contemporary painting, and so was I.

However, despite these points of contact, I didn't want to read his paintings as merely illustrating philosophical views that I'd already formed for myself. I didn't want to engage his work as a philosopher *of* painting, who makes her chosen examples *fit* her already-formed theories. Instead, I wanted to *see* what philosophical issues, if any, were raised by looking at

his paintings. I knew that not all artworks raise questions, let alone philo-sophical ones, but I did find that Tom's paintings do, and just the sort that allowed me to begin my essay as I have, with a meditation on how one critically engages with painting as an art.

Questioning repetitions

Before I wrote this essay on de Freston's work, I wrote the draft of another, more or less a transcription of our interview from the bar. For it was a good interview. Tom had told me about his interests in the binary dual-isms that had long dominated art and the discourse overlaying the arts. He was intrigued by presence and absence; the visible and invisible; sound and silence; movement's speed and its rest; order and chaos; guilt and innocence, joy and suffering; the artist's offerings and withdrawals of meaning. He spoke of how he had increasingly engaged with other types of artists – poets, musicians and playwrights – to produce images that brought out something new in their works. But he spoke more of how he had brought their work into his painting to expand the scope of his own visual imagination. After this, he turned, much at my bidding, to the comedy of repetition, to how the figuration of his quartet series had extended into far more than four paintings. I was relieved and pleased that I had made the same point by choosing to address only two of the four works. Even more, I realized that, although de Freston had connected four paintings by title, there was little to separate these paintings as a set or series from what was evident in the extraordinarily many paintings he'd produced in more or less the same year. Although he spoke of his inter-est in narrative, the narrative was not produced traditionally, as linear or closed, with a beginning, middle and end, but as circular and on-going, which is what one would experience were one to walk the four walls of a room as though the walls were continuing collapsing into a continuous rotunda effect.

De Freston is interested in repetition in so far as this both gives charac-ter to a modernist mass-produced art and generates a comedy of cartoons that depends, as jokes, on the play of similarities or identities to generate dissonant (comic and provocative) differences. If one repeats an image,

sign or word often enough, the familiar meaning is defamilarized, rendered uncanny, and we laugh, cry or otherwise respond. "Ridicule", de Freston has written himself,

> is crucial to my work, whether it's dressing figures in socks and boxers or fitting them with comic book masks. Humour can be used to expose the pathetic or ridiculous nature of figures who are trying to present themselves as heroic or worthy. It helps me create ambivalence in the reading of the paintings.[7]

Yet, as I see his work, de Freston is also interested in repetition as a mode of experimentation, of trial and error. In many of his works, and certainly in his *Quartet* paintings, the repetitive tensions and ambiguities of meaning are staged through a visual technique of suspension – a particular play of gravitational forces – with the result that one's viewing or perspective is constantly put into question. In part, his repetition is that of obvious and easily identifiable images or figures across different paintings, so that the paintings come overall to be easily identifiable as his. That one can recognize a painting of his suggests that he has already developed his own style or at least (and perhaps more interestingly for our times) a trademark that belongs uniquely to him. Yet the repetition is also that of equally easily identifiable images drawn from the history of painting, so that every figure repeated becomes also a figure overlaid by references to an inexhaustible list of names from art's history: Cranach, Bosch, Rembrandt, Velázquez, Rubens, Titian, Caravaggio, Hogarth, Goya, Picasso, Giacometti, Bacon, Klein, Rothko, Warhol, and that's to list only a few of the immediately recognizable names.

Sometimes, in looking at his paintings, one feels as though one were being asked to enter a sort of University Challenge, to guess the correct historical precedent in any of his impressively many paintings. Sometimes one feels one is confronted with a Don Juan who collects images as though he needed to win a contest with the history of his art. This is to read him as a mere history painter, as young, overly prolific, and as too much under the influence. But there is also another outcome of viewing his work, captured by an answer he gave to someone else writing about him, when he was asked why he had chosen to describe himself, paradoxically, as a

"contemporary History Painter". He replied that he was "interested in the idea of History Painting as a bankrupt notion, and if it's possible to have such a thing as contemporary History Painting", and then continued:

> My paintings are not historical in that they are not illustrative of a specific geographic or historic source. Instead they are an amalgamation of numerous sources, fusing timeframes in order to produce autonomous scenes which could be read metaphorically and metaphysically in relation to a contemporary or historical context.[8]

I, however, would like to move his answer away from content to form and suggest that his strategy of juxtaposing the repetition of his own figures with those drawn from and by other artists forces viewers to keep looking at his works until they realize that his point is not to let this looking actually settle in a pattern of recognition. The more you recognize the figures the more the works conceal their meanings: repetition is his way of moving from surface to depth, where the dance and movement of repetition matters more than where one ends up.

De Freston told me that he moves with quite considerable speed between one painting and another, that he often has several on the go at once. Perhaps his way of speed painting captures an impatience and ambition, consistent with the artworld of contemporary times. Or perhaps it captures a personality trait of which he is seemingly proud – that he has eaten pretty much the same thing every day his whole life. But if he is compulsive, and he is, about repetition, he has, in my view, put the compulsion to a productive and philosophical-reflective use: to make his work *about* a certain repetition compulsion. Another way to make the same point, because I enjoy repetition too, is to see de Freston as stressing the movement more than the repetitiveness of repetition less to pose problems to which then, in his paintings, he finds aesthetic or artistic solutions, and more to pose questions that motivate new questions to be asked, because the questions no more stay or stick with one than the repeated figures. For de Freston, to find solutions in paintings is quite different from constantly seeking solutions and new questions. The former is associated with an experiment that has a clear end for which one has to articulate or express

the correct means. The latter is associated with an experimentation that has suspended means–ends relations in favour of constant enquiry. To capture this difference yet further is also for de Freston not to settle with an older concept of *ekphrasis* according to which one becomes satisfied with a description of the image that itself contains a world. It is to engage, rather, a concept of *ekphrasis* as turning descriptive sentences into questions so that a given painting can open up different and often competing worlds, arts and artworks before one's very eyes. As another reviewer of de Freston's work has made the point:

> The term *ekphrasis* and its relationship with poetry is one which troubles me. The word finds its roots in Greek; *ek* meaning "out", and *phrasis* "speak". The general understanding of this concept being that the work of visual art is spoken out on to the page, dramatically translated into written form. Before mass communication made it possible for us to see a work of art without actually being in its presence physically, one function of *ekphrasis* was presumably to "show" us works of art in lieu of a reproduction. In the Google-age the poet's engagement with the visual work of art must go beyond description.[9]

But if a visual work goes beyond description, where does it go? One place is to on-going questioning, to the constant enquiry encouraged by so many philosophers of the twentieth century. In addition, however, it leads to or encourages a dynamic play between image and thought, art and philosophy. Many art critics and philosophers of art have addressed the meaning of thinking (philosophically) through images, and in this address, they have given attention as much to the idea of thinking-in-movement as to the nature or status of the moving image. This, too, is what I was thinking about when, above, I wrote about a dynamic theatre of engagement with images that allows elective affinities to emerge in thought. But as I want to show next, the chemistry that grounds such an emergence of affinities is not that of an empirical science but that of an agonistic testing of one's affections for and disaffections with image-making, a testing that is so much at stake in de Freston's paintings that his figures come to be tied biblically to this very stake.

Suspending the dance

As with so many of his paintings, *Quartet – Stage One* and *Quartet – Stage Two* are produced with oil on a canvas with deep edges. They are painted on a human scale, at 200 × 150 cm or approximately 6.5 × 5 feet (because I still see and think in feet and inches), so that it is possible to meet the figures in the paintings eye to eye. It is a meeting that is *evidently meant* to unsettle the mind as much as the eye. Like his other paintings, we see that the canvases are mostly thick with paint, thick with colour, producing often glossy figures even when the figures are made to be comically flat. The paintings are mannerist, masked and theatrical; they are often voyeuristic, obscene, repellent. Many of his figures move in the hybrid and androgynous space between the human and the animalistic, showing carcasses that are butchered but in a way that reminds one of the anatomical or laboratory interest of Hogarth's *Four Stages of Cruelty*. The paintings wade neck-deep through the Christian themes of sacrifice, martyrdom, crucifixion and resurrection, and play in all the public and private spaces of carnival and catastrophe. And yet, as the paintings repel, they make one laugh, perhaps with the sort of laughter associated with political subversion or satire, or with a more cynical laughter at a history of painting that has staged so much cruelty for the sake of educating and edifying humanity.

Quartet – Stage One strikes the eye immediately for its biblical insinuations: falling bodies, naked and suggestive of death, a fall into hell, which yet, through the abstraction of a general image or *gestalt,* forms an inverted tree indicative of life. The image simultaneously suggests a genealogy of the Western world, of persons and of paintings given obvious allusions to the rising and falling bodies of the many heaven-and-hell or life-and-death paintings of earlier times. In this painting, one sees two saint-like or apostle-like figures pointing upward as though to contradict the downward motion of the many bodies. But perhaps the fingers are less pointing upward and more partially masked (head-dressed) figures of the *commedia dell'arte*, pointing only to the falling bodies to instruct us, as viewers, not to look at the figures pointing, but to that to which they point: "Don't look at us, look at them – we are only the directors of the scene."

But how then do we look at the rising or falling bodies? With eyes wide open or shut, or with eyes slightly squinted? So that more than attending to a multiplicity of figures we see them as one figure repeated, the naked gestures and characteristics the same in design, scar and colour: the colours of a fleshy pink, a muted green, a greyish black and a more glossy nail-paint or lipstick red of the mouths and genitals. With figures repeated, the image assumes the textured form of a tapestry or a mosaic, a single triangular shape of a tree if seen upright, but, if inverted, as a mountain to be climbed. And once, with this shape before our eyes, are we not invited to engage in an Escher-like experiment, to put the figures into the background and the in-between shapes and spaces into the foreground, to bring our eyes to the motion of a form that seems to be turning, like a cyclone, around a central axis? But if this effect is to what our eyes are meant to attend, should we not now read the fingers of the two larger side-figures as deliberately placed at the painting's horizontal axis, with the purpose to display their power, conveyed through their pointing, to set the figure into this circular motion? But to what purpose is their power if not to hold the smaller figures in a suspended state, rendering it ambiguous whether the figures are falling or rising? And to what end is the suspension if not to pose the theological question, whether these figures, devilish or angelic, are being punished or redeemed, given how this question is made an acute question of and for early, Medieval and Renaissance paintings, where raising questions about sin and redemption is often inextricable from raising questions about the status, sacred or secular, of painting as an art. Yet if a sacred question is being posed and staged in de Freston's painting, is it a question that can be asked in his and our times, or is the point to put the question itself into question? When his blankly staring figures seem in our eyes to allude to Michelangelo's *Last Judgement* painted on the Sistine ceiling, do they tell us that the last judgement was really the last, because this sort of judgement is no longer available to us, or at least to those who wish that it were? Is, in other terms, de Freston's painting a continuation of, or a commentary on, theological painting, rendered violently comic by the cartoonish character of the repeated figures?

And what next should one make of the painted fact that the two figures are perched half-on and half-off a square, but skewed, board – a checker or chess board – not shown in full, yet suggestive of a movement or instability

by being half-in and half-out of the picture? And what game is being played on or by the board? Surely not a game between two players, because the squares are not divided in binary pairs of either colour or shape.

The many blacks and blues on the boards suggest rather that, whatever game it is, it has left its players worn out, bruised by a game of history that has gone on for too long, but a game from which the mass of people – the suspended bodies – hasn't yet been entirely freed, because those with power in their fingers still have one foot on the board. But with their other foot off the board, the figures who pull the strings of the movement in this image seem to perch uneasily, perhaps to support the gesture they carry with irony on their breasts, as though they were saying that "although we still hold our hands on our hearts, we don't believe, and you shouldn't either, the movement that we hold between our hands". "So look at us now! We do not stand as stable figures sure of where we are and want to be: no, we're in movement, almost dancing" – indeed twisted with all the agony or wounds shown through the scars on the pasty skin, as once made evident in early representations of Christ, of Saint Sebastian, or even of musician-artists such as Marsyas when he was strung up in punishment on a tree for his musical art. And what, finally, if we, as viewers, choose now to effect an inversion through the glories of modern desktop technology, by literally turning the painting upside down? Would this not bring attention to the obvious hostility in the expressions of the falling/rising figures who seem now to be suspended angry before their maker? The lips, no longer turned up, are turned down contrary to the seemingly neutral expressions held by the two sideline figures. With the image inverted, the small figures more evidently become an ominous pile of bodies as though falling into a hell that will burn them alive. Or perhaps, they are rising, determined to crack a ceiling that is protected by a code provided by the colour of the boards. If they pressed the right colours, would they finally be released from this painting? To enter now another?

Quartet – Stage Two stages a single figure suspended in space above a board of similar design as the previous painting, but gazing upward to a chequered yellow-green crystal or disco ball that hangs by a string as a lamp or sun of illumination, as though to control the movement of the fig-ure in a dance that is being staged between three walls that are chequered by grey, blue, yellow and green squares to match the board below. However,

the walls don't coincide with the frame of the painting, since between the outer edges and the walls is a speckled or marbled background whose two-dimensional flatness contradicts the three-dimensional space of the dance. The single figure dances with legs that seem to run, while the chest is projected outward to bring attention to the arms that end with hands and then fingers that point down, on the figure's right side, and sideways to the wall, on the figure's left side, to suggest that the dance is not revolving harmoniously around a single axis. The eyes gazing upward to the geometric ball are accompanied by red lips that, partly open, could be singing or questioning the situation into which this figure finds itself put. Perhaps this figure is wondering where all the other sibling figures have gone: have they already gone up or down, or have they simply exited the stage? Is the singularity of this figure a sign of its own loneliness or alienation? Or has it come to stand for all – a community of the dispossessed, for each is only a repetition of every other? Has this figure become one, a figure for a wallpaper or a cardboard cut-out that, with its uniform effect, multiplies itself without end to cancel out any individuality it might once have signified, or to void it of any substance or iconic content it might once have had in the history of painting? But if the figure is read as standing for the multiply repeated figures of *Quartet – Stage One*, does not the distortion of its shape, shown also with exaggerations of colour, suggest, through our capacities of recognition, traces of what once was represented and representable in painting? Turned on its side, at a quarter turn, the figure comes to look very like the Christ-figure in Rogier van der Weyden's *Deposition*. But if the deposition is there as residue, is this because the painter is engaging a history of loss – the loss of what was once possible to paint? But if he is, is he then seeking a hopefulness, as a contemporary painter, in the residue? Does he want to re-mythologize a world disenchanted? With his art – and his figuration – does he gesture toward a hope that painting will lose its contemporary imbalance to find some sort of serenity or reconciliation in a world in which he is both making his art and finding his art situated? Perhaps, but who knows, since his paintings, as I have said, leave one not with answers, only more questions.

Broken ensemble

In the already impressive literature on his work, easily accessible on his website, de Freston's paintings are read against evident and intentionally expressed references to the history not only of painting but also of theatre, music and poetry. To complete my own circled square of criticism, I want to set his paintings against four corners of a quartet, though my eventual point will be a philosophical one.

In the first corner, I find Samuel Beckett's "ballet for four people", in two parts *Quad* or, with the German title, *Quadrat I* and *Quadrat II*, first performed in the early 1980s.[10] As others have noted, it engages a notion of *coincidence* to mark the moments of meeting between persons or things in severely contained boxes of time and space.[11] It is not altogether unlike the cage that John Cage staged with the boxed-in exactness of 4 minutes and 33 seconds, although whereas Cage wanted to show the way out of the cage, Beckett's play leaves one stuck inside. In his ballet, according to the terms of a modernist alienation, when persons traverse a board, they cross each other as a sign that communication among them is no longer possible. When meetings occur, which is rare, they are marked as moments of danger in a space that Beckett declared also a "danger zone", after the "quad" of the *quad*-rat, which, by referring to a prison yard and playing on a German–English confusion of terms, shows rats moving endlessly in circles, even if by Beckett's design, the form is that of a rigid square dance, or, as some have described it, a musical canon.[12] Circling in the square, as we see also in de Freston's second quartet, any given figure moves as though with a goal, but where in a gaol, every movement is predetermined. In the meetings between figures, no agency is at stake and no affinities elected. The meetings are imposed through a designing mind and hand that are invisible to all eyes and silent to all ears, for language and conversation have been eliminated. And yet, the force is ever present, dominating and directing the scene. The ballet has all the deep edges of authority with the aim, as I am tempted at some moments to read this aim into de Freston's art, to reveal the lie of any authority that thinks it can contain its figures entirely within four walls.

In the second corner, I find Walter Benjamin's first thesis on the concept of history which offers a *Denkbild* – a thought-image – hung on the

wall for all to read.[13] It tells of an automaton who partakes in a winning game of chess, because each answer of the opponent is met by just the right countermove. Yet what is shown is not two players but one: a puppet attired as a Turk, who, with a hookah in its mouth, sits at a table before a chessboard. As in de Freston's *Quartet – Stage Two*, a system of walls draws up a theatrical space, although, for Benjamin, the "system of mirrors" sustains the specific illusion, which is but an illusion, that the terms of the game are transparent for all to know "on all sides". This deceptive knowing is a theological-political illusion or allegory that Benjamin draws out by reference to how the puppet's moves are pulled by invisible strings by an expert hunchback who, dwarfed, stands for a crippled theology that has determined that the modern ideology of historical materialism will never lose the game that it has made up. How could it lose? The hunchback thus hides that for which its ugly physical disfigurement stands, as an ideology conceals its mechanism: that although it promises the people a prison-break, a rising above the ceiling that has been weighed down to oppress them, it will in truth only cheat them by delivering them to their fate, which is also, as suggested in de Freston's first Quartet, their fall.

In the third corner, stands a painting from 1902, by Henri Rousseau, titled *Happy Quartet*. It shows the members of the first biblical family, aff-ined musically through a string of flowers. It shows an Adam-figure playing a flute, an Eve and a maternal figure, and a Christ or angelic child, all of whom are accompanied, dead centre, by a dog that seems to be listening to his master's voice with an absorption that renders him stilled in move-ment to contrast to the other figures who seem more to be in movement. The scene is framed not by the artifice of any game, but by the natural shape and colours of trees that give off an autumnal glow, although the slightly twisted figure of the mother suggests that something is amiss in this arcadian scene. Might it be that she, as Saint Cecilia, alone knows that a figure that plays the flute, however melodiously, may well end up hanging in agony from a tree, twisted and writhing, as shown in representations of Marsyas, that wind-producing musician who, associated in the history of painting with the agony of Saint Sebastian, is bound to a tree that no longer gives off colour or life, but which holds the figures steadfast in their suffering, while their blood, as in Titian's famed image, is lapped up by a dog? My associations are not ungrounded and not unfounded.

De Freston admits to having Titian's *Flaying of Marsyas* often in mind, as he does also the first biblical family, as shown in his strikingly clever painting, *Hung*, where the mother and child (represented as animals) return home to find the husband and father hanging inverted as an animal carcass with a dog rolling a toy underneath, comically to mark just how normalized in the history of the home – at 5 pm each day – this image has become. With four figures present, de Freston might have titled this painting *Quartet – Stage Three*, had he not used this title for another painting that fits the series just as well, but does not make my point as well as *Hung* does.

In the fourth and last corner, I find myself walking again through the National Gallery in London, stopped in my tracks not only by Holbein's *Ambassadors* but also by a less well-known Saint Sebastian, painted at the end of the fifteenth century by Matteo di Giovanni. I am caught by the twisted body but even more by the hands that make me think of de Freston's hands, and I mean now his hands. For there is often in painting the *possibility* that the hands painted by the painter are correlated to his own invisible hand, so that the painter, by putting the colour and design on the canvas, is the one who finally controls the moves of the artwork by

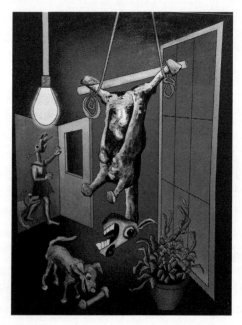

Figure 4.1 Tom de Freston, *Hung* (2013). Oil on canvas, 200 × 150 cm. © Tom de Freston, courtesy Tom de Freston and Breese Little Gallery. Private Collection.

turning the work also into an act of self-portraiture understood as a (self-) reflection on the very capabilities of painting as an art.

Standing before this painting, and with this thought in my head, I am tempted to email Tom to ask him whether he has recently been looking at this particular painting in London. But I resist the urge. The more I've become a viewer of his paintings, the more I've lost my need to depend on him or on what he told me in the bar the evening of the interview. I decide that one enters a danger zone – a prison-yard of meaning – every time one thinks that one has acquired a certain knowledge of an image by aligning the image to intentions articulated by the artist. Even if there is self-portraiture and a certain self-reflection or reflexivity within the painting, this sort of intentionality must be separated from an external set of articulated intentions. Not only because the paintings are then freed from a certain sort of fixity of meaning but also because the viewers are then freed from the quadrat, to engage in the excitement and risk of looking at art. Yet the risk is great, especially if one's thinking about contemporary art will have an impact on the entry of that art into history. Perhaps not wanting to take any risk, it is preferable to declare an end, as many have, to history and to art, so that the responsibility of writing about art is rendered null and void. But then to what purpose the continuation of art criticism? Is it enough to conclude that writing, thinking and painting is a way of liberating oneself from what one finds, allowing one to engage a finding in art with a making that will either make or not make the works of value for those who like to look? It is, but what sort of value do we have in mind?

In condensing his thought about the genre of the quartet [*quatuor*] into his *Dictionnaire de Musique*, Jean-Jacques Rousseau noted that although the ensemble was staged with four musicians, the genre had in fact only two voices: the melody and the harmony. The rest, he quipped was "*pur remplissage*", (ornament, extra or fill), and one ought to be warned against giving too much space to that.[14] Centuries later, Derrida, in writing about "the truth in painting", remarked on how pleasure had been deemed redundant or inessential, leaving pleasure to lie silently as the rest or as the waste in the wasteland on the side of the road that had been enlightened by aesthetic theory.[15] To lay the ground for a different path, he turned the Shakespearean "rest" that had been silenced (this is my language and not his) into a pleasure of thinking and looking when the end of the path is not known in

Figure 4.2 Tom de Freston, *House of the Deaf Man Band* (2012). Oil on canvas, 200 × 150 cm. © Tom de Freston, courtesy Tom de Freston and Breese Little Gallery.

advance. He engaged both the suspension and gravity of the pleasure of being on the path, and on the path he found a value – the value of pleasure – for which he was willing, with pleasure, to be held responsible.

Another of de Freston's paintings, *House of the Deaf Man Band*, bathes musicians in the blood of a history that has not always been good to the art of music. The image is of a quartet disturbed, an ensemble broken. It shows two (jazz) musicians playing instruments, as the two figures in *Quartet – Stage One* producing the tones and rhythm to which the other two figures must dance. But in this case, the other figures are less human than horse-like, suggesting that they are the shadow-selves of the musicians who play. The painting opens up the question, whether the animal dictates the terms to humanity or vice versa? Like many of de Freston's paintings, this one shows a duet performed by four *and* a quartet performed by two, putting thereby the very question of what and who controls what into question. Speaking of which, had I been allowed to do what critics once could do, title the paintings according to how they were reading them, then the *House of the Deaf Man* would have become my fourth quartet *Quartet – Stage Four*, and with that, I would have finished the dance.

5 | Being ironic with style

Tom de Freston
Quartet – Stage Four
(2012) | *Sam Rose*

Ostensibly the most relevant of concepts to painting, style has long been out of favour with writers on visual art. The suggestion made by Svetlana Alpers in 1979 that "the normal invocation of style in art history is a depressing affair indeed" might still be held up as fairly representative of art historians, much as some are keen to stress how widely stylistic analysis is nonetheless implicitly relied on in day-to-day dealings with objects.[1] As philosophers writing with an eye to *art criticism*, both Arthur Danto and Richard Wollheim have made striking pleas for the importance of style, but it seems to have found even less favour in that branch of art writing.[2]

The reasons for this attitude, themselves still worthy of more detailed investigation, have often been related to the various levels at which style has been deployed. At the "general" level, for example, one might point to growing suspicion of the validity of grouping individual objects into overly broad stylistic categories – what do "baroque", "mannerist", and so forth really tell us, and how might we ever begin to deal with contemporary art in the same way?[3] At the "individual" level, the philosophical assumption of style as originating in and embodying the artist has come to seem problematic, with critics and historians trained to be suspicious of "expression"

of the artist's personality and of the unified self this is often thought to presuppose.[4] On a more pragmatic level, an increased sense that connoisseurship, as the attribution of artworks to authors based on style, might be compromised by its role in the art market has, perhaps unwarrantedly, cast doubt on the practice of stylistic analysis as a whole.[5]

With *Quartet – Stage Four* in mind, it is worth highlighting one particular level-based reason for the scepticism towards style – that what might actually be implied by artistic style has become unfortunately narrow. A common view, which might be called the "restricted" view of style, attempts to carve it neatly off from subject matter or content. Following this view of what is termed "pictorial style", one recent writer turns from their account of "how pictures represent" to note that

> it is clear that our interest in painting is directed not only at what is represented but also at the particular way in which the subject has been depicted by the artist. I now want to turn to the broad set of issues that are traditionally grouped under the heading of composition, but which extend to include a wide range of other features, including facture or the handling of the medium, the relative intensity and saturation of colour, the contrast between gradations of light and dark, and the organization of the contents of the painting in relation to the twin boundaries of the framing edge and the picture plane. It is important to recognize that these "design features" are properties of the painting rather than what it represents.[6]

A number of writers have criticized something like this view, though few more cogently than Nelson Goodman. Rejecting attempts to decide what is stylistic based on distinctions between the "what" and the "how" of the work, or of "subject and of wording", or "of content and of form", Goodman instead suggested a provisional definition of style as "those features of the symbolic functioning of a work that are characteristic of author, period, place, or school".[7] As he wrote of the traditional view of style:

> Obviously, subject is what is said, style is how. A little less obviously, that formula is full of faults. Architecture and non-objective

painting and most of music have no subject. Their style cannot be a matter of how they say something, for they do not literally say anything; they do other things, they mean in other ways. Although most literary works say something, they usually do other things, too; and some of the ways they do some of these things are aspects of style. Moreover, the what of one sort of doing may be part of the how of another. Indeed, even where the only function in question is saying, we shall have to recognize that some notable features of style are features of the matter rather than the manner of saying. In more ways than one, subject is involved in style.[8]

While Goodman's actual definition has not been uncontroversial, his general thoughts on style are worth reviving, at least in part. A more inclusive approach to style, incorporating the analogies with personal identity that first grounded its claim to exist as a trace of the artist, as well as a theory of irony that follows from these, might both be implied by this painting and be helpful for the understanding of de Freston's work as a whole. To sum up the point now, while holding off on elaboration, it might allow one to talk of Tom de Freston's practice in terms of a very specific kind of "ironic style".

Quartet – Stage Four

Due to a combination of size and surface quality, the painting is especially hard to photograph and reproduce satisfactorily. My own encounters with it, as with de Freston's paintings in general, have tended to take place at close range.

In reproduction the viewer can more easily take in the whole work at a glance. The figure group to the left of the work makes up its own unified composition, dwarfed by the expanse of painterly abstraction to its right, and in some sense balanced by the geometrical shape above. The graphic, illustrational side of the figures is exaggerated, with the enclosing lines appearing to bound areas of near uniform, and thus intentionally flattened-out, surface. All seems in some sense unified, part of one single

composition, and so intended to refer to one particular event, or a particular narrative.

One might invoke other features of de Freston's practice to support this line of thought. His works, produced in broad groupings of which each tends to be guided by a particular inspiration, often take up novels and plays as their source, in this case Gustav Meyrink's *The Golem*. The individual paintings are often given highly allusive titles that suggest literal reference to moments of thematic or narrative interest. Pictorially, they often allude more or less directly to stage settings, or at least to spaces or rooms in which definite actions can be imagined to take place. The case of figures employed repetitively by de Freston might suggest characters who in some sense partake in, or develop, a narrative across the group of works in question.

In person, however, with the eye roaming over the broad expanse of the canvas, it becomes clear that something rather different is going on. Stretching to over a third of the height of a two-metre-tall canvas, the figures have their own individual presence – almost jarring, but hard to ignore or pass over as part of a larger unity. Their bounding lines carve the rough, thickly textured surface of the figures away from the outer space. One is caught between indulging in them as exercises in serious painterly technique, and the almost grotesque illustrational force of their presence as cartoons – as the most distorted and unrealistic kind of representation, which, as common pictorial practice would have it, is as far from the textured earnestness of thickly laid on oil paint as one might get.

Seen this way, the figures themselves are deeply at odds with the surrounding area. The abstract portion of the image is enormous; more than large enough to be experienced as a painting in itself, in which case it becomes tempting to try and give in to de Freston's apparent employment of free painterly self-expression (de Freston notably started off as an abstract artist, and still displays strictly abstract works from time to time). But the figures on the left then reappear as an even more brutal intrusion – their thick outlines and the flattened planes of the geometrical shape (that object does retain a cartoon-like textureless flattening against the picture plane even at close range) give the appearance of almost having been separately pasted on to the surface.

Various solutions to this oddity could be proposed. To sketch out one crude possibility, the figural group, derived from Caravaggio's *Entombment*

of Christ, might be an attempt to reference a tragic mood or scene in Meyrink's work, perhaps set off by the existential angst of the abstracted background, which is at once expressive and an open night-sky-like expanse or abyss. This reading might be further supported by the figures' precarious position on a platform that is at once theatre stage and chessboard, the latter being another reference to Meyrink.

But the shape above the figural group, on this reading perhaps a reference to the kind of hanging geometrical shape found in Renaissance paintings such as the *Portrait of Luca Pacioli* attributed to Jacopo de' Barbari is revealed by other de Freston works as part of his fondness for Penrose tiling and lights that reference the pattern, an almost kitsch modern touch that makes the chessboard stage below appear more like a 1970s-era disco dance floor. A likeness that initially seems too bizarre to countenance, this is reinforced by another of de Freston's works in which the same kind of floor is supplemented with fluorescent light and dancing figures. Under the pressure of these newly seen likenesses, the initial unified and earnest angst of the picture collapses into farce and indeterminacy.

Style

Goodman's critique of style, intended to counter views that the concept can be adequately described solely in terms of subject matter, of expression or sentiment, or of form or structure, is based around two main lines of attack on the what/how distinction.[9] The first is that many works – architecture, non-objective painting and music are mentioned in the passage above – do not actually say anything, and so the style could not be a question of the way in which what is said is said. More important for my purposes is the argument that that matter and the manner are often impossible to separate neatly, with subject forming a definite part of style. Talking of the neo-classical style of David, it would make little sense to exclude the draped robes in which his figures are clothed, or the columned halls in which the scenes are set, just as discussion of Matisse's style in the 1920s would have to take into account the reclining models and orientalizing decoration repeatedly reconfigured in the interiors of Nice. And these are only the most simplistic of examples. Wollheim has made a detailed case for the idea that style must

include a combination of material, represented and figurative elements; as one example he offers an extreme condensation of an argument first set out in *Painting as an Art*:

> in the style of Titian, the segmentation of, and emphasis upon, skin, human skin, and the eyebrow, envisaged as the arch that frames the organ of sight and shows off the delicacy, the fragility of skin, are crucial factors in the systematic fulfilment of his intentions.[10]

Despite the clear merits of this broadened view of style, however, it has not been widely adopted, and this is at least in part because of the intuitive plausibility of the what/how distinction. Writers have simply been unable to let go of the idea that style is the particular way in which a thing is done.

A useful way around this problem has been offered by Dale Jacquette, who suggests that it is possible to retain the distinction and still remain true to the heart of Goodman's account of style as metaphorical signature or characteristic activity.[11] Already, calling style "the particular way in which a thing is done" assumes part of this, for Jacquette's first step is to shift from Goodman's analogy with verbal communication to a more "pragmatic" focus on actions.[12] Setting aside Goodman's account of symbolic functioning, style is understood on the lines of what is done rather than what is said. The second plank in the revision of Goodman's account is the acknowledgement that style is "systematically ambiguous", with the particular context in which a style is attributed, or the level of classification of the activity, determining the features that can be said to constitute it.[13] Such attributions of style and different styles must thus be relativized, with the "what" and the "how" of the style specified relative to "the level of classification of the activity for which a judgement of style is being considered".[14]

This distinction of levels of artwork classifications, and of corresponding relations of artistic style, underlies Jacquette's proposed "general strategy" against the counterexamples proposed by Goodman. This strategy is that

> whenever the definition seems to be threatened by an application in which what is done appears to be confused with how it is done, that what is done be interpreted at a higher level of

abstraction in the ontology or conventional classification of the relevant activity.[15]

To take Jacquette's example of Impressionist painting, it is thus unnecessary to say that both what the Impressionists are doing and how they are doing it is to paint the particular themes and motifs associated with their style:

> It is reasonable, and well within the spirit of the definition, to say instead in the case of the Impressionists that what they are (mostly) doing is painting, or, more but still not too specifically, that they are recording visual images of interesting landscapes. By either of these accounts of what Impressionists are doing, at this level of abstraction, they are doing what all or many other painters are also doing. So, these ways of characterizing what Impressionists do is not going to distinguish a special style of Impressionist painting. Yet, if we are defending the how-what definition of style, that is precisely what we want. There are many different ways of painting, and many different ways of recording visual images of interesting landscapes. How painting is done, and how visual images of interesting landscapes are recorded, opens up the category of styles of painting and styles of recording visual images of interesting landscapes, within which one identifiable family of styles is particularly characteristic, constituting the signature, in Goodman's idiom, of Impressionism.[16]

As Jacquette concludes, for this reason there can be "different styles of applying the definition of style", in each case with the level of abstraction at which the "what" is decided then determining the scope of the "how".[17] If what a painter is doing is painting Impressionist paintings of the London suburbs, then an account of their style would have to describe the deviations from this norm that constitute the metaphorical signature of their work. If what that same painter is doing is simply making paintings, then their choice and treatment of the particular scenes of the London suburbs would all be included under a stylistic account.

In the case of de Freston's work, a broad view of his practice as a whole must be taken, including the ways in which his paintings fit together, and the fact that he has often ruminated and written on the very possibility of contemporary tragedy or history painting (there it is the fact, more than the detail, that is significant). What is clear, once this stance is adopted, is that aside from a few commissioned works where the scope is narrowed, what he is doing is at once quite general and quite specific, and could be described as something like "painting figurative pictures that are inspired by a mixture of sources from literature, theatre, and the visual arts". The appropriate way of thinking about his style then includes, and is in fact dependent on, the particular way in which pictorial motifs, personal technique, and reference to the work of other artists is combined. But in what way could it then be described as ironic?

Irony

Irony in pictures, like style, can take a variety of more or less widely accepted forms. To take up a recent classification by Gregory Currie, we can distinguish three very general categories: pictures of an ironic situation that, in copying and re-presenting the situation in a straightforward manner, are not themselves properly described as ironic; pictures that are ironic by virtue of their context of presentation, having been co-opted for use in an ironic project regardless of their inherent status as ironic or not; and pictures that are ironic in style, where the originating context of the picture, its history of making, determines its ironic nature.[18] These distinctions are themselves based around a general one between "situational irony", where the actual situation is ironic, and what Currie calls "communicative irony", where it is the verbal or pictorial communication that is ironic.[19] In the first of the three categories given above, the picture depicts situational irony, in the second it partakes in it, and in the third it is communicatively ironic.[20]

Currie's account of communicative irony is based on a particular form of the "pretence theory" of irony, which rejects the old and now somewhat out of favour idea of irony as simply meaning the opposite of what one says.[21] According to the pretence theory, very roughly, one pretends to express a point of view, while in fact the pretence serves to illustrate the deficiencies

in that point of view.[22] A communicatively ironic picture – one that was ironic in style – would then be one "intended to be taken in a certain way: we are to imagine it having been put forward with a certain purpose, but also to see that our imagining this is merely a way of making vivid the drawbacks of really putting it forward with that kind of purpose".[23] An example would be Hans Haacke's *Taking Stock*: a picture which pretends to be a piece of conventionally admiring portraiture, while in fact mocking the pretensions to such grandeur of its apparently unworthy subject, Margaret Thatcher.[24]

While this covers the standard views of irony, there is a further kind that is particularly relevant to de Freston's work. This has been described by D. J. Enright as that which

> doesn't reject or refute or turn upside down, but quietly casts decent doubt and leaves the question open: not evasiveness or lack of courage or conviction, but an admission that there are times when we cannot be sure, not so much because we don't know enough as because uncertainty is intrinsic, of the essence.[25]

This form of irony can go almost all the way down, for not only does it not necessarily allow the meaning of the ironist to be deciphered, but it does not even allow one to be sure that there is an unambiguous meaning that is being held back. Irony of this sort involves the typical requirement of concealment of something, but it does not necessarily imply that the whole of this something is visible to the ironist, or is even available to be uncovered at all.[26]

It is a commonplace in essays on style to refer to the word's origins in the Latin *stylus*, the needle used to write on wax coated tablets, and so to note the connotation of style as a trace or impress of bodily activity.[27] A remnant of this in present-day thinking about works of art is the assumed double link between style and apparent mental state of the creator, and the expectation that style will have a coherence that itself parallels the unity of a single person.[28] Wollheim is typical in talking of "overallness or unity" as crucial to a style, in his requirement of "one artist one style", and even in speaking of certain kinds of unconvincing stylistic influence in terms of the introjection of another artist's style in a time of personal crisis.[29] When

parts of a work appear to be in conflict with each other, such as Meyer Schapiro's example of an African sculpture with a smooth naturalistic head and a rough shapeless body, then the work tends to be seen as a composite.[30] Even if it is demonstrated that a single person has made it, that person might appear divided, and, in cases where the artist has incorporated another's style without sufficient reconciliation or integration, may appear to have practised pastiche.[31]

The potential link between style and the especially deep form of irony should now be apparent. A style that embraces a sense of disjunction in the way that its elements are put together – the apparent rejection of over-allness or unity – can play on the usual assumptions, and itself embody the kind of concealment of the underlying thought that is characteristic of deep irony.

Studio

On my last visit to de Freston's studio, the bottom right segment of one canvas was dominated by the addition of a pot of flowers that seemed directly pulled from a painting at Tate Britain's current Patrick Caulfield exhibition – a characteristic effect of flatness over depth, almost as if painted on a separate patch of canvas and collaged on over the atmospheric textured layer that now formed its ground. On another canvas nearby, a pot of van Gogh sunflowers had appeared in the same position, identifiable as "van Gogh" by their colour and general shape and once again distinguished by their relative flatness, though in this case the forms had been reworked and distorted to give them the same characteristic outline of the figures in the rest of the image. De Freston talked of making a final picture to draw a line under the series, potentially a drawing on a grand scale, in which he would throw together as many of the figures and quotations used in his recent pictures as he could manage.

Witnessing the evolution of de Freston's paintings in the studio, it becomes clear that there is a kind of unfocused logic to their creation. Large groups of paintings – such as the one to which *Quartet* belongs – are done with a very general inspiration in mind – in this case Meyrink – but their actual elements are disparate. As well as pictorial elements that

might be drawn more or less directly from the literary source, they freely incorporate a mixture of past motifs and characters from his own work, and pictorial and technical elements quoted from other artists, with the latter two sources becoming mixed over the course of a number of canvases. A favourite motif, for example, is the left hand figure from Titian's *Diana and Actaeon*, which, over its life in de Freston's work, has been personalized through distortion, reversal, the addition of new elements such as a horse's head, and so on.

Even before they reach the canvas, the motifs or figures go through a process of revision – they are drawn and redrawn in a variety of media, more or less freely, or photographed, or collaged by hand or on Photoshop, in some instances using photographs or models made especially to test particular poses or settings. In at least one case, clay masks were made from the pictures, which were then drawn from in turn.

And when they do reach the canvas – when the actual composition of the work is being created – each of these types of motif can determine new changes one after another. A canvas might start with a familiar quotation from another artist (a Rembrandt ox, a Picasso horse, a Francis Bacon bed), or alternatively a motif drawn from a literary source, and the look of this might in turn suggest an addition of the opposite sort. This addition may in turn suggest a more formal change, such as a repositioning of figures in order to allow for an enlargement of an area of colour or a painterly abstract passage, and in turn this may lead de Freston to revise elements of the original motif, which might be altered slightly, or edited out and swapped for new ones, or just dropped altogether.

This is given an additional twist by the common, though by no means uniform, approach to the actual material creation of each work. Often a charcoal underdrawing is used first. The painterly abstract ground so visible in *Quartet* might then be laid on, formed first of pooled water and diluted pigment allowed to dry on the flat canvas, then of layers of paint thickened with substances – such as concrete powder – that dry and split in uncontrolled ways, then finally layers of more translucent glaze. The figures would then be built up over this, with their characteristic contrast of textured surface and flattened outline. But this process is concurrent with that of the general setting out of motif and composition described above, and at any point a new quotation or motif might be added in, or

alternatively a new swirl of abstract "ground" or thick patch of pure paint laid on over the figures already in place.

It is this multiplication of levels at which alterations and reworkings take place that finally leaves one unclear about what is truly "personal" (bodily reflex, expressive trace), and what is merely rhetorical or even arbitrary (copied from others, or done with techniques that mark the surface in uncontrolled ways). One is left unsure how to differentiate between personal technique and the rhetorical performance or pastiche of technique, though one is extremely conscious that the two are at work in some combination. Unlike any of the large numbers of artists that are quoted from, the picture space tends to be segmented into disparate areas that fail to cohere entirely. Narrative, as suggested above, is implied by the pictorial references and the casts of characters, but even where the space is brought together by a device such as a framing room or a unifying translucent glaze, the basic tension between flattened cartoon-like areas and outlines and more earnestly painterly passages remains.

A number of people notice and comment on this disjunction in de Freston's pictures, in particular the conflict between flatness and textured surface, as if it is somehow jarring or unresolved. But in the context of his process it makes sense as a way of simultaneously maintaining the appearance of the personal and the rhetorical in a deliberately unsettling manner. One sees this at work in many places, but perhaps above all in many of the figures' heads, where extremely closely and carefully painted facial areas are framed by a thick wavering line. The latter defines proportions of a head typical of a deliberately cartoon-like anti-realist manner that is as much de Freston's signature as the textured detail of these areas. These passages gesture towards deep expressiveness, conveying the artist through thickened paint and distortion or emotions that are part of the scene at large. But they are equally masks – appearing to offer the viewer something, but ultimately indeterminate about what that something is.

The concepts of style and irony that cohere with this account of de Freston's practice clear up some of the confusions over *Quartet – Stage Four* gestured towards earlier. To spell out the point, the conflicting elements, with overt incorporation of apparent pastiche, might now be understood as part of a more general strategy of ambiguity that operates through the works' style: a general method of creating grand-scale figurative works

that in their particular way of being put together are ironic about the possibility or significance of this activity. Not, to be clear, ironic in the sense of openly satirizing, but instead in the deeper sense of simply posing a question without the possibility of discerning whether a complete answer exists.

The modified how–what distinction here makes clearer the particular level of ironic style that is at work. If the "what" of the Hans Haacke work mentioned above is a painting of Margaret Thatcher, it is its particular style, or the way in which it is made, that turns it into the negative comment on Margaret Thatcher which determines its status as ironic. With de Freston's painting, taking into account his practice as a whole, the distinction instead needs to be drawn at a more abstract level. With the "what" understood much more generally as a painting loosely based on a literary source, the ironic nature of the style is also taken back a level: it is not just an ironic comment on the subject matter, but is ironic about the possibility of presenting this kind of subject matter. This deep kind of irony is one that opens up an ambiguity so complete that even the normal implication of mocking or satirizing carried by irony cannot gain any firm hold. It asserts while also projecting blankness as part of the assertion: it invites involvement and speculation, but refuses attempts to make the elements finally cohere in a manner that could satisfactorily reassure the viewer.

6 | The radioactive wolf, pieing and the goddess "Fashion"

Adrian Ghenie
Dada is Dead
(2009)
Nickelodeon
(2008)

Chantal Joffe
Black Camisole
(2004)

Raymond Geuss

There was disagreement about the meaning of "Dada" from the very beginning. One of the people who claimed to have invented the word was Hugo Ball, who opened the *Cabaret Voltaire* in Zurich in 1916. He stated: "In Rumanian Dada means Yes Yes; in French it means hobby-horse; for Germans it is a sign of naive silliness and philoprogenitive connection with the perambulator".[1] It is an "international word"[2] representing the vernacular languages of the original members of the Dadaist group who performed in *Cabaret Voltaire*: various speakers of German, a bilingual Alsatian (Hans/Jean Arp) and two multilingual Romanians (Marcel Janco and Sami Rosenstock/Tristan Tzara). Sometimes, to be sure, the benignly philoprogenitive father with his pram loses interest altogether (Ball *also* says that Dada means:[3] "Ciao, please get off my back, see you some other time!"),[4] or even turns into an (anti)-philosopher[5] driven by "demonic scepticism" (*dämonische Skepsis*).[6] Tristan Tzara, perhaps the most energetic and uncompromising member of the original group, pronounced some of his early Dadaist manifestos in the persona of the "anti-philosopher" Monsieur Pyrine. Pyrine *en bon dadaiste*, was tolerant of contradiction and immersed in the ephemera of real history – hence the prominence of

newspapers, dated announcements and so on in Dadaist collages – rather than being devoted to a speculative contemplation of the unchanging.[7] He was a lover of processes rather than "finished products" and of puppets and masks rather than a Stoic sage with an unwavering character and moral disposition, and an aspiration to assimilate as much as possible to God's eye view of the world and its inhabitants.

An artistic movement that began in neutral Switzerland during the First World War would be unlikely to be completely without any relation to politics. Once again Hugo Ball provides the most telling comment:

> While we were involved in the cabaret at Spiegelgasse 1 in Zürich, M. Ulyanov-Lenin lived just across the street in Spiegelgasse 6, if I'm not wrong[8] … Is Dadaism as sign and gesture the opposite [*Gegenspiel*] to Bolshevism? Does Dadaism put forward the utterly quixotic, non-functional [*zweckwidrig*] and ungraspable side of the world in opposition to destruction and complete calculation?[9]

Is it, however, obviously best to construe Dada as at all playing the same game as Bolshevism?

The radioactive wolf

At the end of the war the centre of Dadaism moved from Zurich to Berlin, where in 1920 the first Dada International Fair was held in the Gallerie Burchard. Ghenie's painting *Dada is Dead* is a reworking in 2009 of a photo that was taken by the photographer Hannah Höch of that event. The original photo shows walls covered with politically charged paintings by Otto Dix and Grosz – most of which were later destroyed by the Nazis – and with the slogans the Dadaist liked to employ: "Dada is the wilful dissolution of the bourgeois world of concepts. Dada stands on the side of the revolutionary proletariat"; "Dilettanti, rise up against art"; and "Dada is political".[10]

In reworking the photo, Ghenie changed the brightly lit and salubrious room in the Gallerie Burchard into something dark, derelict and slightly sinister-looking. The chairs and upholstered benches are gone. The walls

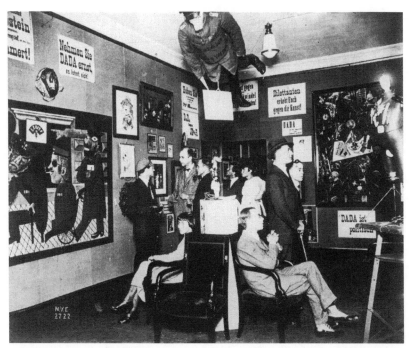

Figure 6.1 Hannah Höch, First International Dada Fair, Berlin, June 1920.

are soiled and covered with empty picture frames and with the mere traces of the pictures and slogans that used to adorn it and which seem to have been removed, or to have fallen away by themselves in the passage of time. The long horizontal picture-frame on the left-centre of Ghenie's painting surrounded (in 1920) Otto Dix's painting, *45% erwerbsfähig*, which is a satirical image of four men who were grotesquely mutilated in the First World War. The second man from the right has no legs and is being pushed in a rudimentary wheeled chair; the third man from the right is represented with three overlapping heads which is presumably a way of trying to depict the tremor or nervous twitching of the head he has acquired as a result of wartime injuries. The point, transmitted by the title of the painting, is that, despite their horrific injuries, they have failed to receive a state pension for disability because they were considered still to be "45% able to earn a living". This painting was confiscated by the Nazis, exhibited as an instance of "decadent art" at their great exhibition in Munich in 1937 and then destroyed, so Ghenie in 2009 is in fact painting from a photograph of an

earlier painting by Dix which has now disappeared, and trying to represent what that earlier painting would have looked like if … if what? If it had not been destroyed in the 1940s? What would have had to have happened to it since then for it to look as it does in Ghenie's painting? *When*, exactly, is the scene depicted supposed to have taken place? Is it a painting of what Gallerie Burchard *would have looked like* in 1945, had it survived to see the Red Army entering Berlin? Or what it would have looked like in 2009?

In Ghenie's picture it looks as if part of the paint in Dix's original had run [*zerfließen*], dripping out of the frame and down onto the wall below it, forming a stain. This stain seems to form the image of a phantom leg on the wall, that is, *outside* Dix's original frame, as if to replace the limb, which the crippled man in the original painting lost in the war. In fact it looks as if the stain forms the image of a military-style boot. The booted foot does not seamlessly connect with the hip of the crippled soldier, but perhaps that is intended. The Dadaists were obsessively concerned with the limits of meaning: to say that something "has meaning/significance", however, usually means to connect it with an assumed framework of refer-ence: "That gesture [e.g. 'squaring the figs'] has no meaning [here in Britain, although it did have a meaning in medieval Italy]"; "To rotate your pawn on a given square [rather than moving it to another square] has no sig-nificance [as a move in chess]". What, then, is *inside* and what *outside* any given framework is always of importance. Can things slip, drip or "run" out of one frame into another (from Dix's painting to Ghenie's)? The wooden frame of Dix's original painting doesn't now define the visual sense of what is inside it. Rather Ghenie represents Dix's frame as "cutting off" the sol-dier's leg; actually the soldier "has" a leg in the form of the stain on the grey wall which in Ghenie's painting is as "real" as the rest of his body. Has Ghenie "replaced" the soldier's leg? Completed or finished Dix's painting? It would be an odd form of "completion" that turned a picture of a crip-ple into a picture of someone with a healthy leg. Is this an imaginary or a real replacement limb? What would affirming either of these alternatives amount to? Or are we to imagine that the very passage of time, the "time" between 1920 and 2009, has by itself caused the paint to run? Natural processes, without any human intervention would, then, have created this image of a boot in the stain.[11] To be more exact, natural processes of dis-solution (moisture seeping down the wall of an abandoned room) seem to

have produced a stain which we with no special prompting "naturally" see as containing the image of a boot. In that case, Ghenie is not responsible for changing Dix's image; he has simply painted what the contingencies of the passage of time have actually done.

In Ghenie's painting, the carefree and sociable Dadaists of the original photo are now gone, replaced only by the single wolf who now occupies the centre of the painting. This wolf looks slightly like one of Man Ray's "solarizations" or a "rayograph". A sliver of intense light from the right illuminates his hind quarters. In contrast to the crippled soldier who is "only" an image, the wolf is "real": he casts a distinct shadow in the painting. There is also an odd white light on his ears and eyes. Conceivably that might be the result of another shaft of light or some play of reflection, but it seems to *emanate* from his ears and eyes – is the wolf perhaps ever so slightly phosphorescent or radioactive?

In the mid-1930s Walter Benjamin wrote about the need to see art as teleological.[12] Technically specific forms of art often seemed to be trying to achieve with great difficulty through "traditional" means effects that would "come naturally" when later techniques were developed. Thus, much of late-eighteenth-century painting seems to be trying to attain effects that would later come "of themselves" with photography. Dadaism, he claimed, was, in one of its aspects, the attempt to anticipate film. So the tremor of Dix's war-cripple would be easy to capture with a cine-camera. When Benjamin wrote "Every epoch dreams the following epoch",[13] he did not specify whether the ensuing reality would be a utopia or dystopia, heaven or hell. Part of the mechanism that holds history, especially the history of art, together is the series of pretensions – references to, anticipations of, expectations about the future – and retentions – memories and associations from the past. Man Ray's solarizations and rayographs cannot now, in retrospect, fail to make us think of Hiroshima or Chernobyl, although we know that radiation does not actually make humans visibly glow. Equally, Hugo Ball's Dada costume of 1916[14] must now be seen as a proleptic reference to that great monument of US foreign policy in the early twenty-first century: Abu Ghraib.

In 1917, Tristan Tzara stated very baldly, "Dada ne signifie rien."[15] It is not, however, that easy to imagine anything that fails to signify *at all*. "Meaning" for conscious creatures like us, is almost inescapable; we are

Figure 6.2 (a) Hugo Ball in cubistic costume, Zurich 1916 (Hugo Ball Nachlass/Robert WalserArchiv, Zurich); (b) Torture of a prisoner at Abu Ghraib.

virtually condemned to make things make one kind of sense or another. The real question is not whether or not we can find or invent some categories and a framework of reference into which we can fit any given phenomenon we encounter, but whether there is one final set of categories or framework within which we can locate everything; and particularly whether there is one antecedently given set of such categories.

Imagine that, while playing chess, instead of making a recognized move, I extend my index finger and rotate it in the air in a circular pattern. My opponent might well say, "That gesture has no meaning", and, of course, he or she would be perfectly correct, if the universe of significance was restricted to "possible chess moves". If, however, the room was warm and my opponent was seated next to a fan, he or she might take me up on my attempt to change the context and see that my gesture was intended as encouragement to turn the fan on so as to cool the room. So it did signify something, just not anything recognizable as a move in chess. The rules of chess, after all, do not exhaust the realm of that which has meaning. By changing the context, what means nothing in chess can still have significance – if one wishes to put it this way – "in another realm". Sometimes rule-governed domains are embedded in yet larger rule-governed domains: the individual game of chess may be part of a tournament in which there are strict regulations about how games are played. The tournament itself

may be governed by rules set down by a chess federation, which, in turn, may be a corporation subject to legal regulation – different regulations in different jurisdictions – and so forth. The gesture of rotating my finger is not, arguably, part of any existing system of meaning which I activate; it is something I more or less make up, assuming you too will be able to rise to the occasion and "see" the point of what I have done, even in the absence of an explicit convention.

Must we simply accept that there are different systems of significance – the "universe" of chess, the English legal system, the DIN system for referring to standard sizes of paper, the Mesopotamian division of the year into a series of twelve months, the set of hand gestures traffic controllers use. Some of these may be formal and more or less closed systems, but many of them are open and constantly evolving (e.g. hand gestures). In any case, at best, they stand in contingent relations with each other, and may not even overlap (e.g. the rules of chess and the rules for determining paper size), so that one can almost always change the notion of "significance" by shifting the context. Or must one assume, as do many philosophers and virtually all Christian theologians, that this process of changing the context cannot continue *ad libitum*. That there is, and *must be*, a final framework which is, as it were, the game of games, the "absolute" game we are and *must be* playing, a game about which the Christian theologian will be happy to give you much more information of a highly detailed kind?

If, however, there is no absolutely final framework of meaning – no God, no fixed and definite structure of "consciousness", no "logic of language" – then "the realm of" meaning/ significance, *and our ability to violate* any given structure of meaning/significance may both have radically indeterminate boundaries. What we "can" or "could not" mean will become a matter of having a more or a less fertile imagination, or of our inventiveness, not of "logic". Failing to obey given rules, breaking the code, can be a way of bringing something to our attention, for instance, that our forms of "intelligibility" are more arbitrary than we usually take them to be, or that they are severely limited and deficient. Tzara's "Dada ne signifie rien" then need not refer to a mere absence – it is not a *nihil privativum* – but it might approach Huelsenbeck's view,[16] which would have it that Dada is "the signifying nothing in which Nothing means something"[17] – Dada's "nothing" is a *nihil significativum*, as when the accused in a court case fails to enter a

plea. That is, the fact that something, say an event, a gesture, or a "work of art" does *not* signify in some particular way can itself be significant. Thus, if my answer to your question fails to make grammatical (or some other kind of) sense, that fact can be significant: I might be confused, a foreign speaker of your language, or trying to make fun of you. If one presupposes a fixed context within which "signify" is taken in an antecedently narrowly specified sense, then it is easy to imagine all kinds of things that "do not signify anything" in that context and in *that* sense. The way we live will determine our sense of what is "intelligible" and if our way of life is sufficiently rigid, unreflective, and conformist, it will be all the more difficult to find any deviancy even intelligible. That Dada means nothing to any of us, might reflect badly not on *it*, but rather on *our life* and our conception of significance. So Tzara's "Dada ne signifie rien" can be seen to be complementary to the 1920s slogans "Dada ist die willentliche Zersetzung der bürgerlichen Begriffswelt" and "Dada ist politisch". Dada doesn't mean anything because it has no place in that bourgeois world and fits into none of its categories; it becomes political to the extent to which it becomes a project of deliberate dissolution. This also makes clear to what extent there is the possibility for collaboration between Dadaism and Marx-inspired political movements, but also the limits of such collaboration. Both Dada and Marxism are committed to the dissolution of the world of bourgeois concepts, but all good Marxists are also committed to "dialectical thinking" and dialecticians, whatever else one might think of them, are rationalists of a kind; one might even say "hyper-rationalists". "Rationalism" in any of its forms is not one of Dada's characteristic stances.

What would it then mean that Dada was dead? Its project of "deliberate dissolution" could be thought to have become historically irrelevant. In Berlin, in 1920, the lay-figure hanging face-down from the ceiling has on the uniform of a Prussian military officer but the head of a pig. This work was entitled *Prussian Archangel*,[18] and the figure held in its hand a paper on which was written "Vom Himmel hoch da komm' ich her".[19] In the original 1920s installation, he would have been a spectre *from the recent past*, but one no longer really able to intimidate the members of the public; a figure, at best, of ridicule. He is certainly dead, but part of the point of representing him in 1920 by such a lay-figure was that in one sense he was never really alive. The Prussian officer only ever had such power and authority as he was

endowed with by the human collective imagination. Heine once said about Kant that he tried to put a Prussian gendarme inside the breast of each individual human, and so one could also imagine this painting being entitled *Kant is Dead*. The empirical self with all its inclinations (*Neigungen*) is still there in the form of the wolf, but he, too, is toxic, irradiated, and thus moribund. If the Kantian raised his eyes to try to behold the starry heavens above, he would behold the pig-headed Prussian Archangel, the closest earthly approximation to the ideally Rational Will. By 2009, the public has disappeared, the works of art on the wall, too, are gone or have run and smeared – although the process of smearing has created a new image in the form of the phantom leg – and if *per impossibile* the officer, who is after all only a stuffed doll, ever tried to exercise his imaginary jurisdiction on the radioactive wolf, he would get nowhere.

"Pieing"

In another of Ghenie's paintings from about the same time, *Nickelodeon* (2008), we seem to be in roughly the same kind of visual world as *Dada is Dead*. In both cases we see the claustrophobically enclosed interior of a shabby and ruinous room painted in sombre tones of dark brown and grey with a strong sense of three-dimensionality. If anything, in *Nickelodeon* there is an even greater sense of enclosure within a room of phosphorescently rotting wood. The painting is a juxtaposition of two canvases of 210 × 120 cm positioned side-by-side, but it is not a traditional diptych because the image spreads continuously over both canvases and does so in such a way that the vertical juncture between the two panels is still visible. The perspective, reinforced by the strong converging lines of the floorboards (and, on the left side, what seems to be a pile of long sections of iron [?] railway tracks), draws both halves of the painting together and also pulls the viewer's eye very powerfully *into* the frame.

Nickelodeon is associated with a series of works Ghenie did on pie fights, especially cinematic-style pie fights of the kind in which Laurel and Hardy specialized. The nickelodeon was a very early form of cinema, a *theatrum mundi* on the cheap for the very early twentieth century. The painting shows a group of men who have just visited a nickelodeon. The men are

dressed in overcoats of a style more characteristic of the middle than of the very beginning of the twentieth century; some of them, a small group on the right, are simply standing together, perhaps talking; others, the figures in the centre and on the left are beginning to walk forward and slightly to the left, following the lines made by the cracks between the floorboards. None of the faces of the men are clearly visible; some still have pie on their faces. Remnants of pie surround the heads of the two figures on the extreme left, giving almost the impression of a halo. The face of the figure in the exact centre of the painting – the visible joint between the two panels runs right through his shoulder – is a white blank. Presumably his face is covered with pie, and both of his hands are raised to the area of his mouth and chin as if the pie were a mask he was desperately trying to pull off. A pie you have thrown which covers my face *is* a kind of mask, albeit one you impose on me, not one I have chosen to put on.

The Dadaists were in any case very keen on puppets, dummies, lay-figures and masks.[20] These pie-masked faces, then, belong with the *Prussian Archangel* exhibited in Gallerie Burchard in 1920. Puppets and dummies are imaginary others, allowing for a play along the boundary of the living and that which is not (really) living, just as a mask can be an imaginary self. The possibility of this play along the border between living and not living, present and not present, real and not fully real traditionally made philosophers deeply suspicious, and the possibility of deception – of hiding one's "real" self from others – that the mask presented was construed as a deep moral danger. The active fascination with and positive valuation of the straddling of these boundaries was one way in which the Dadaist is an "anti-philosopher". Even worse than the possibility that a mask may hide from others my true self, is the thought that I might in some way come to fail to have a "real self". Nietzsche's conception of the radically anti-traditional philosopher as a person who loved to change masks continuously and had no real "face" at all, is the precursor in this of Dada's M. Pyrine, the "anti-philosopher".

The central figure in Ghenie's *Nickelodeon* is perhaps not so much trying to wipe the pie off as frantically trying to palpitate his face to see if it still exists, and, if so, what its nature is. He is "spectral" because although the upper part of his body is fully realized, the bottom part seems to peter out. The other figures seem firmly planted on the floor, but his legs and

feet are transparent – like the "phantom limb" of the cripple in *Dada is dead*. In addition, his upper torso seems to be *behind* the two figures on either side of him, and yet his phantom feet are just barely visible, visible enough, though, for us to see that they are in *front* of the plane on which the two figures on either side of him stand. That suggests that he both is *and is not* part of the world of this antechamber. There is something about all the other men, and about the grouping, which immediately makes one think that they are Party members (of what Party one does not know), members of a Delegation, plain-clothes policemen or Security Agents. The nickelodeon itself, that is, the room in which the audience sits for the performance, is not visible, but in the back depths of the painting in the upper right hand side of the right panel, there is something which seems to be a door at the end of a corridor, and that is presumably the entrance to the auditorium itself. The men have just emerged after a performance from this room into a kind of foyer or antechamber. Why would *these* men have pie on their faces?

One possibility is that they have just come from a meeting in the nickelodeon which has degenerated into a pie-throwing contest. Or are they members of the *Securitate* who have come to close or censor a performance and have been attacked by the members of the audience? This would explain why the men in this group do not, apart from the spectral central figure, seem terribly upset or disaccommodated by what has just happened. This, after all, may be part of their *metier*, and they also may know that they can return the next day or the day after that, and then the joke will very definitely not be on them but on those who threw the pies at them. Where, though, if this is the scenario, would the audience have acquired the pies in the first place? Is it customary to go to a performance with a proleptic pie in case one feels the need of it? Did they know they might be raided by the *Securitate*? A second possibility is that there was a live theatrical performance going on in the nickelodeon, but that this performance has taken a Dadaist turn. The Dadaists, after all, were some of the first to reject the idea of a closed and finished "work of art" and of a sharp distinction between performers and audience, just as they wished to destroy the distinctions between art and politics, everyday life and art, poetry and painting, sense and non-sense. All of these ideas were part of the *"bürgerliche Begriffswelt"* which Dada was out to destroy. Dada "performances" were events that did

not usually have and follow detailed scripts but evolved unpredictably[21] as they were taking place. These performances could be seen as unique organic processes and any images formed were formed in the way in which the phantom leg in Ghenie's version of *45% erwerbsfähig* seems to have been formed, by the unintended action of natural processes. Usually, too, the audience took an active part in making the performance the work of art it was. The "public" shown in Höch's 1920 photo are not anonymous members of a "general public" but individual recognizable Dadaists: the audience *was* the artists. At one of the very first Dada-events in Zurich in 1916, Richard Huelsenbeck read a manifesto that contained the words:[22] "I hope you shall not suffer any bodily harm, but what I have to say to you will hit you like a bullet."[23] So perhaps what has happened here is that the "actors" in the performance have at one point replaced a statement that will hit the audience like a bullet with pies, and have thrown them at the members of the public, who are the people we see exiting in Ghenie's painting.

A "nickelodeon", however, was not simply a theatre, but a *cinema* showing short *films*. So a further possibility is that Laurel and Hardy – although not themselves depicted – have thrown pies at the audience, that is, the men who are seen in the picture emerging from the nickelodeon. Something, that is, has happened to the boundary between the imaginary – what is represented in the film on the screen (Laurel and Hardy throwing pies at each other) – and the "real" men depicted in Ghenie's painting, who presumably constituted the audience. Some of the pies thrown by the actors on screen in a cinema have flown out of the film into the audience and hit some of the members of the audience in the face. To speak of the "real" audience or the "real" men in the painting might seem to be highly peculiar. To be sure, these men are represented in the painting as (if they were) "real": "real", that is, relative to the figures on the (invisible) cinema screen, which we must imagine to exist in a room mapped out in the space defined by the painting, but which is invisible to us as viewers of Ghenie's painting. Nevertheless the men depicted are not "real" in another sense: they are figures in a painting (by Ghenie), and so we might think of them as "imaginary" relative to the people around me in the gallery in which I view Ghenie's painting – each of whom presumably has a National Insurance number, valid credit cards and a unique spatio-temporal physical location.

The *theatrum mundi* was supposed to give us distance from the events of the human world and allow people to see it as a whole and thereby form an overall judgement about it. Here the judgement seems to be that history is a comedy of a sort; not in the sense in which Dante's poem is a "comedy" – ending in a vision of saved human souls in paradise – but a distinctly brutal and absurdist farce in which most of the participants end up with pie on their faces.

One might consider "pieing" (as it is now apparently called) a quintessentially neo-Dadaist gesture because it hovers uncertainly between the real and the merely symbolic – no organic damage or bodily harm is done to those who are "pied", but it is uncomfortable and embarrassing – and between the ludic and the serious – what might be a joke for those watching could be serious for those "pied". People who have been "pied", and are widely perceived to "deserve" it (who finally makes this judgement?) – like Bill Gates in 1998 or Rupert Murdoch in 2011 – suffer a moment of indignity, but their power to harm is not seriously reduced. Many of the most active agents of evil – high-ranking agents of security forces – are so well protected as rarely to be possible targets for this kind of action. Finally, "pieing" will work only on individuals, so corporations, banks, law firms, investment companies are immune, except through actions directed at representative persons. "Pieing" the Chairman of the Board, however, may even backfire in that it can contribute to fostering the illusion that individuals are really responsible for what corporations do. Gates and Murdoch would perhaps like us to believe that they are the motors of their respective corporations and indispensable to the success of the nefarious project of getting monopolistic control of all information and human opinion, but Microsoft and Fox News could easily continue to be forces of darkness without these individuals. Corporations, after all, are *not* really very much like individual persons but rather structures of a very different kind,[24] and judgements about their systemic effects do not reduce to evaluations of the individuals of which they are composed.

Although the painting is not a diptych, for the reasons mentioned above, the visible crease down the centre does raise the possibility that it was supposed to be imagined to swivel on this axis and fold over in the middle. The question would then be which way it was intended to be folded? Since this central juncture runs directly through the spectral figure in the centre, if

the painting is to be folded, it will pivot on him, but which way? Should the two sides pivot backwards, so that the painted surface was on the outside? Then one would have a continuous wrap-around scene, perhaps indicative of a panoramic view of the scene or even of recent history. History then might be construed as a continuous spectacle around an *empty* centre. There would, of course, be a vertical strip down the centre. This strip would be twice as wide as the depth of the framework on which the canvas is stretched; it would run directly through the left shoulder of the spectral figure in the centre, and, for all we know, it might be unpainted. He might then be thought to be a man torn apart by history. If the painting is folded in this way, one might be tempted to open it in the way one opens a book, but would then find that the inside was blank (because one would see the unpainted side of the canvas), like a prayer book with a highly ornamented cover but no text. Or perhaps the painting was supposed to be bent in the opposite way, with the painted side on the inside as if it was a precious content protected by a simple canvas cover (the "back" of the painting we see). Here the suggestion would rather be that the painting was a depiction of esoteric knowledge or of a nightmare in the soul of the spectral figure. Perhaps one is supposed to think of the painting as double-jointed: to be opened or closed in either/both direction(s).

Dada is Dead was a painting based on a historically extant photograph of a (destroyed) painting (which itself represented an imaginary street scene). *Nickelodeon* represents a parallel nested set of different frameworks of reference in which the distinction between image/appearance and reality shifts, and eventually becomes problematic in a number of ways: Ghenie's painted image invites us to imagine a group of men from the 1950s who are exiting a turn-of-the-twentieth-century nickelodeon or to imagine a (real) group of people who have real pie on their faces which was thrown at them by the imaginary figures on a motion picture screen and a spectral figure without real feet and who exists on a different spatial plane apparently standing among them. What would have been serious and unpleasant in reality (pie in the face) becomes comedy by being presented on film, but then reverts to something serious if the event depicted in Ghenie's painting had actually happened. But it is imaginary.

Much of the interpretation of these two paintings by Ghenie has depended on taking the title of each painting particularly seriously. Using

titles in this way, one might think, is problematic. Titles have two distinct origins, and there are two different traditions for thinking about them. In one such tradition, titles are construed as completely extrinsic to the work itself. Thus, in the ancient world most works had no titles; they were unnecessary. For an Athenian the image in the Parthenon didn't need a plaque reading *Athena*. The title becomes necessary when the original context is lost – when it is possible to ask about the statue of the young woman with helmet, owl and shield: "Who is this?" – or if one is running a library or a museum and must have a catalogue. The title, then, is merely a handle. The second tradition comes from forms of human self-aggrandizement. If I want to be remembered, I may have an elaborate tomb made to draw attention to myself, but the effect will be lost if I do not have my name inscribed on the tomb. Here the "title" (e.g. "I am a bronze maiden and have been placed on the tomb of Midas", or simply "Caius fui") is an essential part of the intention. Or a craftsman may sign a work "Antiochus fecit" (for instance on a pot). Or a political figure may claim credit for something as in "M. Agrippa fecit" (on the Pantheon).[25] None of these is a "title" in the modern sense, but the Latin word from which "title" is derived (*titulus*) means any kind of notice or board, bits of paper or inscription conveying information.[26] Eventually, the term comes to be used for "information" about the work in what comes to be taken to be the pre-eminent sense, namely what its name (and its sense or meaning) is. That is, once the context of interpretation is, for whatever reason, no longer clear, works of art come to seem to need "interpretations". This is likely to be increasingly the case, the more art becomes "autonomous", that is once the painter is not painting the altar-piece in the Church of the Virgin (where a painting of a young woman in blue with a halo and child underneath a white-bearded old man and a dove does not require the provision of any extra information in the form of a *titulus*). Once paintings become things to exhibit in galleries and the range of techniques, subjects, genres, associations and so on becomes unsurveyably large, the question of how the work is to be read becomes an important one. Assigning a "title", then, seems an easy way to convey the necessary information, and determine the direction in which the search for meaning proceeds. Who, however, gets to assign the title? Why will the first painting I considered in this essay continue to be called *Dada is Dead* rather than (my suggestion) *Kant is Dead*? When the

National Socialists confiscated Dix's painting, they assigned it additional *tituli* ("Degenerate art", "Insult to the German military"), attempting thus to control the direction of interpretation. In fact they did not succeed in their project, because, apparently, too many of the visitors to the exhibit emerged *liking*, rather than abominating, the works of art exhibited; that, however, was a political failure. When artists gain a sufficient status and autonomy to do so, they can begin to assert themselves by signing their name to their product and then also eventually they can try to channel the interpretations that will be given their work by assigning titles themselves. Once the institution of the "title" exists and an artist can choose one title rather than another, it becomes possible *not* to assign a title – and this may be significant – or one can decide to assign a misleading, whimsical or contingent, or even Dadaistically random title. This world of almost infinitely malleable meanings is the one we live in, and we need all the help in interpreting it we can get.

The Dadaists thought it obvious that the old bourgeois order was crumbling, and some suggested that the only alternatives were Bolshevism and Dada. What, however, if the old world did not die, but merely transformed itself from a universe of industrial manufacturing into one of financial speculation and omnipresent marketing, where the brutal facts of production are covered over by a further layer of glossy appearance?

The goddess "Fashion"

Is the title of Chantal Joffe's 2004 painting *Black Camisole* as significant as *Dada is Dead* or *Nickelodeon*? Why name an image after an item of clothing? This would, of course, make perfect sense in a catalogue or fashion magazine where types of objects for potential purchase are displayed and it becomes important to be able to refer discriminatingly to one specific type among a large stock rather than another. This might be considered a kind of self-assertion on the part of the commodity in question. The size alone (300 cm × 120 cm) suggests self-assertion. The fact that the painting is done on board rather than on canvas, the positioning of the sitter, and the relative lack of fine-grained texturing contribute to making it resemble a huge playing card, or an entry in a glossy catalogue that has been blown up

into a poster for use on hoardings. We know nothing about the sitter's history, and the painting gives few clues as to the immediate context; it does not seem to be considered relevant. Unless her name is "Black Camisole", for us she has no name. Perhaps she is a fashion or advertising model with the *nom de guerre* "(Miss) Black Camisole" (like "La Dame aux Camélias").

Since the sixteenth century, one of the familiar genres of painting was the depiction of a reclining or semi-reclining (female) nude, the subject originally identified as "goddesses", then (eventually) as courtesans. The women are depicted stretched out on greenery or luxurious looking beds or couches.[27] The middle of the nineteenth century had its nude images of *grandes horizontales*, of which "Olympia" was perhaps the most noticeable instance.[28] In the twentieth century, nudes flowed down staircases (Duchamp) or resolved themselves into multiple angular planes (Picasso). Joffe's painting belongs to a historical period (2004) in which the human figure has in general re-integrated itself. The female figure in this painting is not fully nude; she is distinctly upright with neither "nature" nor a couch in sight. In fact the painting seems to go out of its way to emphasize the vertical. It is itself 300 cm high and only 120 cm wide, and even the background of the painting is a series of striking vertical lines on a simple relatively neutral bluish-grey surface, presumably either the joins between panels or planks, or conceivably a stretch of wallpaper visibly marked with a pattern of vertical parallels.

The body of the young woman in the painting is disposed so that it seems to fill the space entirely with the top of her head just grazing the frame. She is wearing stylish shoes with very high heels; the frame cuts off the very tip of the right shoe. Even without the shoes, if she were to stand up, her head would protrude out of the top of the painting; the frame can just about contain her. There is a latent energy here, and the formatting is such as would befit a figure of some authority. Altogether we seem closer to the world of Velázquez's painting of the Pope than to that of Titian's *Venus*, and the young woman in this painting does not need the props of the Pope – jewelled rings, velvet cap, elaborate, throne-like chair – to support that authority. Unless, of course, the authority is given or enhanced by the black camisole she wears. The black camisole suits this blond sitter, but it is also perhaps the analogue of the flat black cap which judges used to need to put on before pronouncing capital sentences.

The sitter is not depicted as absorbed in any physical activity which holds her attention, such as pouring out tea, writing a letter, knitting or even talking with a companion – she sits up straight with her legs confidently crossed; the insouciance of the crossed legs indicating that she is at her ease and that immediate action is not envisaged but she is also not absorbed in a reverie or a moment of introspection. She does not have the vacant look of the barmaid at the Folies Bergères in the famous painting by Manet where part of the point would seem to be the extreme contrast between the publicity of the situation, a public bar, and the privacy of the activity. Nor is she depicted with a lot of empty space around her, as if to emphasize isolation. This sitter is half turned away from the viewer with her head tilted back and her nose in the air so that one sees only one eye under the thick black line of an arched eyebrow – the original meaning of "supercilious". Her mouth has no traces of a smile or even a relaxed neutral expression but is distinctly turned down at both ends, and the throat seems tense. Her demeanour is one of slightly aloof, and perhaps slightly disapproving, detachment from the situation: she is viewing and judging something or someone, not being observed and evaluated.

The garment the young woman is wearing, a camisole, is a half-way house: not properly an outer garment, but also not really a *dessous*. It is in this respect like the "boudoir" in a traditionally furnished set of rooms, which has been described as a space "situé entre le salon, ou règne la conversation, et la chambre où règne l'amour, le boudoir symbolise le lieu d'union de la philosophie et l'érotique".[29] The woman would then be, as it were, dressed for philosophical reflection and judgement, and although no one else is visible, she also does not seem to be alone. The special piquancy of the transitional "boudoir" derived from its ambiguous status, straddling the sharp division often made in bourgeois societies between public and private.

In our Western societies this liminal position has lost much of its ability to energize and focus attention. The deep décolletage half-revealing one breast has in itself no special significance in our post-prurient world and the fact that the position of the sitter reveals much of the bottom half of her very prominent thigh also seems just one more natural fact of no particular consequence. Or is it significant that the left thigh of the sitter is so prominent and fleshy, and is that of particular importance in view of the

generally judgemental attitude of the sitter? What, or whom, in any case is she judging so condescendingly? Given her expression and general posture, the judgement does not seem likely to fall out in his (or her or their) favour. Or is the presumed irrelevancy of her semi-nudity itself a mere appearance; is she perhaps not so much condescending as wary or even apprehensive?

Modern fashion might seem to be a realization of the Dadaist appeal for a breaking down of the "bourgeois" distinction between art and everyday life. After all, the carefully designed and aesthetically vetted items of clothing are intended not to stand in museums as objects of disinterested contemplation, but to be worn by people going about their everyday business. It is perhaps also significant that the camisole as depicted does not conform to the usual structure of such garments. The upper portion of a camisole is more usually in the form of the upper half of the letter "H"; sometimes, to be sure, of a slightly distended H (that is, the top is horizontal (or slightly rounded) with two vertical straps over the shoulders). Here the straps are very thick and the top of the camisole is in the shape of a very deep "U" or "V" extending almost down to the navel. The fabric also seems to be oddly bunched near the bottom, rather than hanging crisply or falling naturally. Has the sitter put the garment on negligently? Is she on break between camera shoots? Has she been interrupted while doing something else which has disarranged her camisole? What was that she was doing? Is, perhaps, this camisole supposed to lie like that?

The woman in the black camisole seems to be a denizen of the "flat world" envisaged by Thomas Friedman,[30] without three-dimensionality, nooks-and-crannies, *chiaroscuro*, the visible signs (or the results) of the passage of time, or ideally, human inertia, cultural difference or idiosyncrasy. Fashion items, even "high-end" items, are actually mass-produced literally anywhere – China, Malaysia, Latin America, Morocco – and given a pseudo-artisanal character by the addition of a designer label. In this world history and ideology are said to be at an end,[31] "one dimensional man"[32] has become the self-evident only reality; there is a uniform final framework of signification which is to replace history, philosophy and politics: the consumerist society of late liberal capitalism and its aesthetic subdivision – fashion.

Is the woman in the black camisole a competitor in a game, and subject to the rules and forms of judgement associated with the game? What game

is that? Glamour, beauty, marketability? If she is a model, are we supposed to be evaluating her? ("She is good at that; she is glamorous; she shows that outfit to its best advantage; that outfit shows *her* to *her* best advantage") Or are we supposed to be evaluating ourselves, taking her as the standard? ("Am I as thin/elegant/self-possessed/blond as she is?") Or is she herself a judge, finding our dress sense wanting? Or a second-order commentator on the game and its rules? Or all three at once? Is she merely subject to rules others impose in the way in which those "pied" must, at least for a moment, carry around the mask and identity imposed on them by those who throw the pies? Or does she enforce pre-given rules herself? If so, "pre-given" by whom or by what, by what person of what set of systemic imperatives? Does she make (some of) the rules up herself, or does she act *ad libitum* with no reference to rules, engaging in a free and spontaneous act of evaluation? If she does all of these things at once, is it still in any *interesting* sense a "game", and not, for instance, "human life"? Does it matter whether – whatever she is *actually* doing – she *thinks* she is enforcing pre-given rules or making them up (or acting *ad hoc*)? If it does matter, for *what* does it matter? If she thinks she is enforcing her *own* rules, but is mistaken about that, does that matter?

"X (say, romanticism, the temperance movement, the Third Way, bimetallism) is dead" can mean at least two distinct things. It can mean that X failed or that X has become irrelevant. Both can arguably be asserted of the original Dadaist movement. The "bourgeois conceptual world" with its strict dichotomies, hierarchies and distinctions which it wished to dissipate, has disappeared to be replaced by an altogether "flatter" world in which certain economic imperatives have significantly wider and more uniform sway. From the perspective of theorists like Adorno, the "flat world" would seem to be nothing new, merely a fuller and more consistent realization of the tendencies that made the old world of the bourgeoisie reprehensible. The dissolution of the bourgeois world was clearly *not* the result of Dada's intervention, but of wider social, economic, military and political forces. So to the extent to which Dada was committed to being the major *means* for that transformation, it failed, and it is hard for us to imagine circumstances under which it *could have* succeeded. Even a Dada-revised and -expanded "art" couldn't have *that* power. So when Huelsenbeck announced in his 1916 manifesto "We wish to change the world with Nothing ... we wish

to bring the war to an end with Nothing",[33] this is a sensible project only if the *Nichts* involved means something significantly more than collages, sound-poems and Dadaist "events". Even throwing pies is no effective alternative to, or form of resistance against, the armaments of the First World War or the real horrors of the Internet. On the other hand, is concern for that which is *not* part of the flat present really so obviously irrelevant or so obviously doomed to complete impotence?

Acknowledgements

I am grateful to Manuel Dries, Lorna Finlayson and Jörg Schaub for some exceedingly helpful comments on a previous draft of this chapter.

7 | Confinement, apathy, indifference

Paul Noble
Heaven
(2009) | *Hallvard Lillehammer*

Heaven, apparently, is a walled enclosure; empty of people, artefacts or any other signs of life. High brick walls, four empty towers, and the shadows they cast, inside and outside. Perhaps these details tell a story. But which? Why, for example, would something called "Heaven" be depicted as a walled enclosure with no doors for entry or exit?

One might wonder what's supposed to have happened here. Did someone build a memorial to something so obvious that there is no need to explain what it is? Did archaeologists come to excavate a monument, and do such a good job of it that every single human artefact or sign of habitation was eventually swept up, measured, labelled and catalogued before being tucked away in the industrial basement of a national museum? Did the curators go too far in their enthusiasm and reconstruct the original enclosure without thinking that at least some of the people who originally used it had to be able to get in and out? Like most interesting works of art, *Heaven* comes without an instruction manual.

There is more than one *Heaven*. There is at least one *Heaven* that is a material object made of paper and marked in graphite, measuring 121.9 × 302 cm, and sometimes hanging on a wall in an art gallery. There

is a *Heaven* that is a function of the artist's intention when he made the picture, and the way those intentions were realized on paper. There is a *Heaven* that is a function of what I see when I look at the picture, regardless of whether or not I know anything about the artist who made it, or his other work. Then there are many other *Heavens* that are a function of what other people see when they look at the picture. I'm not sure if there is such a thing as the real *Heaven*. Nor am I sure it really matters if there were.

What I saw when I first came across Noble's picture was an enclosure meant to keep people in, not out. It was an enclosure from which there is no physical exit. I thought of absent people, who may once have been trapped there, but who are now long gone. I thought of what it means to be un-free or incarcerated; being made so at the hands of others; and with no real hope of escape.

Suppose you found yourself inside a walled enclosure with no real possibility of exit. You would either be aware of this or not. And depending on your level of awareness, you might care more or less about your situation, and do so in some ways rather than others. Thus, you might be ignorant of the fact that you are inescapably enclosed but be completely free of concern, like a child who is obliviously happy, yet lives in a state of extreme dependency. Or you might be ignorant of the fact that you are inescapably enclosed but have a strong desire to leave, thereby suffering the acute risk of extreme frustration, or even madness. Alternatively, you could be perfectly aware of your inescapable confinement and suffer the devastating agony of an unwilling prisoner whose hope of freedom has been wilfully crushed at the hands of others. Or you could know that your predicament is inescapable and simply not care; and thus come to regard your lack of freedom with something approaching a total lack of concern. Suppose you found yourself experiencing a predicament of this fourth kind. Why would you do so, and what might it be like?

Let's say someone is indifferent to something when that someone displays a non-caring orientation to that something in a certain context. Apathetic indifference is a state of not caring about some feature of the world that is of genuine ethical significance, such as the extent of your personal freedom. In this sense, a person can display apathetic indifference towards a narrow range of good or bad things, or towards a wider range.

I say that a subject displays apathetic indifference when they fail to cultivate or sustain some appropriate orientation of concern towards a range of ethically significant features of the world, where this failure does not play any significant strategic or otherwise instrumental role in the pursuit of either their own ends, or the ends of any collective of which they are a part. To this extent, apathetic indifference is indifference without an aim or purpose.

A display of apathetic indifference could be subject to different explanations in different situations. In some cases, apathetic indifference could be characterized by an absence of interest or attention caused by ignorance, laziness, boredom or fatigue. In other cases, apathetic indifference could be characterized by an absence of interest or attention caused by personal or collective suffering in the face of adverse circumstances. In the latter case, apathetic indifference might be a sign of internal trauma or conflict, and would thereby be motivated in some way. Yet a state of apathetic indifference as I understand it would not play the role of a means to an end with which its subject would reflectively identify, such as the bracketing of some ethically significant concern in the service of an end that is perceived to be of greater importance. To that extent, apathetic indifference is comparatively non-dynamic.

To the extent that someone's indifference to a range of things is unrelated to what they take those things to be like, or is otherwise a function of a lack of interest in their nature, their indifference is comparatively object insensitive. This does not mean, however, that coming to be in a state of apathetic indifference towards something could never involve an awareness of what that thing is like. Thus, if I fail to show any real interest in my physical appearance, this could be because I have previously spent a lot of time worrying about how I look; have constantly failed in my efforts to look acceptable to others; and have consequently given up on the whole "appearance thing".

In some cases of apathetic indifference, it is not so much the absence of concern with some ethically relevant aspect of the world as such, but rather the unacceptable narrowness of those concerns that might lead one to describe someone as being afflicted by apathy. Thus, I might classify as apathetically indifferent a teenager who spends all of his or her time doing nothing else than lying in bed, staring at the ceiling. If being virtuous

involves having some kind of caring or otherwise productive relationship to a wide range of goods, then a general state of apathetic indifference is a vice that involves not caring about too many of these.

A subject of apathetic indifference is paradigmatically an individual person, but it is also possible to think of a group of people as collectively indifferent in this way. The paradigmatic object of apathetic indifference is a range of things or states of affairs that are actually worthy of interest, concern or attention; such as the fate of someone else, or a state of oneself (such as one's lack of freedom). Its normal orientation is the absence of a range of attitudes or behaviours that would normally be merited by its object in a certain context, from basic attention on the one hand, to intentional action on the other. To be apathetically indifferent is to be intellectually or practically detached from the realm of good and bad, right or wrong, in an ethically problematic way. The apathetically indifferent person may either not have acquired a virtuous state or disposition, or may effectively have given up on trying to be good in the relevant respect.

In the Christian tradition, the vice of apathy is associated with sloth, laziness and indolence, and was at one time classified as one of the "seven deadly sins". Apathy was thought to be sinful because it entails the failure to do one's duty, in particular the duty of charity. In his thirteenth-century work *Summa Theologiae*, Thomas Aquinas describes apathy as "a sort of depression which stops us from doing anything, a weariness with work, a torpor of spirit which delays getting down to anything good".[1] For Aquinas, the personal failure involved in apathetic indifference is intellectual and practical at the same time, and will normally be caused by some kind of internal conflict. He writes that "apathy is a special vice saddened by the very goodness of God in which charity rejoices", and that "sins that by definition exclude the love of charity are of their nature fatal".[2] This kind of apathetically indifferent person fails to respond appropriately to the goodness of God's creation, and can be expected to end up badly as a result.

The claim that some forms of apathetic indifference are ethically defective continues to be accepted by moral philosophers in the modern period. For example, in his eighteenth-century treatise *A Theory of Moral Sentiments*, Adam Smith condemns indifference to the fate of others as "the cruellest insult". Smith writes:

> To seem not to be affected with the joy of our companions is but want of politeness; but not to wear a serious countenance when they tell us their afflictions, is a real and gross inhumanity ... We can forgive them though they seem to be little affected with the favours which we may have received, but lose all patience if they seem indifferent about the injuries which may have been done to us.[3]

Smith takes a similar view about indifference to wrongs done to oneself:

> A person becomes contemptible who tamely sits still, and submits to insults, without attempting either to repel or to revenge them. We cannot enter into this indifference and insensibility: we call his behaviour mean-spiritedness, and are as provoked by it as by the insolence of his adversary.[4]

The targets of Smith's disapproval in these passages include a variety of ethically problematic personal orientations, from the failure to act in response to injustice and wrongdoing on the one hand, to the failure to respond to suffering and adversity on the other. Not all of the attitudes targeted by Smith would be instances of apathetic indifference as I understand it here. Yet some of them clearly would be.

The ethical significance of apathetic indifference is not just a matter of the intrinsic properties of some personal orientation and its object. It also depends on what explains that orientation in a given context, and the role it plays in a causal network of social and psychological relationships. In some cases, apathetic indifference is the result of something being seriously amiss in the world, either internal or external to the indifferent person. The world itself can be an indifferent, cold or hostile place. Apathetic indifference can arise unwillingly as part of a series of events where a person's ability to pursue a range of goods is undermined or destroyed; whether by human or non-human causes. The failure of a life-plan or the loss of a loved one can have the debilitating effect of removing from view, at least for a time, the reasons that someone previously saw to care. The actions of other people, deliberate or otherwise, can have similar effects; such as when a person is incarcerated against his or her will with no reasonable

prospect of escape. In these and other ways, a state of apathetic indifference is one possible consequence of a person's dignity being assaulted by the violence of others. In his essay "On the Idea of Moral Pathology", M. P. Golding notes that "callousness and indifference are attitudes that may well have to be adopted in order to function in situations of 'tragic choice', choice between evils".[5] As personal "coping strategies", the states of indifference that Golding has in mind would, at least in some cases, be subjectively motivated or otherwise dynamic. Yet not all states of indifference that could result from an assault on someone's dignity are most plausibly interpreted as being intentionally productive, or otherwise interestingly dynamic, in this way. For example, when addressing a similar topic in his personal memoir *Night*, Elie Wiesel recounts his experiences as a prisoner on the "death marches" through central Europe at the end of the Second World War. Describing one part of his journey, packed into an open cattle train along with other dead or dying prisoners in sub-zero temperatures, Wiesel writes: "Pressed tightly against one another, in an effort to resist the cold, our heads empty and heavy, our brains a whirlwind of decaying memories. Our minds numb with indifference. Here, or elsewhere, what did it matter? Die today or tomorrow, or later?"[6]

In this book, Wiesel expresses a deep sense of discomfort at his own increasing detachment from the world around him during this period of his life, including his gradual detachment from his own sick and dying father. Yet the kind of indifference described by Wiesel in these passages is not so much a symptom of a culpable ethical failing on the part of those who have been made to experience it, as a manifestation of the ethical depravity of their captors. It is this ethical depravity that is the main cause of Wiesel's increasingly detached relationship to a world in which events like these can happen, and where, confronted by the extremes of a systematic programme of terror and mass murder, even otherwise admirable people will succumb to an ethics of "each man for himself". In *The Gulag Archipelago*, Aleksandr Solzhenitsyn describes a similar set of reactions experienced by political prisoners who were subject to the brutalizing conditions of the Soviet gulag. He writes: "I remember well my state of mind: a nauseated indifference to my fate: a momentary indifference to whether I survived or not ... This was the true convict mentality; this was what they had brought us to."[7]

Of course, comparable states of object insensitive and non-dynamic indifference could equally be brought about in circumstances where none of the people involved have acted with moral depravity. Examples may include situations where those beset by apathetic indifference are the victims of catastrophic misfortunes, the causes of which are beyond anyone's control. The aftermath of a natural catastrophe (like a plague, as in Albert Camus's novel of that name)[8] is one possible example of this, in which the absence of some virtuous concern on the part of its victims need not be traceable either to their, or to anyone else's, ethically deficient agency.

When I first looked at Noble's *Heaven*, my attention quickly turned to the ideas of confinement, apathy and indifference caused by others; and on the ethical significance of these (and related) conditions of personal or collective detachment. Perhaps I am therefore committed to interpreting the title of Noble's picture as ironic. Alternatively, I am willing to concede that I have completely misunderstood the intended significance of the picture, or at least that my *Heaven* is not the artist's (or any other spectator's) *Heaven*. Either way, what I saw when I first came across the picture were the elementary materials for these basic philosophical reflections on the nature and ethics of indifference.

8 | Thinking outside the frame

Plato, Quinn and Artaud on representation and thought

Ged Quinn
The Fall
(2006)

M. M. McCabe

The first visual impact of Ged Quinn's *The Fall* is of a gentle bucolic dilapidation. A ruined temple stands to the left in front of a bright landscape, feathery weeds growing out of its crevices. In the distance the sea shines with white light, mountains vaguely outlined on the right. The foreground is framed by a row of broken pillars and vegetation, and the upper middle of the painting is marked by a darker cloud drifting across the sky.

Within this apparently romantic framing, however, the central subject jars, both in its formal arrangement and in its figures. Emerging from the temple's ruined wall is a tattered shack, whose structural scaffolding shows through to what seems to be an abandoned artist's studio, drawings scattered and discarded. And in the midst of the dark cloud a grimacing figure, winged and burning, plunges towards the Earth.

The effect of the whole is a grotesque rejection of sentiment. Even without knowing that the frame is a direct copy of Claude Lorrain's *Landscape with Abraham Expelling Hagar and Ishmael*,[1] the viewer is shocked by the sheer inconcinnity of the central action. But the shock has consequences for how we think about the painting, consequences which expand when we know more about its content and its context. As a result, I shall suggest,

this is a thoroughly intellectual work, engaging in interesting ways with all sorts of other works and genres. But the price of that seems to be a thinness in its aesthetic content; and that, I shall suggest, is betrayed by its connections elsewhere.

In what follows, I shall offer some thoughts about the complex composition of the painting, in comparison with the challenges that Plato lays down when he is thinking about art and representation. For Plato's various critiques of art and its representational quality seem to be in tension with his own artistic practices. I make no apologies for returning to Plato in this context, both because he offers an interesting parallel to Quinn's intellectualism, and because he affords a developed account of how art may be representational, and of its consequent limitations and its provocation. His challenge to aesthetic representations has long been a thorn in the side of the history of aesthetics as well as a direct challenge to his own artistic practice. How he meets that challenge in his own work, I shall suggest, may help us here; and it shows, in the end, what the price of intellectualism may be.

Knowledge: the inside and the outside of a work of art

Should we be able to appreciate or understand art just by contemplating the work itself? Should our mind be a *tabula rasa* when we first encounter an aesthetic object? Of course in general terms this is impossible (we need to know that this is a ruin, or a cloud, or a tattered hut); but how much extraneous and particular information do we need?

Begin with the title, *The Fall*. The subject seems to be the fall of Icarus; and the idealized dilapidation of the frame might suggest an old-fashioned mythological *topos*, to moralize about the limitations of humanity.[2] Icarus made the mistake of thinking he could emulate the gods and fly with waxen wings to the sky; human builders make the mistake of thinking that they can build something that will last forever; human artists are always deceived of the hope that they can construct what Thucydides called a "possession for ever".[3] The brazen monument is bound to fall in the end, the book to be burned and the library demolished. All the paraphernalia of mythology remind us of human limitation, and warn us against emulating the gods.

This work, however, is not *The Fall of Icarus* (or even – a point to which I shall return – *The Fall of Artaud*), but just *The Fall*. The Icarus story might bring out a different point, about human ability, not human fragility. For Icarus was the beneficiary of the masterly skill of his father, Daedalus, who could build statues that could run away, or labyrinths to hide a Minotaur.[4] Icarus flew too high because his father had the skill to enable him to fly at all. Equally, in The Fall (*simpliciter*) of Adam and Eve, they are thrown out of Eden because they eat the fruit of knowledge and lose their previous innocence. Like Icarus, they too come to grief because of knowledge, not ignorance; the story of The Fall is a story not only about failure but also about knowledge or even genius. What does that have to do with Quinn's work? More generally, what kind of difference to our view of an artwork does it make to know its title: how far is that, apparently extrinsic, feature of the art itself (as a naive account might have it; there is nothing wrong with naiveté, of course) also a part of the work? This painting may ask such questions with some vigour, if knowledge is thematic of a Fall.

It may turn, I shall suggest, on three different questions. The first is about what visual representations have to do with knowledge: what does a painting such as this tell us, what do we learn from it? What does it represent to us? The second is a converse question: in order to understand a painting like this, how do we see it? What do we bring to it? How much do we need to know of the external context of the painting, of how it is framed in its extrinsic connections, to represent it to ourselves?[5] Both these questions, I shall suggest, may turn on what is going on in representation: is what happens in figurative art that some state of affairs (real or fictional) is represented directly to the viewer (just as, we might think, some phenomenal appearance, or even some descriptive item such as a sentence, represents some part of the world before us)? Or is seeing art a matter of what we see in it, how we represent what we see to ourselves? We might think about this in terms of action and passion: do we suffer art? Or do we act upon it to make it so? Or both? Or are such questions just misplaced? The third question is about those questions themselves: are they in the wrong register? Is it helpful to talk about artistic seeing in terms of knowledge? Or does an intellectualist approach damage our understanding of what it is to see art? I shall return to my third question towards the end.

Frames and framing

Where does a work of art begin and end? What are its edges? A traditional view of a painting hanging in a gallery might be that the artwork is what is inside the frame, and the frame merely its container. This is most obviously a feature of flat art; but sculpture, for example, might be equally framed either by what it stands on, or by the context in which it is placed. The frame (one might think) is external to the "art"; often the frame is derived, not so much from the content of the painting, but from extraneous pressures – a cultural pressure towards simple or baroque framing, for example – the frame is what the "art" is *in*, not a part of the art itself.

On the other hand, there are some cases where the formal frame becomes part of the painting itself; or even where the artwork appears to be the frame alone.[6] Further, there are cases where the frame in fact occurs within what at first sight seems to be the piece as a whole. This happens across all sorts of artistic genres. Compare, for example, any play-within-a-play (*The Taming of the Shrew*, for example, or the play-within-a-play in *Hamlet* that precipitates the action), where we see not only the inner play, but in the outer the characters as spectators. In all such cases, that an artwork is *in* something does not disqualify *what it is in* from being a work of art too. The notion of the frame, that is to say, is a shifting one, dependent on a great deal else about the work and always relative to what is framed (even where that is nothing at all).

The framing structure of *The Fall*, I suggest, brings out this relativity. For the outer part of the painting, the idealized setting of the central action, ostentatiously encloses the centre in a frame radically different in style and tone. Notice, for example, the jarring effect of the intrusion of the strange hut into the very structure of the ruined temple. At first it seems merely to lean against the ruin; then to extend into it; and then somehow to be a part of it, as though the ruin is itself made of scaffolding and canvas. This has a provocative effect: the frame distances the viewer from what is framed, but still – because the frame is also notably part of the work – demands some kind of resolution of the relation between frame and framed. The sheer inconsistency of tone and style between one and the other asks the viewer to consider how far what are depicted – in either – are mere simulacra, images superimposed or left as background; or whether what we have here

is some kind of odd puzzle. Once the framing picture is seen to frame, it adds to the enigmatic construction of the piece and its images.

This leaves the viewer alienated both from the central scene and from the frame. That alienation is provoked by a bad fit between the one and the other, an inconsistency that demands rational solution. We see the fall as a representation, both in tension with its frame and formalized by it. But in seeing it thus, we become aware of the lacuna between the representation and what it might be a representation of; there are (we might think) no inconsistencies out here in the world.[7] That there is representation *of something* here is immediately puzzling.

Furthermore, the frame of *The Fall*, in enclosing the drama of the painting, dissociates itself from it. Then, in framing, it takes up a point of view outside the dismal hut or the grimaces of the falling figure. When we then see frame and framed, we become aware, not only of the representation, but also of the subject to whom it is represented. This provides, thus, the conscious distance to allow the viewer to see herself as the viewer; and even, in thinking about the frame, to think about how we think about representations at all.

At the same time, the intrusion of the hut into the ruin in *The Fall* subverts the easy assumption that the frame is itself detached from the action, since it seems, nonetheless, infected by the grimness of the central scene. The delicate pastoral imagery is turned into something formalized, something that may *merely* frame, instead of filling our eyes with meaning. The unstable relation, that is to say, between the inner scene of the painting and the outer, generates a sequence of reflective moves in the viewer, rendering the painting as a whole an intellectual provocation, an encouragement to think.[8] If we recall Quinn's title, and its invitation to think about the connections between knowledge and failure, we may hardly be surprised.

Plato's challenge

Plato was worried about art. He was worried about how pictures represent what they depict, and that in so doing they would deceive the observer into thinking that what is depicted is in fact the real thing: all the more so when pictures persuade us to believe them just because they are beautiful.[9] So

his worry is in particular about imitation: about how some depicted figure might stand between us and reality, and prevent us from ever seeing the truth.[10]

This might of course be a pragmatic problem – we might be fooled into thinking we have, for example, something for dinner, when this is merely a *Still Life with Dead Duck*. Or it might be an intellectual problem: that we might think that something really is what it is not (for this is not a dead duck at all, but only a picture of one). So not only does a representation appear to tell us an untruth; we are trapped by it, since as we look, we are deceived.

Suppose we seek to understand ourselves and our world, but all we see are our images and reflections (in a mirror, shadows cast on a wall). Can we ever penetrate beyond the appearance to get at the reality? Not – or so Plato seems to have said – through representations alone. Pictures, from the intellectual point of view, are worse than useless. We might think about it like this: as a matter of fact, pictures are representations of something else (however we might account for that – whether what they are of is an idea in the mind of the artist, or some state of affairs out there in the world). But when they present themselves to us, they do so without reference to the idea or the state of affairs they are about; instead, they just present *themselves.* So a photograph just is the flat described shapes therein. We only think of it as a photograph *of* something because we have all sorts of other information (we know, for example, what a photograph is; we are given it as a picture of Auntie Maisie; we recognize the inimitable nose of our second cousin twice removed). But without that sort of context, we can do nothing with the photograph, or with any other representation, but take it at face value.

This is Plato's image of the prisoners in the Cave in *Republic* book 7. Socrates imagines that we are like people who have been tied in an underground cave all our lives, facing a wall. Behind these prisoners there is a fire, in front of which some people walk to and fro carrying all sorts of plastic images and statues (animals, furniture, three-dimensional copies of the ordinary objects of the phenomenal world). On the wall of the cave in front of the prisoners are cast both the shadows of these plastic copies and the shadows of the prisoners themselves. Because the prisoners are tied motionless facing forwards, their view is restricted to and exhausted

by the representations before them (the shadows on the wall of the cave). Their lifelong imprisonment precludes their having any of the contextual information that would allow them to see the shadows as shadows *of something else.* The shadows they see cast on the wall before them exhaust their reality.[11]

As such, and without a frame to put them in context, representations obscure reality, rather than informing us about it. They point us away from what is real and self-standing, towards something which is derivative, in ways from which we shall never be able to escape.[12] Representational art, on this account, both hides and supplants reality in ways the viewer will never be able to understand.

The Cave offers an even more paradoxical situation. When the prisoner faces the wall, and sees the shadows cast before him, he takes himself to be a part of what is represented to him – he has, Socrates insists, seen "nothing of himself or the other prisoners" but his shadow on the wall.[13] In terms of how the representation works, this implies that the viewer (of the shadows in the cave; of the representations) never sees himself *as the viewer* – never takes a stance on what he sees from the outside. He has, that is to say, not only no sense of what he sees as a representation of something else but also he has no sense of himself as having a view of it, no sense that this representation is being presented *to him.* In the story of the Cave, all experience is somehow flattened into the image before one; and the complexities of the view from here or there are rendered invisible. This – on Plato's view – is what goes wrong when imitations constitute our world.

Platonic writing

Even although Plato was worried about art and about imitation, however, he was also a consummate artist himself. Without any apparent scruple about the dangers of imitation, he represents the characters of his written dialogues in conversation with each other, fully described and articulate, presented to us through the medium of his literary art.[14] Commentators have long struggled to reconcile Plato's practice with his theory; and long worried about whether the literary aspects of his work are merely gratuitous or exploitative – ways to gratify his readers and to inveigle them into

philosophy, but lacking philosophy's direct appeal to rationality. The style of the dialogues betrays reason – so it is argued – by standing between the reader and the hard philosophical truths which the dialogues advocate. Once in, the reader can never escape – as in Quine's fable, the assumptions are already made, and can never be scrutinized from outside. Moreover, the dialogue itself – on such an account – provides us with no view *that* we are outside, no direct engagement with the reader's perspective beyond following the words on the page and imagining what is depicted therein. The reader would thus be merely the passive recipient of what the dialogues actually say, engaged only in envisaging the scenes described.

The defence that is sometimes offered is the deplorable antiquarian riposte – that Plato was after all writing two and a half millennia ago, and surely cannot be expected to get things right, or consistent. But this seems to me to miss the point very badly; and I hope that the example of Quinn's painting may help us to see why. Conversely, I think that both Plato's self-defence, and his worry about imitation and representation and perspective, has a counterpart in the Quinn painting.

In the Platonic dialogues, there seem to be offered first-order discussions between various interlocutors (usually Socrates and some unfortunate friend, doomed to find himself reduced to incoherence) which are sometimes effective, sometimes not, and often irritatingly incomplete or obscure.[15] One might think that often the first-order arguments that are offered – the overt "theme" of the discussion – are poor copies of what we might expect philosophical discussion to be like (some, for example, find the figure of Socrates intolerably smug, or the interlocutors shockingly inept). Further, one might think that the conversations in which those arguments are embedded are there to further the deception – they are part of making us believe in stories of philosophical heroes and martyrs, and thence of swallowing the arguments they offer with a less than critical approach. The arguments, that is, are framed in the dialogue form; and it seems – especially to the eye of the philosopher who thinks of philosophy as first-order argument – that somehow these frames are either extraneous or positively duplicitous. The framing effect in these contexts – so critics suppose – is *not* a central part of the work itself.[16]

In fact, however, this supposition is a mistake. On the contrary, I claim, the framing feature of the Platonic dialogues is central to their philosophical

content.[17] For it is in these passages that the characters – and thereafter, and by various devices, the reader too – are brought to reflect on the arguments that are being offered. That reflective stance is essential to thinking about philosophical questions. They are, that is to say, not only particular (What is virtue? What is knowledge?) but generic (What is it to follow an argument, or to be persuaded by one? What counts as an explanation? On what are the conditions for argument – consistency, for example – based?). For the generic questions, the terms of engagement for the particular questions are brought into reflective scrutiny.[18] But notice how this reflective stance comes about: it takes the arguments (the first-order arguments) as its object, and considers them as such. In so doing, reflection acknowledges its own relation to and distance from the arguments, and exploits its detachment as part of the frame in which the arguments appear. So, we might think, these frame devices both recognize their objects (the framed arguments) and recognize their own role as reflective frames. This second-order stance is an essential part of the structure of these dialogues; and it is central to the dialogues' philosophical content.

This in turn affects how we might think of the dialogues as "representations". The formal structuring of the dialogues allows us to see the direct conversational argument as the content of the reflective frame. So the first-order arguments are seen there *as represented*, considered *as uttered* and endorsed or rejected. If the arguments are represented, they are seen *as representations*. Equally, the distancing effect of the dialogue's frame is iterative; often we see the framing discussion itself framed in a further outer frame; and within these baroque structures we see ourselves, the readers, framing the dialogue itself from without.[19] But this complex arrangement means that the dialogues are never simply offered to the reader as if they were records of what happened one day when Socrates was on his way to court, or languishing in prison.[20] They are never direct representations, imitations of the sort Plato finds so objectionable. Instead they are complex reflective compositions, where representations are seen to be representations, and envisaged as such. As a consequence, the dialogues do not fall to Plato's own objections, since they are not standing between the reader and reality, but implicating the reader in reflection on the tripartite relation between what is represented, what it represents and how the representation is seen.[21]

Quinn and Artaud

The framing effect of *The Fall*, and the sharp contrast between the central scene and the depicted frame, starts to set up the kind of reflective relations that Plato's dialogues invite. For the tension in the structure of the painting is directly provocative: it makes the viewer stand back, rethink and attempt to resolve the incoherence. As I view the painting, I struggle with what this can be a representation of, and in thus trying to see *through* the painting, I realize how I am seeing it *from here*.

But once the viewer comes thus into view, two questions impose themselves. First, how does what I know about this subject matter explain what it represents? And, second, what is it that I bring to seeing the painting that informs my view from here?

These two questions are associated with something rather more banal: what are the "rules" for looking at figurative painting? How much do I need to know in advance? How far is what I see there determined by minute particularities of culture and knowledge, which are inaccessible to others elsewhere, at other times? My reading of the painting so far merely considers its surface appearance, arguing that its structural complexity gives it reflective content. However, there are three pieces of information that may change and enrich how we come to think about it. The first is the source of the framing picture: Claude's *Landscape with Abraham expelling Hagar and Ishmael*; the second is the identification of the falling man as Antonin Artaud, whose theatre of cruelty is symbolized, perhaps by the grimace on the face of the falling man; the third is the original of the hut in the foreground, apparently Thomas Edison's studio, the "Black Maria".[22]

Begin with the highly specific references to Artaud and Edison. They are not given in the painting itself. How far does it matter that we know they are depicted here? I have suggested that the structure of the painting is designed to challenge the easy assumption that pictures merely represent; instead it makes the viewer think explicitly about *how* they represent, so that the content of the thought includes the condition that it is a representation, and that we see it as such. As a consequence, the picture does not seek to stand in front of reality, but rather to engage with what it is to represent it. In this spirit, the two icons to whom reference is made – Artaud,

the actor and advocate of the theatre of cruelty, portrayed in his anguished fall, and Edison, the pioneer of the dream factory in collapse – represent representation. They may indeed do so without the distance of the framing features. But here, they are seen as such; and that knowledge dismantles the illusion that they create and undoes the deception.

But it is a stark irruption of these images into the pastoral scene of the frame. The harsh juxtapositions, the anguish on Artaud's face, the collapse of the hut, and the pictures strewn on the ground serve to enhance the cognitive dissonance of the piece; and in doing so they promote what Artaud himself recommends. For, Artaud argues, culture obscures reality, and it is the task of art to shatter cultural representation and to reach the reality behind it.

> The contemporary theater is decadent because it has lost the feeling on the one hand for seriousness and on the other for laughter; because it has broken away from gravity, from effects that are immediate and painful – in a word, from Danger. Because it has lost a sense of real humor, a sense of laughter's power of physical and anarchic dissociation. Because it has broken away from the spirit of profound anarchy which is at the root of all poetry ... The best way, it seems to me, to realize this idea of danger on the stage is by the objective unforeseen, the unforeseen not in situations but in things, the abrupt, untimely transition from an intellectual image to a true image; for example, a man who is blaspheming sees suddenly and realistically materialized before him the image of his blasphemy (always on condition, I would add, that such an image is not entirely gratuitous but engenders in its turn other images in the same spiritual vein, etc.).[23]

Plato might be to some degree in agreement. The cave exhausts the world of the prisoners; they are trapped in its images, with neither any sense of their relations to their originals, nor any sense of their own detached stance from what they see. For Plato, somehow the world we inhabit – whether by virtue of its intrinsically derivative nature, or by virtue of the manipulations of politicians, or by virtue of our inability to locate ourselves within

it – just fails to provide us with a direct view of reality. To reach that, our chains must be shattered, our eyes blinded, and our perspective completely changed.[24] We need to shift both what we see and how we see it; only then will we be able to understand the way things are.

But Plato notices – as Artaud does – the trap. For, in escaping the world of the shadows, either we rely on the shadows to help us (but the shadows are entirely limited to their own domain); or we somehow already have access to the other world (which begs the question); or our escape must be forced upon us somehow. In the *Republic*, Plato is evasive in his response to this problem. Artaud's response is cruelty – the violence of iconoclasm, of harsh juxtaposition, of imagistic dissonance. The shock of the cruel forces us away from the images of culture to the reality behind. So too, I think, Quinn: the incongruence of the collected images, the grim nature of the central construction set against the romance of the frame, is designed to force an active and thoughtful role on us, the viewers, and to resist the passivity of merely looking at art.

Shock, cruelty and paradox

But Artaud (knowingly shocking) says: "The library at Alexandria can be burned down".[25] For him, and perhaps for Quinn too, their role is just to shock rather than to engage in discussion: the viewer is left alone to process the cruelty and to take what she can from it. Plato, by contrast, saw the dangers of the written word; but he devised less chaotic ways to avoid them, and still to render engagement with writing a way to think actively. For he supposes that thinking is discursive; and that active engagement is participation in discursive, collaborative thought. Like Artaud, he exploits the idea of shock, in exploiting paradox. Unlike Artaud, he supposes that what follows the shock can be a genuine philosophical collaboration.

In the *Phaedrus*, for example, Plato describes (represents) an odd meeting between Socrates and Phaedrus, who have a long discussion of philosophy and rhetoric. Late in the discussion, Socrates tells the tale of the Egyptian Theuth, who invents writing, and goes excitedly to his king Thamus to report his discovery, his charm for memory. Thamus is damning:

You have found no panacea for memory, but for forgetting. You provide the belief in wisdom for your pupils, not its truth, for becoming conversant with many things without teaching, they will seem to be knowledgeable about much, while they are for the most part ignorant and hard to be with, having become apparent-wise instead of wise.[26]

Within the context of the dialogue – where Socrates and Phaedrus are having an amiable discussion – Thamus' remarks are provocative but not otherwise very puzzling (indeed, we might find them plausible in some contexts and to some degree). But the context itself is highly self-conscious; as we read, we recognize that these words are in fact said in writing: how far do they apply to themselves? The paradox that ensues is a part of the Platonic armoury to force his readers into active reflection on the nature of discursive thought, the nature of reality and the value of anything. For paradox – like the ostentatious shock of the frame – forces our attention to particular topics and ideas, and in the best cases provokes an ordered, argued resolution.[27] Plato's way of getting us to think through the medium of writing has some of the violent effect that Artaud advocates (paradox and puzzles are uncomfortable); but its outcome is directly and carefully ordered, structuring the responsive thought into a reflective view of knowledge, truth and value.[28] Plato's purpose, after all, is to write philosophy.

Intellect and emotion

The Fall may, then, be cruel in Artaud's sense; and perhaps this is why Artaud himself is the figure who falls, failing to know his limitations, perhaps (as Icarus), or knowing far too much (as Adam). But the violation works because these figures are set against the bucolic background of Claude's original. As a result, the cruelty provokes an intellectual response, rather than allowing us to understand it with any depth of emotion. Does a painting like this, thoroughly intellectualized as it may be, have aesthetic value beyond its intellectual appeal? Perhaps there is no such thing; or perhaps the very emotional austerity of Quinn's painting shows that there is.

Artaud makes expansive claims for how anarchic poetry will expose its true tragedy, or its true comedy. His thought appears to be that we would understand, through and through, the human condition by seeing the violence of these images, experiencing the intellectual cruelty of the shattering words.[29] (Plato's response would be a different one: that we harness our wayward emotions by training and education, of which poetry of the right kind may be an element.)[30] This, it seems to me, is thoroughly questionable as an account of paintings like *The Fall*. The risk in the intellectualist approach is that the images are reduced to mere cyphers in a puzzling structure; they tell us nothing of joy or pain, and nothing of beauty or ugliness, because they are divorced from their human content.

Compare and contrast the rather different violence of Claude's painting. Against the looming background of ruins and mountains, we see the small figures, the patriarchal Abraham expelling Hagar and her son Ishmael. The portrait of Hagar's distress and that of her child is set against the hugeness of natural and manmade objects; and that in turn serves to emphasize the

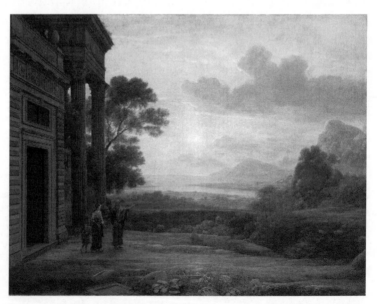

Figure 8.1 Claude Lorrain (Claude Gellée), *The Expulsion of Hagar* (c.1668). Oil on canvas, 106.5 × 140.3 cm. Collection Alte Pinakothek, Munich. © bpk - Bildagentur für Kunst, Kultur und Geschichte, Berlin / Bayerische Staatsgemäldesammlungen.

affective features of the human scene within. It is one of the tragedies of the human condition to be thus insignificant and tiny in the natural world; and to be insignificant and tiny against the background of our own creations, even when they are crumbling to dust. It is still about the tension between the human content and the grand scale: but here it is about pain and grief and loss, Hagar's downcast look, the isolation of Ishmael. Auden has it right:

> About suffering they were never wrong,
> The old Masters: how well they understood
> Its human position: how it takes place
> While someone else is eating or opening a window or just walking dully along ...[31]

Abraham's absolute rejection of the woman and (his own) child does not merely affect us intellectually. Instead, we feel pity, indignation, fear: and the moral emotions that are provoked are not – as both Plato in the *Republic* and Artaud seem to think – somehow subordinate to reason, but instead integral to it. Claude's painting makes us understand the human condition with full emotional engagement; and that, in itself, matters. So the structure of Claude's painting, by contrast with the careful framing of Quinn's, does not provoke, or directly encourage higher-order reflection. Instead, it provokes first-order deep thought and feeling about the particular exigencies and tragedies that are central to what it is to be human. This kind of understanding is, I think, rejected by Quinn's view; just because that relies on something intellectually far more complex, but emotionally etiolated. The danger here is to think – as Plato invited us to wonder – that the intellect is apart from the emotions and superior to them; and that we can understand our world – whether through art or otherwise – by letting emotion – and its appeal to aesthetic value – pass us by. This may give us cruelty; but it will not give us pity and fear, and will leave the human condition untouched.

9 | Nature, life and spirit

A Hegelian reading of Quinn's vanitas art

Ged Quinn
Hegel's Happy End
(2012)

Alexis Papazoglou

Ged Quinn's painting *Hegel's Happy End* is a nod to the vanitas style of early-seventeenth-century Dutch painting, as the artist explicitly mentions in an interview,[1] but as is also apparent from the group of paintings to which this one belongs. The *Encyclopaedia Britannica* defines a vanitas painting as one that "contains collections of objects symbolic of the inevitability of death and the transience and vanity of earthly pleasures".[2] Vanitas paintings contained mainly still life infused with symbols, part of a code that was well recognized at the time, aiming at reminding us of the temporal character of this life. The main aspect of Quinn's painting is again still life, a fresh bouquet of flowers. The other elements in the painting are a bust of Hegel, an image that looks like the reproduction of a photograph, depicting a woman holding the hand of a boy, and a peculiar molecule-shaped object on a plinth. If we are to follow the code of the vanitas style of painting, these elements are symbols the artist uses to highlight what the painting is about, including, of course, the enigmatic title, *Hegel's Happy End*. However, not all symbols are on an equal footing, and I take it as a clue from the painting's title that Hegel's bust is the main symbol that unlocks the meaning of the rest of the painting.

Art and philosophy

When it comes to interpreting art through philosophy, Hegel is a special case of a philosopher who sees a deep connection between the two practices.[3] Hegel sees art as attempting to express through a different medium, the sensuous and material rather than the conceptual, the same thing that philosophy aims to express: the ultimate understanding of reality and ourselves. Hegel puts this view in different ways in his writings. In the *Phenomenology of Spirit* and in the *Encyclopaedia*, art is seen as a form of *absolute spirit*, whereas, in his lectures on aesthetics,[4] art is identified as the sensuous appearance or showing of the *Idea*.[5] Hegel reserves the term *absolute spirit* for the highest cultural activities that involve reflecting on ourselves and on how we make sense of the world – in other words, *absolute spirit* is *spirit* reflecting on itself. *Spirit* in all its manifestations, Hegel claims, aims for self-knowledge and freedom, but this aim becomes more explicit and is more fully achieved through practices that belong to *absolute spirit*: art, religion and philosophy. Art then, according to Hegel, is an attempt to gain knowledge of ourselves and our place within the world.

But art is also the showing of the *Idea*. For Hegel, reality – the natural world and the human world (*spirit*) – are different manifestations of the *Idea*.[6] That is, they are the ways in which the intelligible, that which can be given an account – an explanation – can be incarnated. Art, then, is also a way in which intelligibility is manifested, namely through sensuous media that are created by humans – beings who are themselves intelligible and who strive to make the world and themselves intelligible to themselves. Hegel's two ways of defining art can of course be brought together: by being a form of *spirit*, art is at the same time a manifestation of the *Idea*.

In what follows, I shall offer a reading of each of the elements of Quinn's painting, as well as of the painting as a whole, against the background of Hegel's philosophy and his idea that art reveals the truths of philosophy through a different medium.

The two perspectives on nature

Still life was the main element in vanitas paintings and so it is with Quinn's piece. Vibrant, colourful flowers take up most of the painting, suggesting what the main topic might be: nature. This assumption, I believe, is supported by one of the other elements in the painting, the peculiar-looking molecule-like shape, as well as by the vanitas genre to which Quinn is alluding: Nature is that which represents earthly, transient things, as opposed to the eternal, immaterial and divine. Hegel might not have applauded this prevalence of nature in the painting. As Robert Pippin puts it, "Hegel's position is that the beauty of nature is not a proper or significant subject for reflection (nature is 'spiritless' and by and large natural beauty simply doesn't matter …)."[7] The reason for nature's not qualifying as a proper subject matter for art is that art, being a manifestation of absolute *spirit*, should, according to Hegel, express the more "spiritual" aspects of reality, namely human reality and human rationality, which in Hegel's philosophy is opposed to nature. That's the reason why Hegel thought that the most beautiful art involved reflection on the human form (which is one of the reasons why he saw ancient Greek art, especially its sculptures, as the highest moment of art's history). However, as I have already mentioned, Hegel also saw art as a sensuous depiction of the *Idea*, and one of the two manifestations of the *Idea* is nature, so nature cannot be an altogether irrelevant topic for art. What is more, as I shall discuss in one of the next sections, the vanitas genre that Quinn chose to make use of can be seen as making a statement akin to that of Hegel's philosophy, namely that nature is indeed something that perishes and is to be left behind so that *spirit* can come forth.

In the beginning of his *Philosophy of Nature*, Hegel claims that we approach nature in two very different ways: from a practical perspective,[8] and from a theoretical perspective. In our practical approach to nature we see it as a means to our ends. We have certain needs as human beings and we see nature as containing elements that can be used to satisfy those needs. Hegel probably has in mind here things like our need for shelter and our need for sustenance. This approach has the characteristic that we see nature not for what it is in itself, but only as what it can be for *us*. Hegel claims that this way of thinking about nature is, however, faulty, for it can lead to an absurd kind of teleological view of nature, according to which

the objective purpose of various natural kinds is to fulfil our needs (e.g. seeing the wool on sheep as existing to provide us with clothing, cork trees as existing to provide us with corks for our wine bottles, etc.).

The flowers in the painting can be seen as signifying this practical approach humans often have towards nature. We use flowers in various social contexts as a means to an end (be it as a way of celebrating birth, congratulating someone on an achievement, offering them as a sign of friendship and affection, as a token of love and respect at someone's funeral, etc.). One might object that these ways of using flowers do not accurately correspond to a use of nature as a means to a specific human end, because, in all these instances, the use of flowers is nowhere near as instrumental as, say, the use of an animal's fur to make clothes from. Flowers are used in these contexts because they are beautiful, and beauty, the objection might continue, is an end in itself.

Even if beauty *is* an end in itself, the uses of flowers mentioned above are still examples of using nature practically, to fulfil certain social ends; any beauty that the flowers might have is put to practical use, it is not appreciated in itself, devoid of any instrumental purposes. Furthermore, Hegel's objection to the practical approach towards nature is that it does not see nature for what it is in itself, but instead projects onto it ends that are not there. It would be a rather implausible suggestion to say that the intrinsic purpose of flowers is to be beautiful. But even aside from whether the intrinsic purpose of flowers as they are found in nature is beauty, the way humans go on to make use of them, cultivate them purposefully, cut them, sell them, buy them and offer them to others, surely could not be their intrinsic purpose. Our practical standpoint towards nature, then, is deficient, according to Hegel, for it distorts nature and makes it into something that it is not.

The theoretical approach to nature, according to Hegel, attempts to overcome the shortcomings of the practical approach, by removing the human subjective standpoint as much as possible. In the theoretical approach to nature, we express a disinterestedness towards nature: we do not see it as a means of satisfying our needs, we are not out to use it and manipulate it but "we stand back from natural objects, leaving them as they are and adjusting ourselves to them".[9] This study of nature starts with sense-perception. However, Hegel quickly points out that sense-perception alone cannot

be enough, for animals can perceive nature too, yet they cannot arrive at knowledge of what nature is. Immediate sense-perception is not enough; it is the possession of thought that allows perceptual observation to lead to knowledge.[10] The problem that arises, however, from subjecting nature to thought, is that we violate the prerequisite of the theoretical approach to nature, namely to let nature speak for itself:

> The more thought enters into our representation of things, the less do they retain their naturalness, their singularity and imme-diacy ... We give them [natural things] the form of something subjective, of something produced by us, and belonging to us in our specifically human character.[11]

Thus, the attempt of the theoretical approach to avoid the subjective stance fails, even if the kind of subjectivity now imposed on nature is very differ-ent, not having to do with the subjective human needs, but with the use of concepts.

Hegel has another complaint about the theoretical approach to nature. According to Hegel the disinterested, non-practical character of the theo-retical approach creates a subject–object divide:

> The theoretical approach begins with the arrest of the appetite, is disinterested, lets things exist and go on just as they are; with this attitude to Nature, we have straight away established a dual-ity of object and subject and their separation, something here and something yonder.[12]

The theoretical approach, then, not only distorts nature but also alienates us from it, according to Hegel. This divide and the way it comes about is analysed and critiqued in more detail in the "Force and Understanding" section of the *Phenomenology of Spirit*. In "Force and Understanding", Hegel assesses the theoretical perspective on nature's ontology that is offered by the natural sciences and in particular the one expounded in Newton's phys-ics, the ontology of forces.

This new perspective on the fundamental ontology of reality creates a divide between nature as it appears to us, as we experience it in everyday

life, and nature as it is described by science. The way in which the two are supposed to be connected, according to this framework, is the following: Nature as it appears to us is to be explained by linking appearances to the underlying, supersensible reality of forces via laws of nature. Individual instances of perceptible phenomena are explained as special cases of laws of nature, the latter being relationships between the universals of nature's forces and matter. For example, the falling of an apple from an apple tree is explained by recourse to the unobservable universals of mass and the force of gravity, as described by Newton's law of gravity. This perspective of reality belongs to what Hegel terms the "understanding" which has a tendency towards ever-increasing abstraction and unity. In the understanding's account of reality as governed by forces this translates into a tendency to formulate laws ever more abstract, and an attempt to unify different forces into fewer and eventually one final and fundamental force. The way that modern theoretical physics has developed, unifying previously disparate forces, and seeing the holy grail of physics as formulating the one, unified "theory of everything" seems an extraordinary vindication of Hegel's insight regarding the aspirations of natural science, and specifically physics.

This tendency towards abstraction, generality and unity, however, creates, according to Hegel, the problem that it becomes increasingly difficult to see the connection between the laws of nature and nature as we experience it. The divide between the world of appearance and the underlying supersensible reality of forces becomes impossible to bridge. Furthermore, the kind of reality that the natural sciences describe is not only removed from that of everyday experience, but seemingly opposed to it to the extent that Hegel calls it an "inverted world".[13]

The physicist Sir Arthur Edington also described this divide between the world as it presents itself to us in everyday experience, and the world as it is revealed to us by science, in terms of opposition and inversion. In a famous example, Edington talked about how the table that he sat down to write at was in fact two tables! The one was the table that he was familiar with since an early age – a plain object, a thing that was solid, extended, stable and relatively permanent. The other table was the one described by science – an opposite to the table of everyday experience. The table as science describes it is mostly empty space, containing tiny particles that are electrically charged, and which are constantly whirling around at incredibly

high speeds. This tension between the everyday conception of reality, on the one hand, and the scientific conception of reality, on the other, is one of the central themes of modern philosophy. In fact, Wilfrid Sellars saw the main task of modern philosophy as the attempt to unify these two disparate images of reality – the manifest image and the scientific image.[14]

Quinn's painting can be seen as highlighting this philosophical theme, the tension between the image of nature as we perceive it and that of nature as it is described by science. This tension is manifest in a tension found within the painting itself. On the one hand, there is the depiction of nature as we experience it in everyday life, represented by the colourful flowers. On the other hand, the painting offers a very different image of nature, represented by the molecule-like shape on the plinth at the bottom left. It is the image of nature as revealed by science: colourless, odourless tiny particles joined together by supersensible forces and void.

The organic unity of life

One element in the painting stands out more than the others: the black and white image of a woman holding a boy's hand. This image seems like an absurd intervention within the painting, both because of its position (it appears at the place where a vase for the flowers would normally be), as well as because of the photographic quality of the image that jars with the tone of the rest of the painting. In the interview in which the artist talks about the painting, he mentions that this image is the reproduction of a still from the 1960 film *Peeping Tom* by Michael Powell.[15] There Quinn highlights the fact that this is "a dead image". Here I should like to investigate what the inclusion of a "dead" image in the painting might mean against Hegel's philosophy.

Powell's film includes a home-movie-type sequence. The image in Quinn's painting is a still from the home-movie sequence, taken by the main character's father, and which the main character projects for one of his neighbours; it is a film within a film. I will not focus here on the content of the image, or what it means within the context of the film. What matters here, I think, is purely formal, that this image is a still from a film, with the further complication that it is a still from within another film. The reason why Quinn says of

the image that it's dead is, I think, because it has been completely removed from its original context and its original function as a frame within a film.[16] The original function of that image – what gave it its meaning – was not only its position in relation to the images that came before it and after it within the original film, but, more importantly, its relation to the film as a whole. A film is like an organic whole in the sense that the function of each part of the film is defined by the purpose of the film as a whole. The organic analogy is modelled on the way an animal's parts relate to its whole: in an animal, the functions of its parts and what makes those parts what they are, can only be defined in relation to the ends of the organism as a whole (e.g. its survival and procreation).[17] Having the home-movie film placed within another film already changes the original function of the image in question, given that the whole to which it belongs changes.[18] However, taken out of its proper medium and depicted in a fragmentary fashion, as a still within a painting, the image seems to lose its proper function entirely, and while it remains an image, it is dead, devoid of life. Following Aristotle, we might say that it is now an image only by name, in the same way that an eye removed from the body, and so no longer fulfilling its proper function – enabling one to see – is no longer an eye, but only an eye by name.[19]

For Hegel, the concept of organic unity was of central significance to his philosophy as a whole, as well as to his philosophy of art. Organic unity was essential, Hegel thought, for a piece of art to be beautiful. As a commentator put it, "the beauty of an artwork … corresponds to its degree of organization or integration. In the ideal case, no elements of an artwork appear arbitrary, unplanned, accidental or irrational".[20] The reason for this is that, as already mentioned, art is supposed to reveal the *Idea*, the ultimate articulation of the nature of thought and reality, through a sensuous medium, and, according to Hegel, the closest concept to that of the *Idea* is the concept of *Life*, the paradigm of organic unity.

Hegel tried to show in the *Logic* that a certain kind of teleological explanation, i.e. an explanation that makes reference to ends rather than simply to efficient causes (events prior in time that can be said to have caused a later event), was the ultimate form of explanation. In particular, Hegel believed that the form of *immanent* or *internal* teleology, a kind of teleology that Aristotle and Kant had highlighted before him, was the highest form of explanation.[21] Hegel applauded Kant's reminder of the immanent form of

teleology (even though he clearly identifies Aristotle with originally forming the concept) and said that "one of Kant's great services to philosophy consists in the distinction he has made between relative or external and internal purposiveness; in the latter he has opened up the Notion of life, the Idea".[22]

Hegel believed that the most fundamental and necessary concepts without which any thought is impossible have a certain dynamic structure that can only be grasped if understood as *Life*; that is, through immanent teleology, a structure whose parts can only really be grasped by reference to the whole, which in turn can only be grasped as being created by its parts. Thought, according to Hegel, is self-generating and self-organizing, just as life is. This dynamic structure of the most fundamental concepts of thought, Hegel agued, is in turn manifested in the way in which reality itself is structured; the *Idea* is "rational thought that fully organises and pervades objective reality",[23] and hence the *Logic* is also a metaphysics, an account of the fundamental structure of reality, rather than simply an account of the conceptual scheme through which human beings necessarily have to think.

Let's return now to the image in question; the image that Quinn describes as a dead image. As mentioned, the image seems disruptive of the unity of the painting as a whole, given its very different quality and style, thus seemingly violating Hegel's condition for qualifying as a beautiful piece of art. At the same time this disruption is executed by violating the organic unity of the film from which this image is taken, thus rendering this reproduction of the still a dead image. However, this disruption functions as a way of *highlighting* the issue of organic unity. It brings the issue of organic unity to our attention, forces us to reflect on it by violating and disrupting it. An image of *life*, a child holding a woman's hand, the paradigmatic case of organic unity, even when used in a way that disrupts the painting's unity as well as that of the film from which the image is taken, can become a reason to reflect on the concept of the organic and its instantiation in nature, thought and art.

Overcoming nature

As already mentioned, the genre of vanitas paintings had as its theme the transience of earthly existence; the inevitable death of everything natural,

and hence the futility of assigning value to and seeking earthly pleasures and recognition, as one day we shall all inevitably perish. This theme of reminding the viewer of the vanity of attributing value to earthly existence was communicated via various objects in the paintings that would function as symbols, sometimes with rather obvious meaning, for example, a human skull, and sometimes with a less transparent significance. Still life was, however, the main element through which the theme of the vanitas painting was communicated, and, in Quinn's painting, the flowers, which take up the most space in the painting, can be seen as playing that central role. The flowers depicted in Quinn's painting might be full of life – vibrant, colourful, still capable of attracting bees and butterflies – yet flowers, even when not cut and put on display, inevitably dry out, shrivel, loose their vibrant colours, their attractive odour – they perish. In the context of the seventeenth-century vanitas painting, the reminder of the finitude of earthly existence might have functioned as a warning against the *sin* of vanity, and as a promise that the truly important life is the one that comes after the death of the body. Hence, the painters may have been reminding the viewers that they should be more invested in the afterlife rather than in this earthly form of existence.

In the context of Hegel's philosophy, the original message of vanitas-style painting would make little sense. For one thing, there is no room in Hegel's philosophy for an immortal, immaterial soul that lives on after the death of the body. However, what I want to suggest is that the message of vanitas art can be translated in Hegel's philosophy as an indication of the transient character of nature in the developmental story of Hegel's philosophy. According to Hegel, nature represents a stage of reality that is to be overcome, or left behind, in order for a higher form of existence – a characteristically human form of life – to come forth: *spirit*. The undertones, as well as the terminology, are of course also Christian in origin, but for Hegel *spirit* is not some immaterial, disembodied state of being, but simply one that organizes itself according to a higher responsiveness to rationality and one that instantiates a higher level of intelligibility. Hegel characterizes this transition from nature to *spirit* as the death of nature, showing the close link with the vanitas theme: "Above this death of Nature, from this dead husk, proceeds a more beautiful Nature, spirit."[24]

Hegel sees nature as a series of stages, each representing different ways in which nature is intelligible (i.e. available to reason and open to

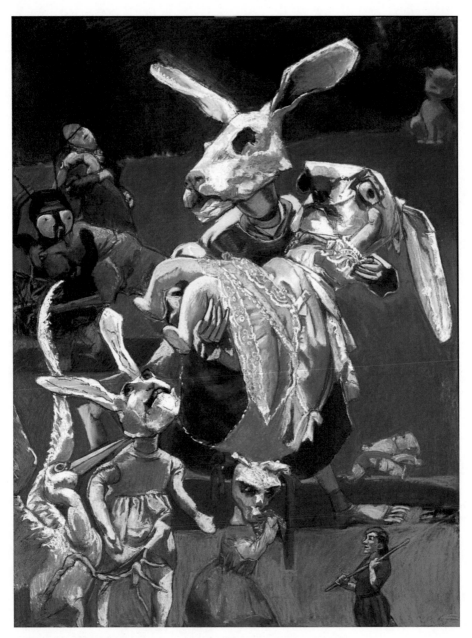

Paula Rego, *War* (2003, pastel on paper on aluminium, 160 × 120 cm).
Image © Paula Rego, courtesy Marlborough Gallery. Tate Collection, London.

John Currin, *The Dane* (2006, oil on canvas, 122 × 81 cm).
Image © John Currin, courtesy Gagosian Gallery.

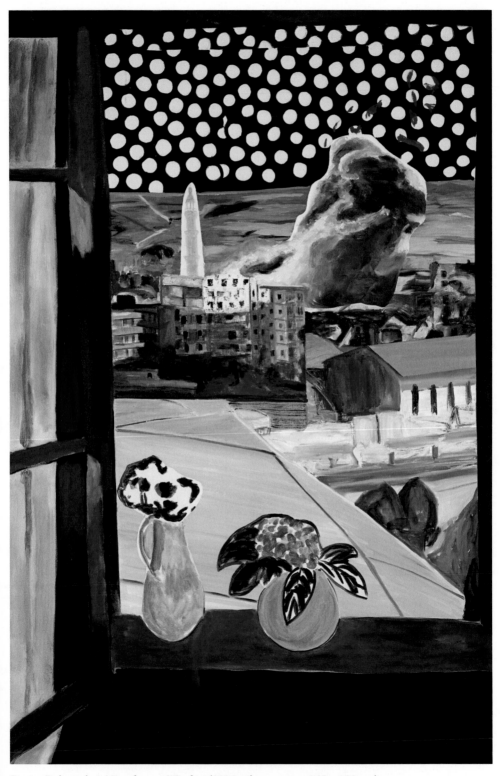

Dexter Dalwood, *A View from a Window* (2006, oil on canvas, 165 × 109 cm).
Image © Dexter Dalwood, courtesy Gagosian Gallery. Photo by Prudence Cumming Associates.

Tom de Freston, *Quartet–Stage One* (2012, oil on canvas, 200 × 150 cm).
Image © Tom de Freston, courtesy Breese Little Gallery. Private Collection.

Tom de Freston, *Quartet–Stage Two* (2012, oil on canvas, 200 × 150 cm).
Image © Tom de Freston, courtesy Breese Little Gallery. Private Collection.

Tom de Freston, *Quartet–Stage Four* (2012, oil on canvas, 200 × 150 cm).
Image © Tom de Freston, courtesy Breese Little Gallery. Private Collection.

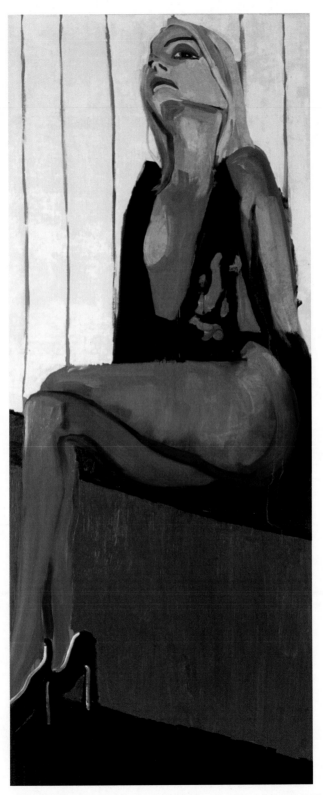

Chantal Joffe, *The Black Camisole* (2004, oil on board, 300 × 120 cm).
Image © Chantal Joffe, courtesy Victoria Miro Gallery.

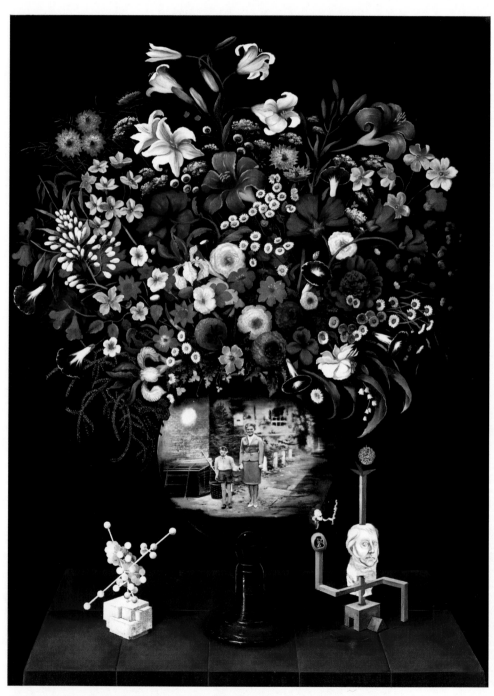

Ged Quinn, *Hegel's Happy End* (2012, oil on linen, 200 × 148 cm).
Image © Ged Quinn, courtesy Ged Quinn and Private Collection, USA.

Dexter Dalwood, *Hendrix's Last Basement*
(2001, oil on canvas, 203.2 × 182.9 cm).
Image © Dexter Dalwood, courtesy Gagosian Gallery. Photo by Dave Morgan.

Dexter Dalwood, *Room 100 Chelsea Hotel* (1999, oil on canvas, 183 × 213 cm).
Image © Dexter Dalwood, courtesy Dexter Dalwood. Photo by Peter White FXP.

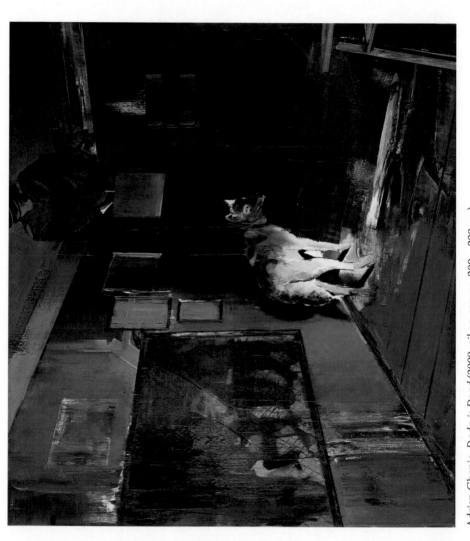

Adrian Ghenie, *Dada is Dead* (2009, oil on canvas, 200 × 220 cm).
Image © Adrian Ghenie, courtesy The Pace Gallery.

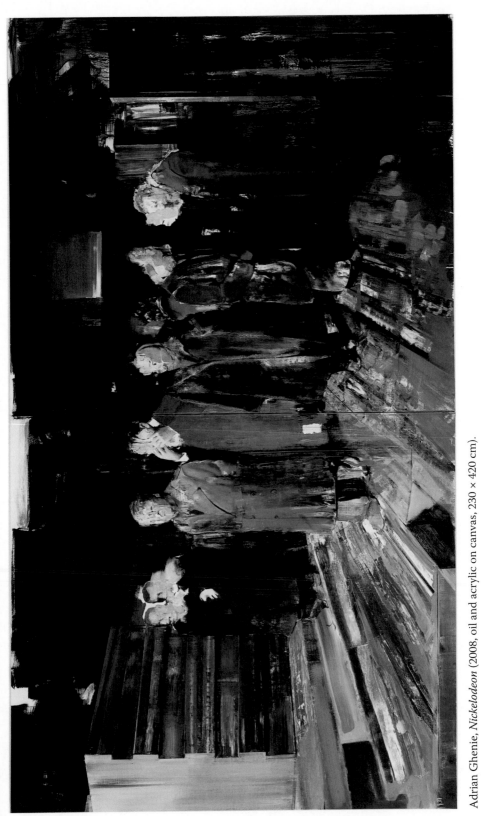

Adrian Ghenie, *Nickelodeon* (2008, oil and acrylic on canvas, 230 × 420 cm).
Image © Adrian Ghenie, courtesy The Pace Gallery.

Paul Noble, *Heaven* (2009, pencil on paper, 114 × 286.5 cm).

Image © Paul Noble, courtesy Gagosian Gallery.

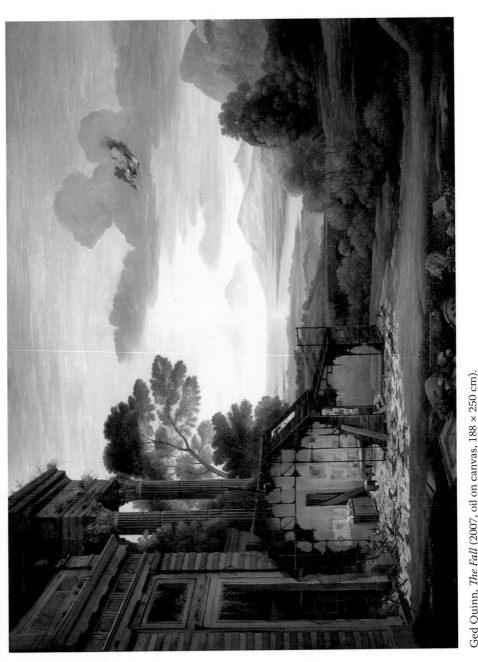

Ged Quinn, *The Fall* (2007, oil on canvas, 188 × 250 cm).

Image © Ged Quinn, courtesy Ged Quinn and Stephen Friedman Gallery.

George Shaw, *This Sporting Life* (2009, Humbrol enamel on board, 43 × 53 cm).
Image © George Shaw, courtesy Wilkinson Gallery. Private Collection.

George Shaw, *No Returns* (2009, Humbrol enamel on board, 147.5 × 198 cm).
Image © George Shaw, courtesy of Wilkinson Gallery. Private Collection, Devon.

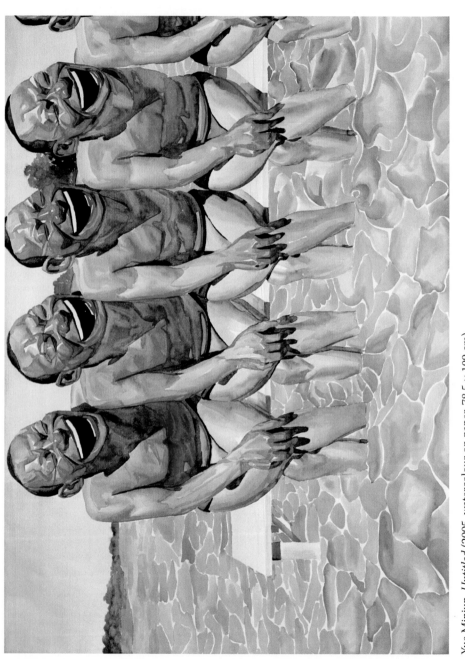

Yue Minjun, *Untitled* (2005, watercolour on paper, 78.5 × 109 cm).
Image © Yue Minjun, courtesy Yue Minjun and Pace Gallery.

explanation); in this sense, Hegel sees nature as rational; as a manifestation of the *Idea*.[25] *Spirit* in Hegel's philosophy represents a new, higher level of reality in which the *Idea* also manifests itself. Just as organic nature is a higher level of the realisation of the *Idea* than mere material nature, *spirit* represents an even higher level of rationality and intelligibility, only this level can no longer be understood as nature.[26]

Spirit represents a human, social form of intelligibility that is structured normatively and rationally in such a way that it can be given an explanation in terms that the natural world is not responsive to. Human thought and action, both at an individual as well as at a collective level, is responsive to what Wilfrid Sellars called the logical space of reasons, that is, we can ask human beings to provide *reasons* for why they think something is true, as well as why they acted in a particular way. This form of intelligibility is social because the practice of asking and offering reasons can only take place and only makes sense within a context where other human agents can recognize something as a reason, can assess whether an explanation offered for why something is believed to be the case, or some action to be appropriate, is indeed a rational explanation or not. Furthermore, *spirit* is a socially embedded form of intelligibility because it is not only manifest in individual human agents, but also structures entire social and political practices and institutions of which we expect a rational organisation, such as, for example, the justice system of a state.

According to Hegel, this form of intelligibility of *spirit* cannot be understood simply as a higher form of natural intelligibility, in the same way that teleology is a higher natural form of intelligibility than mechanism. *Spirit* is a more complete manifestation of the *Idea*, whereas Hegel calls nature the *Idea* in the form of otherness.[27] The reason why Hegel sees nature as an imperfect manifestation of the *Idea*, in comparison with *spirit*, is the fact that *spirit* organizes itself through the medium of thought and reason – the proper home of intelligibility – whereas nature is the expression of intelligibility through the medium of matter, the "other" of thought, as Hegel calls it.

The point of interest here, in relation to the theme of vanitas paintings, is the idea that partaking in the form of intelligibility of *spirit* requires an overcoming of nature, or a leaving behind of nature. In order to organize ourselves and our institutions in accordance with the logical space of

reasons, we must leave behind us the ways in which animal organisms – the most intelligible beings to be found in nature – organize their lives, that is, through an immediate reaction to their senses and desires. Hegel sees *spirit* as a form of liberation from nature:

> Spirit is this movement, this process, this activity of going out of nature and of liberating itself from nature ... The nature of spirit is to be this absolute liveliness, to be this process itself, namely, of proceeding out of its natural origins and natural immediacy, to abandon and suspend these conditions and thus to come to itself, to free itself.[28]

Human beings share with the rest of the animal kingdom the fact that they perceive the world through their senses and that they have desires that motivate their action according to an implicit sense of self-preservation and procreation. However, whereas other animals' existence is all consumed by their senses and their desires, humans are able to step back and organize them according to a sense of self. They can then see their perceptual input and their desires as potential reasons to believe that something is the case, or to act in a particular fashion, given their self-conception as agents.[29] Liberation from nature is achieved, according to Hegel, through acquiring the ability to think, to be responsive to reasons. In the process of acquiring a spiritual side, humans manage to make their sensory input and their desires their own, rather than, say, merely their species's. Desire and sense perception become incorporated into one's sense of self in accordance with one's self-organizing principles – the principles according to which one defines who one is and how one lives out one's life.[30]

This then is one way of reading the theme of vanitas paintings from the point of view of Hegel's philosophy. Just as the vanitas genre was supposed to remind people of the relative unimportance of earthly existence, compared with what might come after it, Hegel's philosophy shows us that nature is not everything there is to reality and that something of higher significance, of higher rationality comes after it. Nature is something lacking, an imperfect manifestation of the *Idea*, something that can never be responsive to rational argument in the way human beings can be. Nature, in Hegel's philosophy, has to perish, or be overcome, in order to give rise

to something that is more rational – a more perfect incarnation of the *Idea – spirit*.

Spirit's happy end

An interpretation of a painting that ignores its title cannot but fall short of being complete. What exactly is Hegel's happy end supposed to refer to, and how does it relate to the painting? When talking about the painting, Ged Quinn says that it contains many absurd, as well as violent, elements. One way in which we can understand absurdity is through contradiction, or incompatibility. When Quinn is referring to the absurd elements of his painting, he is, I think, referring to the fact that, at least prima facie, there appears to be a tension between the various elements: there is no obvious way in which they relate to each other to make up the unity that is the painting. Quinn also refers to the molecule-like shape in the painting as absurd, both, I think, because it is unclear what it's doing there (because it seems like another intervention that jars with the rest of the painting), as well as because it is unclear whether such a molecule is possible (i.e. whether atoms can really be organized in this fashion).

Regarding the violent aspects of the painting, Quinn seems to be referring to the still image from the film *Peeping Tom*. Even though it is perhaps too demanding to have to know and rely on the content of the film from which the still depicted in the painting was taken, in order to be able to interpret the painting, it seems that Quinn did not pick the image at random.[31] The film in which this image appears is indeed a rather violent film, in which the central character is a man who films the expressions of terror in women's faces as he murders them. The image in the painting is a still from a home-video-like film that the man projects for one of his potential victims, a film taken by his father, and which depicts the man as a child with his stepmother, just a few weeks after his mother had died. The stepmother is "her successor" comments the man in the film. The circumstances of his mother's death remain unclear, but, given the context of the film, murder is what comes to mind. Quinn also talks of "the violence of the process of modernism" as a theme that relates to his painting, possibly in relation to the molecule as a representation of the scientific revolution.[32]

Contradiction, sometimes in the form of absurdity,[33] as well as violence, are themes prominent in Hegel's *Phenomenology of Spirit*. According to one reading, in that book Hegel gives an exposition of different forms of consciousness, or forms of life, that are shaped by particular normative claims regarding what knowledge is, what constitutes a good reason to judge that something is true, what constitutes a good reason to act, and so on.[34] Hegel shows in the *Phenomenology* that forms of life are often in contradiction with themselves (e.g. by making claims that are inconsistent with each other). When a shape of consciousness, or a form of life, is in contradiction with itself, it has to be overcome and replaced by a new form of consciousness free of the previous contradiction, a process that can sometimes be a violent affair.

One of the best examples of a form of life in contradiction with itself (and the violence that may come of it) that Hegel discusses in the *Phenomenology* involves a commentary on Sophocles' tragedy *Antigone*. The story goes as follows: both of Antigone's brothers have died in battle, in a civil war scenario, fighting for the throne. Creon, the new king of Thebes, decides that the one brother, Eteocles, is to be buried with great military honours, whereas the other brother, Polynices, is to be left unburied as a sign of ultimate disrespect. In addition Creon publicly legislates against Polynices' burial, with death being the punishment for those who disobey. In the context of Sophocles' tragedy, this can appear as simply being a difficult situation that individuals find themselves in: Antigone finds herself in a tight spot given that, by tradition and the law of the gods, it is her role as a woman to take care of her family's private matters, including, importantly, the burial ceremony of relatives. However, if she follows her duty as a woman towards her family, she will be breaking the law of the public sphere as set by Creon and face the death penalty. Unable to bear the disgrace of her brother being left unburied, she decides to act against Creon, justifying her actions as being in accordance to the divine law. Creon then is also put in a difficult position after he discovers that Antigone has attempted to bury Polynices, as Antigone is herself a noble and engaged to Creon's son. The way Hegel reads the play, however, is not as the clash of individual wills, nor even as the clash of one individual, Antigone, against the harsh authority of the ruler, Creon.[35] Hegel suggests that what Sophocles' play exposes is a cultural contradiction within ancient

Greece. The play, according to Hegel, shows the incompatibility between the two spheres of Greek life: on the one hand, the private sphere, which was structured in accordance with divine law and was the responsibility of women, and, on the other hand, the public sphere, which operated according to the law of the state and was the responsibility of men. When the two domains of ancient Greece's form of life came into conflict, there could be no other immediate resolution but bloodshed (in the play, Creon interprets Antigone's act as self-righteous and follows through with his order, resulting in the death of Antigone, as well as, in a dramatic turn of events, of Creon's son and Creon's wife).

Hegel sees this central tension in the Greek world, between the private sphere of women and the public sphere of men, as ultimately leading to the demise of the Greek form of life. This "shattering" of the Greek *polis* under the weight of its own internal contradictions leads to a new form of life: that of the Roman world. The details of this transition are not important here. What is important is that Hegel sees history as progressing in this fashion, resolving contradictions by replacing old, contradictory forms of life with new ones. Retrospectively, this process can be seen, Hegel claims, as *spirit* reflecting on the norms that shape a form of life and rationally resolving any contradictions, with the ultimate aim of arriving at a point in history where *spirit* is at peace with itself, when no contradictions remain.[36]

This, then, can be one way in which we understand *Hegel's Happy End*, as the end of history, as the point in time where *spirit* has solved the problem of finding ways of organizing social and political life in such a way that no contradictions are involved, and in such a way that *spirit* is at home with itself; able, if pressed, to offer reasons for why it is rational and not absurd or contradictory that our social and political life is shaped in the way that it is.[37] This project of attempting to reach a form of life that is not shaped by arbitrary authority, but one that stands to rational scrutiny, enabling its occupants to be free in the sense that they can shape their lives according to rational principles, can be seen as the long and never ending project of modernism, that Quinn refers to in his interview. Thinking back to the previous section, this project of modernism involved, among other things, the overcoming of nature in the sense of overcoming its authority over the human domain. This attempt to overcome nature's authority took place in two stages. The first stage was the scientific revolution, by coming

to see nature as disenchanted, as a domain that could be fully explained by using the appropriate methods, containing no opaque meaning that humans should be responsive to. The second stage involved trying to figure out how human autonomy was possible within a disenchanted, physical universe determined by mechanical laws. Hegel's philosophy of nature, as well as his account of *spirit* as the process of overcoming of nature, can be seen as responses to both of these aspects of modernism.

When first encountering Quinn's painting, it can strike us as absurd and contradictory. The painting's individual elements seem to be in tension with each other. As the artist himself admits, "the images are intended to collide".[38] However, the theme of the painting is not contradiction. As I have tried to show in the above sections, through the key element of the image, the reference to Hegel's philosophy, and the promise of a happy end, as well as by reflecting on the genre of painting that Quinn makes use of, we can begin to see the elements of the image as coming together to form a unity that is intelligible, even if the narrative is not entirely linear, as Quinn himself admits. Quinn's picture, as a reworking of the vanitas style of painting, is a reflection on nature, and its transient character, as well as of what supersedes nature. Quinn's painting presents us with the two images of nature: the one that we can immediately relate to – flowers – as well as the one that seems alien and divorced from our experience – molecules. Quinn also reminds us of the organic unity of nature and its fragility, by showing us its opposite: a dead image whose life has been sucked out, having been removed from its original organic whole, and thus having lost its proper function. Nature, then, is something that can die, but, according to Hegel, its death is not something to be mourned but celebrated. The death of nature allows *spirit* to appear on the scene, with its aim of a happy end: self-knowledge and freedom, not least from nature.

10 | Of war and madness

Paula Rego
War
(2003) | *Noël Carroll*

War, what is it good for?
Absolutely nothing!

> (From "War", a song composed
> by Norman Whitfield and Barrett Strong)

As its title broadcasts, *War* by Paula Rego annotates one of the most endur-
ing human experiences. However, her treatment of war is anything but
celebratory. Whereas paintings like *Bonaparte at Arcole* (by Antoine-Jean
Gros) and *The First Consul Crossing the Alps* (by Jacques-Louis David) glo-
rify martial heroics, Rego's *War* is horrific. Eschewing the idealizations of
Gros and David, Rego portrays war as nightmarish and disgusting.

To this end, Rego employs a number of strategies. The first to catch my
eye was allusion. The most visually prominent item in the image is what
appears to be the bleached head of a donkey, or, perhaps better, a donkey-
man (or woman). The donkey-head (with smoke unaccountably issuing
from its hollowed eye-sockets) compels attention for a number of reasons,
apart from its oddness. It is the largest head in the picture; it is white on
a dark field; it lies on the horizontal edge of the highest segment of the

picture's golden section, parallel to the horizon line on the upper third of the image. If there were a vanishing point in the picture, the donkey-head would mark it. It irresistibly draws us to it. Moreover, this signals Rego's attitude towards war by way of alluding to the donkeys in Francisco Goya's *Los Caprichos*, notably plates 37–42.[1]

Los Caprichos was a vehicle for Goya to express his criticism, often satirically, of aspects of Spanish society, such as the clergy. Goya attempted to insulate his criticism from persecution by presenting his etchings as the products of irrational or disturbed mental states – caprices, or, as we might say, ravings.

Originally, the volume was to open with its perhaps best known plate: *The Sleep of Reason Produces Monsters*. These monsters include the donkey-men to whom Rego alludes. But the published version of the volume does not begin this way; instead there is a self-portrait of Goya. Nevertheless, by initiating the text in this way, Goya still suggests that what follows is merely idiosyncratic to him and, for that reason, it should not alarm the censors.

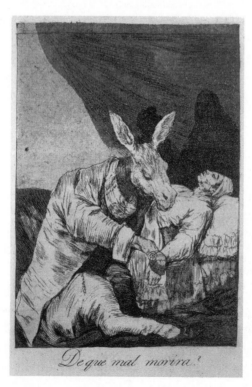

Figure 10.1 Francisco Goya, *Of What Ill Will He Die?* (*c*.1797). Aquatint with etching, 21.7 × 15 cm. Plate 40 of *Los Caprichos*, Private Collection / Index / Bridgeman Imanges.

Goya's donkey-men frequently seem to represent the aristocracy. In plate 39 (*And So Was His Grandfather*), Goya makes fun of their mindless preoccupation with genealogies. He also excoriates their taste by showing their uninformed admiration for music and paintings by monkeys. The etching by Goya that thematically most recalls Rego's picture for me is plate 40: *Of What Ill Will He Die?*

This image shows a clothed donkey, identified as a doctor, ministering to a patient. Rego's donkey also appears to have a patient – a wounded rabbit, her face bruised and bleeding while she wears a dishevelled wedding dress. The caption accompanying Goya's etching indicates that his donkey-doctor is a quack. Indeed, by means of his bestiary of asses, Goya subversively identifies the Spanish ruling class as an empty-headed, self-deceived, asinine crew of nitwits. Thus by enlisting Goya's imagery allusively, Rego similarly indicts the rulers who lead us into war. As doctors of society, they are more likely to kill the patient than they are apt to save her.

Of course, Rego need not fear censorship in the way that Goya had to. Rather she alludes to Goya rhetorically in order to symbolically flag her sceptical stance towards the powers-that-be. Moreover, she not only appropriates Goya's thematic content (from *Los Caprichos* and, interestingly also from his other great series of etchings, *The Disasters of War*); she appropriates some of the visual strategies of *Los Caprichos* as well. Probably the most obvious is the oneiric texture of the imagery.

Goya, of course, is quite explicit about his adoption of the dream frame. In fact, he not only suggests that his imagery represents dreams; they are representations of nightmares – they are the monsters produced by the sleep of reason. Goya recruited this dream conceit not simply to avoid the wrath of the Inquisition, but also to stigmatize the pertinent aspects of his society as irrational – as bad dreams.

Rego not only levels a comparable charge of nightmarishness at war (and at warlords), but in addition the very structures of her images are oneiric, recalling the iconography of anxiety dreams.

What I have in mind here, especially, is what Freud called condensation – composite figures combining features from disparate categories.[2] Throughout *War*, Rego proliferates strange amalgams of humans and animals. In the lower left-hand corner of the picture, there is an image of a creature – part rabbit, part primate – about to be stabbed in the neck by a

stork. Next to him there is what appears to be a bulldog in a long red party dress. Of course, the aforesaid donkey-man is also an arresting example of a composite: part animal, part human (or, at least, part vertebrate) and part robot – notice its metallic neck, hands and feet. His ward – the bleeding rabbit-bride is likewise part human and part hare, albeit of a rather fantastical sort, given its large scale (she is a very big bunny).

This use of condensation, of course, is also precedented in *Los Caprichos*, where the composite figures, including the donkeys, abound. They are monsters called forth by sleep, or, as Freud would have it, they are productions of the dreamwork.

Moreover, other symbolic mechanisms of the dreamwork are also in operation, notably literalization which both Goya and Rego employ to disparage the ruling class by rendering them visually as asses.

The presence of these psychic mechanisms as structuring devices in *War* – as in many surrealist works – encourage us to regard Rego's picture as, on the whole, oneiric – indeed, as a nightmare, given chaotic crowding of the image and the amount of blood that is flowing in the picture which, in consequence, suffuses the imagery with a mood of menace.

Therefore, speaking very loosely, if we suppose that the title *War* gives us the subject of the picture and the picture itself represents a nightmare, then it is suggestive to interpret the work as an expression of the metaphor that "war is a nightmare". This, furthermore, is borne out by the other distorted (or at least strange) imagery: the dog beset by the giant insect, the bespectacled gentleman with the mottled, greenish bird (?) slung over his shoulder, the infant in red trunks who is twisted or flattened out of shape as well as the congestion of the image, so reminiscent of Hell as conceived of by Bosch.

Scanning *War*, there are only two naturalistically "normal" figures – the woman in brown on the lower right corner of the picture (who is perhaps some sort of soldier, shouldering a stick like a weapon), and the tabby cat in the upper right corner, who, if truth be told, looks more like cartoon-Kitty than a realistically drawn one. Like most of the rest of the population of *War*, this cat is emphatically symbolic.

With respect to the woman, in particular, there is an explicit contrast in the picture between the naturalistically rendered and the un-naturally rendered creatures, such as the many composites which mix elements of

different categories – including animal, human and robot – that violate the conceptual mappings we standardly use to organize experience. The oxymoronic bulldog in the red dress is a visual category mistake – its upright posture, a biological anomaly. Because of such imagery, we are perhaps inclined to describe the content of the picture as "unnatural", yielding yet another metaphor, namely: "War is unnatural".

The hybrid, mixed, composite cast of the imagery, along with the crude modelling of the figures, the brutal, sometimes blurry colour contrasts, and the splotchy application of the pastels present the work intentionally as a mess, both pictorially and ontologically. *War* is the very antithesis of any ideal of purity. It advertises its impurity across multiple dimensions. It is meant to discomfit and disgust the viewer. Its violations of standing conceptual categories in particular are designed to unnerve and to disturb – to get under our skin.

Roughly speaking, there are at least four, not mutually exclusive, artistic modes for provoking disgust:[3]

1. Where the content of the work – what the painting is about – is literally disgusting. For example, Thomas Hirschhorn's *Touching Reality* is a video of a hand scrolling through images of conflict – bodies gruesomely broken in a relentless montage. The effect can be actually nauseating. The rhetorical function, here, is to induce a visceral reaction to violence. Of course, literally disgusting content need not have an ulterior motive. Many horror fictions explore disgust for its own sake.

2. Where the real content of the work is characterized figuratively as disgusting. *Vanitas* paintings juxtapose images of the pleasures of the flesh – such as the joys of the table – with skulls, thereby figuratively associating disgust with mortal delights as a way of warning us against their seductions. Or, for a more recent example, consider Paul McCarthy's installation *WS*, which characterizes the world of Walt Disney, represented by Snow White, the Seven Dwarfs and Walt as engaged in every sort of sexual perversion, addiction and orgiastic revels, including bouts of sadistic mayhem, even unto murder. Characters defecate, masturbate, copulate, vomit and so on frequently and fulsomely in order to register McCarthy's disgust and denunciation of America as Disneyland.

3. Where the style or form of the work itself is literally disgusting. For example, Lennie Lee's 1990 performances involving faeces, blood and vomit for the purpose of exploring the themes of abjection and taboo experientially, that is, by evoking their associated sensations for their own sake.

4. Where the style or form of the work functions to characterize the content of the work negatively. For example, the use of distortion in the caricatures of George Grosz, where the imperfection and impurity is intended to portray the plutocrats in the image as disgusting.

Rego's *War* clearly exploits the second and fourth modes of engendering disgust. Both in the content of her composite and otherwise oneiric images and in the intentionally harsh primitivism and the deliberate clutteredness of her compositional style, the array is predicated on eliciting an "Ugh" response. In a manner of speaking, she has melded the category violations of the Surrealists with the contorted, figural distortions of the German expressionists, marshalling form and content in order to provoke a visceral reaction of disgust. But this response is not engaged for its own sake. It is evoked in order to be transferred to the explicit subject of the work: war.

Although we often think of disgust purely in subjective or experiential terms, it is also important to remember that it has an intersubjective dimension as a means of signalling dangers, such as the existence of disease producing elements in the environment like poisons, parasites and pathogens. In this regard, we can interpret Rego's work as dramatically warning us of one of the most dangerous plagues known to humanity – once again, war.

11 | Showing us how it is

George Shaw
This Sporting Life
(2009) | *Simon Blackburn*

Science deals exclusively with things as they are in themselves; and art exclusively with things as they affect the human senses and human soul. Her work is to portray the appearances of things, and to deepen the natural impressions which they produce upon living creatures. The work of science is to substitute facts for appearances, and demonstrations for impressions. Both, observe, are equally concerned with truth; the one with truth of aspect, the other with truth of essence. Art does not represent things falsely, but truly as they appear to mankind. Science studies the relations of things to each other: but art studies only their relations to man.

(John Ruskin, *Stones of Venice*)[1]

I shall introduce my reaction to Shaw's *This Sporting Life* by explaining why I chose to talk about it. For me, painting that says that "this is how it is" means much more than painting which rests with "this is how I am". The usual labels for the contrast are realism versus expressionism. But the labels conceal more than they reveal. George Shaw's painting would be

put on the realism side of this divide, yet it certainly expresses a great deal: There is an artistic imagination and its feeling is far from absent; indeed it infuses the whole work. But we only know the feeling via its object, the topic of industrial decline.

For those of us who are not painters, the normal response to a work does not start with what we might call the painterly eye: an eye that reads colour, pattern, form and texture, but nothing else. These may make up the intrinsic properties of the painting. But if our aesthetics confined itself to them, it would become arbitrary and potentially inadmissible in a critical context to insist that the painting actually depicts a house or a human being, a frown or a smile.

This arbitrariness was, I think, the defining boast of abstract expressionism. Here there is only paint, and no topic. But actually the agent substitutes for a topic so the message is unfortunately apt to be: me, me, me. This is how I – by implication, I the genius, the person whose work you are to admire and to whom you have to listen – am. The artist displays his soul for our admiration, all too often on a bombastic scale: laugh if you dare. But since there is no visual language or discipline, such as is necessary to depict any kind of aspect of the world, and since, for that matter, the artist's soul is nothing that can be manifested only in abstract pattern and colour (it needs a richer indication of thought to reveal itself), there is nothing steering our imagination either. It is as if the painter comes to the Parthenon, and can think of nothing to do or say but to scratch "I was here" on it; he or she looks at the world and can think of nothing to say, and we in turn, entering into this imaginative emptiness, find nothing to say either.

Of course, I exaggerate a little: plenty of critics have found things to say about abstract expressionist works. But in my experience these are often guided, as Tom Wolfe perceptively noted in his great polemic *The Painted Word*,[2] by the commentary, rather than the actual painting, of the perpetrator. And I do not remember that they have ever enabled me to look any more intelligently or pleasurably at the paintings themselves. If anything, they provide a distraction, possibly not unwelcome, from the fundamentally uncontrolled exercise of doing so. In saying this I am not talking about my no doubt deficient painterly eye: certainly, patterns and textures and colours are interesting enough, and can even be beautiful. But if, after that, interpretation has no foothold, then nothing can count as engagement with

the work, as opposed to a chronicle of its parts. No doubt certain aspects of an abstract work can suggest a mood: sombre paints suggest sadness; bright fizzy patterns suggest excitement, and so on. But as the work itself gives us no inkling what the artist might have been sad or excited about, his or her moods are of little interest. I say moods, since emotions need intentional objects, but providing those would take us back to figurative art.

Music might provide a counterexample to this claim. But here too it is surely easier to detect one-word moods – excitement, melancholy, contentment, and so on – than emotions, unless, of course, the words of songs, or accompanying titles or programme notes, tell us what we are to regard as the objects of the work. I am fortified in saying this by a wonderful recent essay by philosopher and musician Robert Kraut, who builds on the ideas of expressivism, as it has played out in metathetics in recent philosophy, to suggest that, strictly speaking, works of music have no expressive properties: in writing about what the work expresses, the critic can only be issuing invitations to see it one way or another; not descriptions of what is there, anyway:

> Critics have their agendas: their preferences for how best to experience a work, and how best to think about it. And we are free, given our own agendas, to not embark upon the perceptual experiences to which the critic invites us. But that's not a matter of failing to see expressive properties that are somehow present in the work or performance, because there are none. It is rather a matter of our preferring different travel routes.[3]

I think this is absolutely right, although with figurative painting, I shall suggest, there is less indeterminacy in which routes are valuable to travel than there is in more open cases, including instrumental music and abstract art. With figurative painting we are given an aspect of the world, and may be given it in a way that more or less compels a particular kind of emotional response.

As Ruskin puts it, then, there are truths of aspect: of how things struck the artist, or how they strike us. Other writers than Ruskin have tried to delineate the difference between art and science, or art on the one hand and science or history, alethic, truth-seeking disciplines on the other.

Following Benedetto Croce, Collingwood at one point held that art purported only to show us possibilities, whereas the ambition of history is to confine itself to the actual. Art, on this account, does not even get as far as Ruskin allowed, since giving us possibilities, including possibilities concerning how something might strike some people, must fall short of a true account of how something actually strikes us. Elsewhere, Collingwood substitutes the rather different idea that art gives us intuition rather than cognition, and so "knows nothing of any distinction between the real and the imaginary".[4]

This cannot be right, although there may be a grain of truth in the offing. Art can give us a scene, but how we then interpret it may seem open enough to suggest the distinction between intuition and cognition. Open enough, but this is not yet to say wide open. Perhaps some postmodernists and some formalists have thought otherwise, in effect suggesting that any painting or any text, whatever they apparently represent, is as open to indeterminacy of interpretation as music or abstract art. The intrinsic properties of syntax in the case of a text, or those of colour, form and so on in the case of a painting, provide the only stable facts; the rest is interpretation, and indefinitely contestable, or even beyond rational debate at all.

The distinguished critic Stanley Fish was at one time apt to defend something like this.[5] Yet of course it would seem not only perverse but flatly wrong to interpret, say, Géricault's *The Raft of the Medusa* as showing anything other than a number of human beings desperate for rescue in a situation of horror and great distress, and the skill of the painterly imagination was to bring out and express the horror and the drama. The painterly eye leaves out all this in its fixation on the canvas itself. But to the ordinary viewer, while it is certainly salutary to try to adopt the painterly eye once in a while, this is not where appreciation and response start. Just as, walking down the street, most of us do not see patterns of light and uninterpreted shapes, but only human beings and pavements and lampposts; so, confronted with the Géricault, we start with the perception of human beings at sea on a raft. And it is then important to our appreciation that Géricault got a lot about them right. He himself was certainly not unconcerned about truth: he interviewed survivors of the actual shipwreck; constructed a scale model of the raft, and visited the Paris morgue to maximize

the verisimilitude of his depiction of the corpses strewed around. Other aspects of the painting, such as the precise layout of the living and the dead are, of course, imaginary, or if not they might as well be, since their business is entirely different. It is to stimulate the imagination of the viewer to rise to the "indescribable" horror of the situation.

Or so it seems to us. But are we merely standing on "the authority of the interpretive community" as Fish has it? This brings us to one of Croce's sayings that was also much appreciated by Collingwood: all history is history of the present. This takes a little explanation. First, we have the distinction between a history and what Collingwood called a chronicle. A chronicle corresponds to the painterly eye: it sees only the pixels of history. But it is only in so far as the historian is concerned with past thought that he or she is an historian at all, rather than a mere registrar of events in their "external" aspects. The events that interest the historian are the doings of human beings, individually and collectively. To give the "internal" aspect of these events is to interpret the minds of the people involved in them: their beliefs, intentions, hopes, and so on. But, second, to perform this interpretation, historians must, famously, re-enact those thinkings, and must throw themselves, as far as possible, into the minds of the original agents. However, it is here that the present intrudes, since there are unfortunately huge obstacles to doing this. Time has wrought its changes. We think differently; we deploy new categories, we know more or different things, and have forgotten others. We sail on different odysseys, and displacing ourselves is never more than partially successful. Pessimism on this front rapidly leads to Croce's idealism. Reading history tells us about the minds of historians, if they are contemporary, and not even that if they themselves have been swallowed up by time, for then we will again betray them, reading them with twenty-first-century eyes. We cannot escape the here and now: in our words or our paintings or music, we can only display our own minds, and history can be nothing but what is in our minds in our own time.

Fortunately there is something wrong about this train of thought as well, since its terminus is going to be cognitive solipsism: the individual's inability to understand anyone else. It is extremely hard to weigh whatever grain of truth it contains. But for the purpose of this essay, I only want to suggest that the grain weighs much more heavily when the writer is not

an historian but a critic. It is not a hyperbolic scepticism that leads one to think that most art critics – Ruskin is no exception – tell us more about themselves than about what they purport to describe. If Ruskin is right about art, art critics share their plight with artists themselves: each give us the aspect of things that strikes them as salient. Each issues an invitation, trying to share that salience: to mould the imagination of the viewer in the one case, and the reader in the other, into whatever conformity with the artist or critic's own mind survives Croce's descent into idealism or solipsism. But each confronts the pathos of distance in trying to do so.

After this philosophical preamble, I am perhaps less nervous about trying to say something about George Shaw's painting. A failure would be a failure to issue an attractive invitation, or to express how it strikes me, rather than a failure of less personal truth. Other viewers may get more or different things from it, and I shall even suggest at the end that maybe the artist would be surprised or even disappointed or annoyed at what I make of it. But here goes.

The painting strikes me most immediately as a riposte to Lowry, whose basically cheerful depictions of street life in the industrial north of England bring to mind an innocent, busy, bustling age. Lowry did for that time and place something of what Pieter Breughel the Elder did for the sixteenth-century Netherlands. In *This Sporting Life*, by contrast, nothing is cheerful or busy. Under the leaden sky the scene is bleak and desolate. The vandalized goal post speaks of decline: the throngs of children or sportsmen have departed, and it is not even worth repairing their facilities. Looking closer there are additional, almost surrealist indications of unease, or threat. The disproportionate, brooding conifers seem to belong neither to the park nor to the houses, but are fenced off in enforced isolation, as if they had arrived by accident. The little row of garages seems incongruous, scarcely connected with the world by any road, since little more than a path lies between the aggressively hedged off gardens of the street. The houses that face us on right and left barely peer over the barriers between them and the viewer; their windows suggesting a malevolent, brooding gaze that matches the sombre flat sky. Time has stopped here. The chimneys no longer smoke. Life has come to a halt, or, perhaps, it is on a wintry hold, and any spring is still far away. In showing us how it is, the painting also opens our imaginations to how it once was, and challenges us to be content with the society

we are; a society that allows or engineers the desolation it shows. Or so I invite you to think.

I was brought up in the industrial north-east of Britain, now an area of closed shipyards, abandoned coal mines, and high unemployment. George Shaw was brought up on the Tile Hill estate in the Midlands city of Coventry, but the scene that he gives us could belong to any of a dozen towns I knew well: Sunderland, Middlesbrough, Hartlepool, Newcastle… It speaks of the ugly council estates that ring such towns. It speaks of decline and of demoralization; of the absence of play or games or sports; of now empty playing-fields; and, above all, of the hopeless acquiescence in casual vandalism, symbolized by the unrepaired goal post. Or at least, this is what Shaw has so effectively expressed. I believe that he himself has a rather more positive view of the landscape he constantly returns to painting: he actually liked Tile Hill. But the artist and his works are two different things.

Living not far from this kind of scene as a child, I knew more of the potential warmth, the attachments to village and town, and the neighbourliness that made up for material deprivation. Back in the 1950s and 1960s, there was a strong sense of community animating many of those living in these places, and a fierce local pride, often expressed by fanatical attachment to the local football team. This sense of rooted social identity was celebrated, half enviously, and somewhat romantically, by commentators like Raymond Williams, Richard Hoggart or F. R. Leavis himself. Their working men and women were literate, articulate, gregarious and politically conscious. Neither these commentators nor the people they depicted would have been satisfied with Shaw's vision, although Hoggart, for one, might not have been surprised that it would come about, since his work is partly a lament for what the age of the mass media would do to old working class communities and values. But to many people on those estates at that time, the painting would not have represented how their lives felt. So the bleakness of Shaw's painting is politically engaged. It speaks of the ineluctable decline of old industrial Britain. It speaks of what once was, and is now gone.

Just as there is diminishing marginal utility of money, so, in conservative thinking, there is diminishing marginal disutility of poverty. Just as being rich increases your well-being, but being richer does not increase it at so great a rate, so, in this ideology, being poor diminishes your well-being,

but being poorer does not diminish it at the same rate either. The relevant curve would be S-shaped. So, when Mrs Thatcher destroyed the communities admired by Williams, Hoggart or Leavis, by destroying the livelihood of most people in the north of England, one of her Ministers, Norman Tebbit, suggested as a remedy for unemployment that those affected should "get on their bikes", or, in other words, pedal away from their homes to the south, where there might be unskilled jobs, perhaps as servants or gardeners. He probably did not think of himself as particularly callous. For nobody, surely, could retain any affection for homes such as those? Yet recently, in the summer of 2013, there was a furore when a Conservative peer, Lord Howell, an adviser to the government on energy – uncle, indeed, of the Old Etonian in charge of the economy of the country, the Chancellor of the Exchequer – put forward a policy recommendation in connection with the controversial technique of fracking for shale gas:

> "There are obviously, in beautiful rural areas, worries not just about the drilling and the fracking, which I think are exaggerated, but about the trucks, the delivery and the roads and the disturbance", Lord Howell said. "And those are quite justified worries.
>
> "But there are large uninhabited and desolate areas, certainly up in the North East where there's plenty of room for fracking well away from anyone's residence where it can be conducted without any kind of threat to the rural environment."[6]

I was pleasantly surprised at the hostile reaction this generated, since Conservatives in Britain, like Republicans in the United States, are quite unabashed about their well-known attachment to the Gospel according to Mark 4:25 – "For he that hath, to him shall be given; and from he that hath not, shall be taken even that which he hath." The residents of Shaw's estate do not, like Lord Howell, live in beautiful rural areas. And thus, to Lord Howell and his tribe, many in the northeast might be supposed too brutish, too diminished, too demoralized, to care if even their neighbouring playing fields or surrounding countryside are wrecked more than they already are. A bit more impoverishment doesn't really make life *that* much worse for those up there, whereas for *us*, down here, it would be catastrophic.

This is the diminishing marginal disutility of poverty. To the unsympathetic southerner, the blight that hangs over such areas, and which Shaw so effectively conjures up, actually justifies Lord Howell. To be fair, the noble lord later retracted his remark, by explaining that when he said northeast he had meant to say northwest. Unfortunately, the northwest of each of England, Wales and Scotland contains some of the country's most beautiful rural areas, so this insincere bid for redemption merely shot a hole in his other foot.

Jean-Jacques Rousseau liked to quote Virgil's *Aeneid*: "not unacquainted with misfortune, I learn to help those who are miserable".[7] Rousseau said, "I know nothing so fine, so full of meaning, so touching, so true, as these words."[8] But what he really believed to be so significant was the converse, that when we are unacquainted with misfortune, we do not care about helping those who suffer it. The king in his palace, the banker in his gated community, or the Etonian in the Treasury, is in a different mental world from the unemployed, the sick, the old, the lost. His imagination cannot stretch so far: the exercise of decentring himself and recreating for himself the thoughts and feelings, despairs and desolations of those in such a different sphere does not work.

It is just here that the artist's jolt to our imagination can in principle improve us. But there are many forces in its way. Those who are *ignara mali* do not want their consciousness raised. The millionaire only compares himself with his more fortunate and richer colleagues, so that vanity and envy fill the place that might have been given over to compassion or imagination. Inequality in Britain, as in the United States, has increased at a startling rate over the last thirty years or so, and what are brutally called "sink estates" are one symptom of it.

There is an irony already in the title of Shaw's painting. *This Sporting Life* was a gritty film about a sporting hero whose brutal exploits on the field contrasted sharply with his catastrophic personal failings off it. In Shaw's painting there is no sporting success. Perhaps there once was: the abandoned and presumably vandalized pitch may once have seen deeds of sporting prowess. It certainly does so no longer, but there is no real suggestion that it ever did. Perhaps its one-time users were never more than the bottom division; perhaps they just lost hope and went away, or perhaps they now remain inside the bleak, poor, houses of their sink estate, too

depressed to make up a team, or too lethargic or too locked into squalid mass entertainments even to try.

I see Shaw's painting as a worthy contribution to a great tradition. Painters in the Christian centuries painted suffering often enough, often sentimentally, or in order to elicit a sentimental reaction, and sometimes almost pornographically, as in much Spanish art of the Counter-Reformation. The genre scenes of some Dutch painters depict the lower orders at work or play, but invite the viewer in as an amused spectator rather than anything else. So the earliest precursor of a different social and political tradition that I can bring to mind is perhaps Hogarth. But in the nineteenth century, just as the socially engaged novel flowered, so did painters such as Francisco Goya, Jean-Francois Millet, Honoré Daumier, Vincent van Gogh, the Glasgow boys, and many others concerned simply to show the marginalized, the poor and the forgotten. This tradition is the reverse of romanticism, and the economic forces of the art market inevitably confine it to a minority niche. We, the public, would prefer to have a pretty Renoir or Monet or Matisse on our walls than a gritty, disturbing piece of social realism. The tradition typically gives us nothing sentimental, nothing pretty, nothing to patronize or to be amused about. In fact, it gives us nothing at all except the flat: "there it is". Goya's drawing *As if They Were a Different Breed*, or his howling dog in its metaphysical vacuum, or Millet's stooped and faceless women gleaning for scraps left over from the harvest, come up to date in George Shaw's presentation of the emptiness left by the lost life of industrial Britain.

Have I said the right things about Shaw's vision? Well, is there any such thing as the right thing to say, as opposed to more or less useful invitations to issue? In his poem, "I Remember, I Remember", Philip Larkin bleakly looks out of a train at Coventry, the city where he too spent his childhood. He catalogues the things that are supposed to happen to children in a nice healthy *bildungsroman*, none of which happened to him. In the poem, a friend addresses Larkin (or the poem's persona), observing that Larkin's physiognomy suggests he "wished the place in Hell", to which Larkin replies, "Oh well, I suppose it's not the place's fault" that nothing happens there.[9] Given Larkin's temperament, perhaps he was right not to blame Coventry. Perhaps Shaw himself forgives the kind of estate he depicts. It might be possible for a critic to see forgiveness in the painting.

The houses seem neat; the trees flourish; the grass is trimmed; life goes on, perhaps the goal post is temporarily under repair, the evening lights will shortly twinkle, and with a cheerful stoicism we can surmount any environment, or any climate of economic ideology, however unpromising. A grey day does not have to defeat us.

So while Shaw has given me the object for a set of thoughts and emotions, or perhaps "feelings" would be a better word, he might have given a different viewer the object for some quite different feelings. But I prefer to follow his invitation my own way, supposing that he has confronted us with a shameful truth about the country we live in, and one that we might have preferred to avoid. And that is one of the functions of art, and not the least of them.

12 | Paintings, photographs, titles

George Shaw
No Returns
(2009) | *Jerrold Levinson*

I am struck by the frontality of George Shaw's *No Returns*, the semi-abstract aspect, the limited colour palette, the evident formalist preoccupation, the subtly subverted realism, the way the canvas draws you in and keeps you out at the same time. *No Returns* gives off a powerful sense of spatial compression, one that recalls van Gogh's final canvas, *Wheatfield with Crows* (1890), perhaps the ultimate pictorial expression of physical and psychological blockedness. There are, for me, also notable resonances in different respects with artists as diverse as Gerhard Richter (the photographic derivation), Charles Demuth (the industrial theme), Richard Diebenkorn (the subdued colours), Piet Mondrian (the rectilinear emphasis), Andrew Wyeth (the eye for detail) and even Egon Schiele (the orderliness of his early landscapes).

I note next the mild indeterminacy of what one is looking at in *No Returns*: is it a wall, a fence, a freight car, a set of storage lockers? Next there is the studied anonymity of the scene, together with its utter familiarity – this is no fantasy world, no romantic evasion, no exotic Shangri-La. And lastly, there is the painting's clear division into three distinct zones, with three rather distinct feels – the airy, liquid feel of the blue-grey top zone,

the solid, impassive feel of the green middle zone, and the mysterious, earthy feel of the brownish bottom zone. The suggestion is powerful of three separate worlds only accidentally connected by juxtaposition in space.

Paintings are not philosophical tracts. If they raise philosophical issues it is in an indirect way, through what they suggest, exemplify, draw attention to or induce us to reflect on. What follows are thus some philosophical questions prompted by the painting, if not as such posed by it, all of which fall within the ambit of the philosophy of art.

The question raised most saliently by this painting is that of the difference between painting and photography. *No Returns*, by blatantly but only superficially aiming to pass for a photograph, puts the issue before us front and centre. Of course the difference is at base a technical one, having to do with the causal process by which an image is produced. But more interesting is how it *feels* to experience an image in the knowledge that it is either a painting or a photograph. Many have written on this with insight: Roland Barthes, Susan Sontag, Roger Scruton, Kendall Walton and Jonathan Friday, to name only a few.[1] What I say here about the phenomenology of experiencing images of each sort will undoubtedly echo some of what has been said by those thinkers and others, but I will not trouble myself or my readers with identifying the specific sources of the following reflections, nor with elaborating or qualifying them in detail.

To view a photograph knowing it is such is to feel in contact with what it pictures, even if that contact is interrupted or displaced in space and time. A photograph is always in some degree and at some level a trace of something real, something that exists or that existed at some time, and which one could have seen or might still see in the most straightforward and robust sense that the action of seeing can support. To view a painting knowing it is such, by contrast, is to feel in contact, not so much with what it pictures, as with the eye and the mind, the heart and the spirit, of the painter. What one sees in a painting *may*, of course, be something that exists in reality and that one might have seen or might yet see outside of painting, but inevitably and above all, it is something the artist has conceived, envisaged, imagined and interpreted, in accord with his or her aims, attitudes, desires and temperament. And in many cases, of course, what one sees in a painting is not something that exists or existed in reality, but something merely invented, in whole or in part.

If one accepts that broad contrast between paintings and photographs, then what are the implications for paintings of the particular sort that Shaw creates – paintings that both *derive* from photographs and also *resemble* photographs enough to pass for actually *being* photographs, at least at first blush? The most obvious upshot is that the viewer in the know finds himself or herself oscillating between two different stances toward what is pictured, the one roughly being that it is as if one is actually seeing the *subject*, the other roughly being that it is as if one is seeing – or maybe apprehending – the artist's *vision* of the subject, where this oscillation adds to the richness of the experience of the picture. Another upshot is that one is inevitably led to dwell on how *No Returns*, in virtue of exploiting, appropriating and mimicking the methods and techniques of photography, is thereby in some manner also interrogating its sister medium, and with perhaps not wholly friendly intentions. With painters like Shaw, it is as if painting is now turning the tables on photography, with the implied taunt of "whatever you can do I can do better" being raised to the second degree.

No Returns also rather prominently calls attention to the function of *titles* in works of art by the ambiguous yet quite suggestive title that it bears.[2] Titles of works of visual art, we might observe, seem as a rule to have more weight in inflecting the content of what they title than titles of literary, musical, cinematic or choreographic works, though it is hard to say why that is so. It may have something to do with their being static rather than temporal works, but perhaps more so, with their being less inherently narrative than works of those other sorts.

Consider how many ways there are to construe the expression "no returns". One relates to unsatisfactory purchases that cannot be brought back to a merchant for a refund. A second relates to glass or plastic containers that are sometimes recyclable for credit, but apparently not here. A third relates to travellers who have departed but who won't, for some reason, be coming back. And a fourth relates to the absence of those wished-for goods – the time-honoured "happy returns" – that are supposed to accompany a birthday or anniversary. No doubt there are others.

So which of these meanings is appropriately evoked in interpreting the painting, its embodied message or emotional expression? Criteria that theorists of artistic interpretation have proposed in answer to that question include the following: such a meaning was intended by the artist;

such a meaning is plausibly attributed to the artist as intended, given the work, artist and creative context; such a meaning adds artistic value to the painting; such a meaning coheres best with the other elements of the work. Judging the comparative merits of those proposals here would take us too far afield, though each can be defended to some extent.[3] In any case, the first and second possibilities above – those seeing in the phrase "no returns" primarily a commercial resonance – seem the most apt.

That said, how does the title *No Returns* operate to inflect the meaning of the canvas to which it is attached? The phrase "no returns", understood in its unwelcoming commercial sense, arguably serves to underline and reinforce the atmosphere of exclusion and closedness that the painting apart from its title projects, in virtue of its sombre colours, stark frontality and harshly flattened pictorial space.

It is interesting to compare George Shaw's painting, which has unmistakable representational content, with Arthur Danto's fictional paintings, *Newton's First Law* and *Newton's Third Law*, described in his classic essay "The Artworld", and which are in themselves abstract.[4] Those canvases, in two senses Newtonian, are basically just white rectangles, twice as high as they are wide, cut by a black line about one-third of the way up from the bottom. When the divided rectangle is read in the light of Newton's first law of motion ("a body in motion remains in motion unless acted upon by an outside force") the dividing line is most readily seen as the path of a particle in space and the painting remains flat; when it is read in the light of Newton's third law ("for every action there is an equal and opposite reaction") the line is easily seen as the edge of a plane separating two blocks or masses pushing against each other and the painting becomes three-dimensional.

When shorn of their titles, Shaw's canvas shares with Danto's imaginary canvases not only the foregrounding of rectangularity, but the ambiguous character of the space they represent: Is the elongated irregular green oblong that forms the middle zone of the painting just a façade, or rather, the leading face of a solid projecting backwards into the picture? But in contrast to Danto's examples, the inclusion of a title in Shaw's case does not resolve the spatial ambiguity. Instead, it adds some ambiguity of its own, given the different ways that the idea of "no returns" can be read.

Here is another ambiguity in the painting, one that adds to its interest. The trees depicted in the background of the highly compressed space

of *No Returns* call attention to themselves by their wispy and feathery quality. They induce the viewer to reflect on whether that character is an aspect of the trees depicted, or an aspect of how they are depicted. In other words, does the painting faithfully represent wispy and feathery trees, or does it represent non-wispy-and-feathery trees in a wispy-and-feathery manner? The reader may recall a related conceit in Woody Allen's film *Deconstructing Harry*, in which the Allen character, Harry Block, at one point begins to exhibit a blurriness that attaches to him as an individual, rather than to the manner in which he is being seen or photographed. Shaw is perhaps also playing here, if less straightforwardly, with the strange idea of an object that is intrinsically or metaphysically blurry or out-of-focus.

In addition, Shaw's *No Returns* highlights in a particular way how the materials and the materiality of a painting can enter into what it conveys. Michael Baxandall and Richard Wollheim remarked on this some time ago with the observation that the use of rare pigments, such as those derived from gold leaf and lapis lazuli, can convey an idea of preciousness as well as making canvases literally more precious.[5] As is often noted in commentaries on Shaw's art, Shaw fashions his paintings exclusively with Humbrol enamel paints, which were originally designed and manufactured, in the 1950s, for model airplane decoration. This adds a nostalgic flavour to his paintings of working-class English suburbia and countryside, which take as subject the Coventry council estate where he grew up. Shaw's paintings thus literally incarnate some of the past world that they lovingly, at least for the most part, memorialize. There is thus perhaps an indirect religious undertone to this ostensibly wholly secular art, along the lines of "the word made flesh".

I return, in conclusion, to the contrast between paintings and photographs, and how our experience of them differs. While we can, to a certain extent, see into the picture's depth in its upper and lower zones, its middle zone, that of the green wall or fence, stops us cold. If *No Returns* were a photograph, then there would be a fact of the matter as to what lies beyond the green barrier, or rather, more precisely, of what lay beyond the barrier when the photograph was made. But since *No Returns* is a painting, albeit one based on a photograph, there is no such fact of the matter, or rather, more precisely, nothing that the painting represents as lying beyond the green barrier that it does represent. Paintings and photographs may

sometimes approach perceptual indiscernibility, but metaphysically they remain worlds apart. And that is because, qualifications aside, a painting is a work of fiction, an invitation to imagine what may never have been, while a photograph is a work of non-fiction, a testament to what was the case at some place and time. Of course, that difference between them does not preclude photographs from being works of art.

13 | The laughter behind the painted smile

Yue Minjun
Untitled
(2005)

Sondra Bacharach

Yue Minjun is one of the leading Chinese artists today. He turned to art later in life, joining an artists' village in Yuanmingyuan in the early 1990s, after the 1989 Tiananmen Square student crackdown and the closure of the *China/Avant-Garde* exhibition at the National Gallery – events that were symbolic of the political and social turbulence in China. A few years later, this village became home to most of the leading contemporary Chinese artists today, including Wang Guangyi, Fang Lijun, Liu Wei and Zhang Xiaogang, among others. Many of these artists were loosely grouped together as "cynical realists", artists disillusioned with the aesthetics of social realism, the then-current ideologically driven artistic style imposed on artists, but also weary of the commercialism of Western capitalism.[1] Struggling to make sense of the contemporary society in which they found themselves, these artists' works encapsulate the unease of asserting oneself as a unique individual within the conformist-driven, collective mindset of Chinese culture. Drawing on the iconography and style of social realism, they turn propagandistic art on its head, using it to reject the utopian visions of collective identities. With wry sarcasm and stinging irony, these artists appropriate the idealized imagery of socialist propaganda

to highlight its disturbing use as a form of social control over collective identity.

Yue's *Untitled* from 2005 is a work that is representative of the visual scepticism that Yue's work evokes. The canvas is filled with a whole row of men – smiling, dangling their toes in the water, enjoying the delights of a beautiful day. Each person in the row has the same face, the same smile, the same pose, the same body – this row of smiling men appears to continue indefinitely, if only we could see beyond the picture plane. The mass of faces, identical in expression, look like paper cut-outs glued onto the row of rigid bodies that are carefully perched on the small white bench floating above an equally artificial lake of sparkling, clear blue water. These smiling faces take over most of the canvas, and what little space remains is given over to an almost completely nondescript background – some pristine water below and generic greenery around the edges of the canvas.

It would be convenient to situate this work, and Yue's *oeuvre* as a whole, within the style of cynical realism, but I think such attempts are misguided. Like his contemporaries, Yue's works adopt an exaggerated, simplistic visual imagery that is so straightforward that one cannot help but want to look beyond the surface interpretations for something deeper. If there is anything obvious in Yue's work, it's that the obvious isn't so; that reality is not as it appears. And, indeed, a constant theme of Yue's work is the repetition of simple motifs, obvious styles and stereotypical icons, all in order to encourage this sceptical attitude toward the surface appearances in his work. Like the cynical realists, Yue creates art whose visual representations do not accurately or truthfully reflect reality in a way that is designed to get the viewer to question the appearances. This is a kind of visual scepticism: a scepticism about how to interpret the appearances represented in the work.

But what distinguishes Yue from his fellow contemporaries is how he wants us to respond to visual scepticism: cynical realists respond to the socio-political situation with a cynical, critical and disillusioned attitude; Yue's work, in contrast, invites the viewer to imagine alternative social and political possibilities – a positive and empowering attitude.

To defend this alternative, positive interpretation of Yue's work, I shall consider a particular work by Yue, *Untitled* of 2005. I explore first the way in which this work invites us to adopt a visual scepticism toward his

paintings, the view that reality is not as it appears in this work. It does so by offering the viewer an image, whose content is absurd, an image whose apparent surface meaning cannot coherently constitute the actual meaning of the work. As a result, the standard viewer expectation that we should appreciate what we see in the image is thwarted – whatever it is that we ought to appreciate in this work is not what we can in fact see.

How then should we approach Yue's work if what we ought to appreciate is not what we in fact see? One might be tempted to give up trying to make sense of his work. But then one would miss something deep and important in the work. Yue is inviting us to imagine alternatives and possibilities that we cannot literally see in the work, but which stem from the image presented: it invites us to break away from the rigid conformism of contemporary Chinese culture. In this respect, Yue's visual scepticism calls on viewers to look beyond what is merely presented and to imagine how life could be otherwise, to walk away from the traditional rule-bound culture and the socio-political conformism used to control thinking. I conclude by commenting on the positive recommendations we should take from Yue's work about how we ought to approach life more generally.

Beneath the surface

Let us then consider the laughing men in Yue's work. These identical men appear in the middle of nowhere, completely disconnected from anything and everything. Moreover, they are disconnected from one another, and from us, the viewers. This is rather surprising, because, at least from what we can see, they have every reason to be completely connected to each other: they are tightly squashed together, sitting almost on top of each other; they are in the middle of nowhere, which suggests that there must be something common to these men that brings them together; they are all smiling, an inherently social and bonding activity that typically is the result of having shared a common experience together. And yet, everything else in the picture tells us that these individuals have nothing in common: they seem radically separated from one another, without any connection to each other, without any relations to each other. Their smile is done with eyes closed tight, as if to block the world out, to obliterate the outside world,

and shut themselves off either from anyone in the fictional world of the picture or from us viewers.

The absurdity intensifies when we consider the men's faces. They are not faces of men, but in fact self-portraits of Yue himself. We typically expect a self-portrait to be the kind of image that highlights a person's singularities, that identifies what is distinctive and unique to him alone, that points out what sets him apart from everyone else. A self-portrait is a window into the artist's own soul, revealing his most intimate secrets and inner, private emotional states. These are our expectations when confronting a self-portrait. But in contradiction to all this, Yue uses his self-portrait as a template, copying its image over and over again. This is a clever move on many levels: artistically, to repeat the image contained within the self-portrait undermines our traditional expectations of a self-portrait. Where a single self-portrait invites us to consider the author's individuality, Yue's multiple images remind the viewer that his own individuality has been suppressed, replaced with an oppressive, collective identity. The cartoonish, mocking quality of these self-portraits draws attention to an unusual use of physiognomic expression for artistic purposes.

Using the self-portrait to represent every man, Yue underscores the collective sameness and cultural conformity – a socio-political critique of his country. In addition, by repeating the self-portrait, Yue constructs a plural subject – a "we" that is also an "I". Hiding behind this plural subject, Yue can distance himself from the criticisms contained in his work, a clever political move to voice opposition. Better still, the plural subject also transforms the criticisms contained in Yue's work into criticisms attributable to the plural subject instead of Yue himself.

Finally, the absurdity of the smile as a mask to hide behind has particular importance in Chinese culture. Repeated in Yue's work is not just his own self-portrait, but, more importantly, his smile. Again, the physiognomic expression here is used for socio-political critique. The grinning, pink-faced man, eyes closed, mouth open almost physically impossibly wide, is larger than life – so much so that his image fights to take over the entirety of the canvas. At first glance, it is a simple, light-hearted smile, one that might convey an openness and honesty that is to be valued and prized. And yet, it is a smile as mysterious as the Mona Lisa's – for there is no apparent reason given to the viewer that might explain why this man is smiling. It is

a smile completely dissociated from the happiness that ought to be causing the smile: the physiognomic expression is completely divorced from the person's underlying emotional state. The physiognomic expression is used to artistic end – to create artifice.

But, what are we meant to be seeing, then, if not what we literally see? If visual scepticism prompts us to challenge what we see, and if what we see are caricatured physiognomic expressions, then we ought to be questioning the physiognomic expression as an authentic expression of the self, and how this is used for socio-political commentary.

The laughing man

Yue Minjun's paintings are situated in a long tradition of deceiving images, especially ones involving smiling self-portraits: former communist-style propaganda posters were designed to construct an alternative narrative of history and of the individuals experiencing that history, one according to which workers are happy, a kind and gentle leader looks down benevolently on those workers, and everyone works together happily for the collective good. In propaganda posters, the mythologized leader's detached, smiling head hangs high in the sky over the workers. Yue turns this smiling self-portrait around: instead of the party leader, we see Yue's own face, smiling down on us all and laughing at us. The smiling Yue, who stands for anyone and everyone, has replaced the smiling leader that Yue now mocks. The laughing man is laughing at how we see our past and challenging us to think about how we see ourselves now.

The propaganda posters' deception is merely a particular instance of a broader phenomenon. This discrepancy between what is portrayed, and the reality it represents, underscores the highly ambiguous attitudes that the Chinese have about their actual past and the related official history. Where most (pre-modernist) art embodies the standard mimetic goal of art imitating life in a bid for representational realism, propaganda art does the opposite: to get life to imitate the art they present, art that embodies an idealized, sanitized version of reality.

But, this duplicity of the smile extends into Chinese attitudes about their contemporary world as well.[2] Even today, images rarely reflect reality, and

much of life involves portraying oneself differently than how one feels: one's physiognomy cannot betray one's authentic feelings. This is something to which Yue himself is deeply sensitive:

> Everyone had to appear to do the right thing all the time ... Conforming was an all-consuming activity in the work life of many individuals. At least that much was the same for everyone in China at that time. Which, incidentally, is why to laugh, to assume a smile in order to mask your real feelings of helplessness, had such resonance for my generation.[3]

Yue adopts propaganda posters' stylistic features in order to negate their traditional meanings and infuse them with a meaning that any common Chinese person would find apparent beneath the surface: this smile masks the helpless feeling that paralyses people. And, indeed, that is exactly how these men appear to us: frozen in time and space, smiling because there is no other appropriate response.

At this point, we can appreciate another explanation for what Yue is trying to achieve with visual scepticism. We have already seen that Yue articulates a visual scepticism in order to prompt viewers to question what they see in the paintings. But, these paintings are clearly analogous to the lives of ordinary Chinese: given the crackdowns of the late 1980s and early 1990s, the Chinese must have been questioning what they perceived all around them. Their own socio-political reality is one that ought to prompt the very same visual scepticism that Yue himself represents in his paintings: the way reality is represented, what we see – in paintings, as in life – is not as it truly is.

So, Yue's work is intended to prompt viewers to experience a visual scepticism in two different domains – first, a literal visual scepticism with regard to the physiognomic expression in Yue's self-portraits, and, second, a symbolic visual scepticism with regard to the socio-political reality of contemporary Chinese life. From the point of view of an ordinary Chinese worker, who has lived his entire life in a work unit, who is told what to do, how to live, what to believe, it might be frightening to find oneself not having anything to do but to enjoy oneself, as these characters have themselves found in this image. The challenge of constructing meaning in life out of

nothing, while in the middle of nowhere, doing nothing, without any purpose, would be a very daunting enterprise indeed. Such a fear might even prevent us from being able to appreciate the amazing things that surround us or to enjoy the people in whose company we find ourselves. What to do when one suddenly finds oneself in a world in which reality is not as it appears? If we take Yue's works to embody visual scepticism in both painting and real life, then we can interpret Yue to be recommending laughter as an appropriate response in both arenas.

Yue's work embodies a simple truth about laughing which I believe is crucial to understanding how he thinks we ought to respond to the sceptical challenge: laughter is a source of hope and optimism that things will be better. It is a challenge for the viewer, to resist the simple, passive response of disappointment with life, and instead find energy to confront reality as it is, and embrace laughter as an authentic response to the socio-political situation. For Yue, this optimism is central:

> So this is how it all began: I was thinking that the image of a laughing face ought to be perceived as an assurance that things would be better: that a future life could be as rewarding and meaningful as the Buddha promised ... I decided that my laughing faces would be my own personal reminder of our situation, and which would be easily understood by people around me, and ordinary folk, too, who had learned to laugh because they understood that any other response was futile.[4]

The smile, then, is a mask to hide behind, but a mask whose fakeness Yue hopes will eventually become genuine.

Philosophical import

It might seem that we have now come full circle – we began by noting the absurdity of these smiling men in the middle of nowhere; we explained away this apparent absurdity by appealing to Yue's visual scepticism about taking representations at face value; Yue's scepticism, in turn, is a device to reassure viewers that the best response to absurd situations is to laugh

– the apparent absurdity of the laugh turns out to be the most appropriate response given the situation.

Of what use is visual scepticism for Yue, if we end up exactly where we started? We may be back at the same recommendation – laughter. But, the reasons behind the recommendation are quite different. Where at first, the physiognomic expression of laughter was used solely to artistic effect, to prompt a visual scepticism, to challenge the viewer to confront his socio-political reality as it truly is, now, the very same physiognomic expression is being encouraged not for artistic reasons, but for socio-political ones – to confront the authorities, to challenge the status quo. Where, socio-politically, Chinese were forced to smile in order to hide their personal expression, to mask their authentic feelings, and to promote a rule-following, compliant attitude imposed by the government, now Yue encourages us to laugh as an expression of socio-political criticism, as a confrontation to authorities. The reasons for laughing are now very different indeed!

We have already examined in detail the nature of Yue's visual scepticism. We must now understand how the physiognomic expression can be used as a socio-political expression of hope and optimism. To appreciate this, it is useful to situate Yue within his artistic and socio-political context. Yue and his fellow contemporaries first experienced the exhilarating excitement of being able to leave their work units to start new, self-sufficient lives in an artists' village; to have the freedom to present themselves authentically through new and exciting work. And, then, this all comes to an abrupt end with the Tiananmen Square crackdown and the National Gallery's unexpected closure. Pervading the art scene is a sense of unease and weariness about the possibility of artistic freedom and the future of individual expression. To respond to these emotions with the listlessness of disappointment is to accept that the government's impositions on artists have been successful, and to grant that the government has already won. For the artists to express disappointment or sadness about the situation is for them tacitly to accept that the artists have already lost the fight. Worse, it buys into the basic starting point of the government: that the government can control artists, and the artists' expression of disappointment is proof that the government has already won.

Against this backdrop, Yue's laughing man no longer looks absurd – instead, the laughing man offers us a way of escaping government control.

To laugh at, or in spite of, the government is to recognize that some challenges and problems cannot be dealt with using reason, rationality or argumentation. To laugh at the government's use of coercion and force, is to walk away from the fight with the government and to deny that it is a fight worth having. Artistically creative as a response to the crackdown, it is also politically astute: to laugh is to place oneself outside of any battle, to deny the very existence of a battle, against the government's attempt to impose conformism upon the artists. The laugh, then, is a politically savvy response to an immediate threat. But, it also shows the way to a philosophically enlightened attitude as well.

The reason that laughter is a philosophically enlightened activity is that to laugh is to appreciate more about the situation than we might otherwise see if we were to remain critical, negative and ironic. The laughing man motif very generally is a useful device that encourages us to break free from our individual perspective; to detach ourselves from the situation, in order to understand that situation more clearly. The laughing man, then, exemplifies a certain attitude toward life, a certain way of being in the world that Yue is recommending we adopt:

> Yue comes closest to saying something subversive when he describes the role of laughter in his works. "If you are faced with a situation you cannot change, then laughter may be the only possible reaction", he says. "But if many people start laughing, it can become a proactive force for change." His creature might lack the wit and wisdom of a Shakespearean fool, and any wry comment on the human condition is hidden behind the laughter. But maybe that's the point in a country whose critics are silenced.[5]

The epistemic stance we are invited to take toward these laughing men is precisely the same epistemic stance that Yue is suggesting that the Chinese themselves take to their own situation. In the face of the laughing men's absurd situation, they laugh; and so too, should we laugh in the face of our own life when it appears absurd to us.

Laughing can exemplify this detachment from life because laughing is a form of acknowledging uncertainty. When confronted with a difficult

situation, we might respond with criticism or negativity, as the cynical realists recommend, or with laughter, as Yue encourages. To be negative, however, is a very limiting response. For one, it presupposes a particular perspective on the situation – that the situation is as difficult as it appears. To be critical of a situation is already to grant a hopelessness, an inability to escape the situation. But, Yue encourages us to laugh in the face of difficult situations. To laugh is to acknowledge uncertainty, to remain open to all options, not to close oneself off to different responses. Laughing, then, allows us to detach ourselves from our own perspective, to appreciate the situation for what it is, for all that it might be. While we may not have access to all those options, laughing allows us to rid ourselves from prejudices that prevent us from seeing things for what they really are.

And so we return to the laugh – but now with new reasons. In today's world, as in Yue's work, when confronted with appearances that do not conform to reality, we are invited to laugh. But, if Yue is right, the reason we are laughing is not to conform to the collective identity imposed by the Chinese culture, but instead to laugh as an authentic and personal expression of hope when faced with an uncertain future. In so doing, we can appreciate the way in which Yue puts physiognomic expression to a novel artistic use, to point the way toward a clever socio-political critique embedded in the simple act of laughter.

The use of the smile and laughter as a way of promoting detachment and openness is not uncommon to Chinese thought. Daoism is one of the main religious and philosophical systems of thought that encourages an anti-authoritarian, free-spirited and open-minded approach to life. Expressed through the classic texts *Tao Te Ching* and *Zhuangzi*, the socio-political views about how to live are expressed through literary stories with humour and light-heartedness. In this respect, we can see Yue's use of physiognomic caricature to engender certain socio-political critiques of his country to be firmly entrenched within China's artistic traditions.

But, there are lessons here for Westerners, too. Physiognomic caricatures abound in contemporary Western culture as well – advertisements, fashion magazines, clothing stores are all full of images of men and women appearing a certain way. These men and women are represented to us with artificially great big smiles on their faces, just like Yue's laughing men.

What difference is there really, between a propaganda poster encouraging us to take pride in our hard work, and a computer advertisement encouraging us to take pride in getting our jobs done no matter where we might be? Between a work unit that uses social pressure to keep everyone's hair cut in a particular way, and a fashion magazine that gives us step-by step instructions to recreate the hair styles of the rich and famous?

Yue's laughing men may look radically different from the smiling models that pervade Western culture, but they both share that artificial physiognomic expression that Yue exaggerates to generate his socio-political critique. In many respects, Yue's work has even more serious implications for Western society, since not only does our society idealize that artificial physiognomic expression, but we do so in the name of valuing our individuality and personal expression.

Acknowledgements

I'd like to thank Damien Freeman, Josephine Breese and my colleagues, Nick Agar, Ismay Barwell, Stuart Brock and Ramon Das at Victoria University of Wellington for helpful comments on earlier drafts of this chapter.

| Contributors

Sondra Bacharach is a Senior Lecturer at Victoria University of Wellington in New Zealand. In 2003, she won the *Journal of Aesthetics and Art Criticism's* John Fisher Memorial Prize for her article "Towards a Metaphysical Historicism".

Simon Blackburn is a Distinguished Research Professor of Philosophy in the University of North Carolina at Chapel Hill, and a Fellow of Trinity College, Cambridge, having previously held the Bertrand Russell Chair of Philosophy in the University of Cambridge. His publications include *Spreading the Word*, *Essay in Quasi-realism*, *Ruling Passions*, *Think*, *Being Good* and *Lust*.

Josephine Breese is a London-based curator, writer and gallerist who was educated at the University of Cambridge and the Courtauld Institute of Art, London. She is a regular contributor to the arts pages of *The Herald* and other publications on the subject of contemporary art, with specific reference to South Asian art.

Noël Carroll is a Distinguished Professor of Philosophy in the Graduate Center at the City University of New York. His publications include *Art in Three Dimensions*, *Living in an Artworld*, *Minerva's Night Out: Philosophy, Movies and Popular Culture* and *Humor: A Very Short Introduction*.

Damien Freeman lectures on ethics and aesthetics at Pembroke College, Cambridge, and the Art Gallery of New South Wales in Sydney. His publications include *Art's Emotions: Ethics, Expression and Aesthetic Experience* and, as a biographer, *Mao's Toe*, *Roddy's Folly* and *The Aunt's Mirrors*.

Raymond Geuss is Emeritus Professor of Philosophy in the University of Cambridge. His publications include *The Idea of a Critical Theory*, *Morality, Culture, and History*, *History and Illusion in Politics*, *Public Goods, Private Goods*, *Glück und Politik: Potsdamer Vorlesungen*, *Outside Ethics*, *Philosophy and Real Politics* and *Politics and the Imagination*.

Lydia Goehr is Professor of Philosophy at Columbia University, New York. Her publications include *The Imaginary Museum of Musical Works: An Essay in the Philosophy of Music*, *The Quest for Voice: Music, Politics, and the Limits of Philosophy* and *Elective Affinities: Musical Essays on the History of Aesthetic Theory*.

Jerrold Levinson is a Distinguished University Professor of Philosophy at the University of Maryland. His publications include *Music, Art, and Metaphysics*, *The Pleasures of Aesthetics*, *Music in the Moment*, *Contemplating Art* and the forthcoming *Aesthetic Pursuits*.

Hallvard Lillehammer is Professor of Philosopher at Birkbeck College, University of London. His publications include *Companions in Guilt: Arguments for Ethical Objectivity*.

Henry Little is a London-based curator, writer and gallerist who was educated at the University of Cambridge and the Courtauld Institute of Art, London. His current research interests include a cultural history of art dealing. He has contributed to *The White Review*, *Apollo* and *this is tomorrow*.

M. M. (Mary Margaret) McCabe is Professor of Ancient Philosophy at King's College, University of London. Her publications include *Plato on Punishment*, *Plato's Individuals* and *Plato and His Predecessors*.

Derek Matravers is Professor of Philosophy at The Open University. His publications include *Art and Emotion*, *Introducing Philosophy of Art: Eight Case Studies* and *Fiction and Narrative*.

Alexis Papazoglou is an Affiliated Lecturer in the Faculty of Philosophy at the University of Cambridge, and Director of Studies in Philosophy at Jesus College, Cambridge. His publications include an edited volume, *The Pursuit of Philosophy: Some Cambridge Perspectives*.

Jesse Prinz is a Distinguished Professor of Philosophy in the Graduate Center at the City University of New York. His publications include *The Conscious Brain*, *Beyond Human Nature*, *The Emotional Construction of Morals*, *Gut Reactions: A Perceptual Theory of Emotion* and *Furnishing the Mind: Concepts and Their Perceptual Basis*.

Sam Rose is a Research Fellow at Peterhouse, Cambridge. He is currently working on a book about formalism and aestheticism in England.

Barry C. Smith is Professor of Philosophy and Director of the Institute of Philosophy in the School of Advanced Study, University of London. His publications include *Realism and Anti-Realism: An Enquiry into Meaning, Truth and Objectivity*.

Edward Winters is an artist and writer. His publications include a co-edited volume, *Dealing with the Visual, Aesthetics and Architecture*, and his forthcoming *The Contemporary Work of Marcus Rees Roberts*.

| Notes

Introduction: figurative art and figurative philosophy

1. It is notable that in Act IV, scene 3, when Macbeth's antagonist, Macduff, receives news that his wife and children have been murdered, and is advised that he should "dispute it like a man", his impulse is to respond emotionally – rather than philosophically – to the misfortune, explaining: "I shall do so: But I must also feel it as a man". In *Hamlet*, the Prince also responds philosophically to news of the murder of his father by his uncle, but Hamlet's philosophizing serves to delay his murdering the king of Denmark, whereas, in *Macbeth*, the philosophizing comes after Macbeth's dastardly murder of the king of Scotland.
2. W. Shakespeare, *Macbeth*, A. P. Riemer (ed.) (Sydney: Sydney University Press, 1980), 7–8.
3. T. S. Eliot, "Shakespeare and the Stoicism of Seneca", in his *Selected Essays, 1917–1932* (London: Faber, 1932).
4. B. Newman, "The Sublime is Now", *Barnett Newman: Selected Writings and Interviews*, J. P. O'Neill (ed.), 171–3 (Berkeley, CA: University of California Press, 1992).
5. H. Rosenberg, "The American Action Painters", in his *The Tradition of the New*, 23–39 (New York: Horizon Press, 1960), 32.
6. See www.tate.org.uk/whats-on/tate-liverpool/exhibition/dla-piper-series-twentieth-century/twentieth-century-exhibition-4 and www.tate.org.uk/whats-on/tate-liverpool/exhibition/dla-piper-series-twentieth-century/twentieth-century-exhibitio-11 (accessed 1 November 2013).
7. M. Budd, *Values of Art* (London: Allen Lane, 1995), 1.
8. *Ibid.*: 4–5.
9. R. G. Collingwood, *The Principles of Art* (Oxford: Clarendon Press, 1938), vii.
10. N. Carroll & J. Gibson (eds), *Narrative, Emotion, and Insight* (University Park, PA: Pennsylvania State University Press, 2011), reviewed in *Philosophical Quarterly* (2013), 405–7.

1. John Currin and pornography

1. K. Rosenberg, "Influences: John Currin", *New York Magazine* 39(42) (2006), 134.
2. *Jacobellis v. Ohio* 378 U.S. 184 (1964).
3. M. Rae, "What is Pornography?", *Nous* 35 (2001), 118–45.
4. A. Dworkin & C. MacKinnon, *Pornography and Civil Rights* (Minnesota, MN: Organizing Against Pornography, 1988), 35, 134.
5. H. Longino, "What is Pornography", *Take Back the Night: Women on Pornography*, L. Lederer (ed.), 40–54 (New York: William Morrow, 1980).
6. L. LeMoncheck, *Dehumanizing Women: Treating Persons as Sex Objects* (Totowa, NJ: Rowman & Allenheld, 1985).
7. A. Lorde, *The Uses of the Erotic: The Erotic As Power* (Trumansburg, NY: Crossing Press, 1978).
8. A. L. Carse, "Pornography: An Uncivil Liberty?", *Hypatia* 10 (1995), 155–82.
9. J. Levinson, "Erotic Art and Pornographic Pictures", *Philosophy and Literature* 29 (2005), 228–40.
10. *Ibid.*, 229.
11. See a video interview by Kim Morgan in G. Snyder & M. St John (prod.), T. Flaxman (ed.), *13 Artists in the Studio: John Currin* (New York: Mass Productions, 1996).
12. *Ibid.*
13. Walter Annenberg Annual Lecture, Whitney Museum of American Art, 29 October 2013.

2. A moment of capture

1. C. Smith, "Dexter Dalwood: Interview", *Kaleidoscope Magazine* 8 (2010), kaleidoscope-press.com/issue-contents/dexter-dalwood-interview-by-cherry-smith (accessed 12 December 2013).

3. Uncanny absence and imaginative presence in Dalwood's paintings

1. See A. Bruno, "Punk Rock Romeo and Juliet: Sid Vicious and Nancy Spungen", *Crime Library*, www.trutv.com/library/crime/notorious_murders/celebrity/sid_vicious/3b.html (accessed 13 September 2013).
2. Aristotle, *De Anima*, H. Lawson-Tancred (trans.) (London: Penguin, 1986), 198.
3. L. Wittgenstein, *Philosophical Investigations*, G. E. M. Anscombe (trans.) (Oxford: Blackwell, 1953), p. 213e.
4. L. Wittgenstein, *Remarks on the Philosophy of Psychology*, G. H. von Wright & Heikki Nyman (eds), C. G. Luckhardt & M. A. E. Aue (trans.) (Oxford: Blackwell, 1980), vol. II, 543.
5. Wittgenstein, *Philosophical Investigations*, 207e.
6. *Ibid.*, 201e.
7. H. Ishiguro, "Imagination", *Proceedings of the Aristotelian Society* supplementary volume (1967), 50. See also R. Scruton, *Art and Imagination* (London: Methuen, 1974), 112.
8. Wittgenstein, *Remarks on the Philosophy of Psychology*, vol. II, 733.
9. J.-P. Sartre, *The Psychology of Imagination*, B. Frechtman (trans.) (New York: Washington Square Press, 1966), 47.
10. C. McGinn, *Mindsight* (Cambridge, MA: Harvard University Press, 2004), 50.
11. *Ibid.*
12. *Ibid.*, 172, n. 7.

13. F. Lunn, "Foreword", *Dexter Dalwood*, exhibition catalogue (Biel: CentrePasquArt, 2013).
14. *Dexter Dalwood*, British and Irish exhibition catalogue edition for Tate Publishing (Zurich: JRP|Ringler Publishing), 7.
15. L. Cohen, *The Favourite Game* (London: Jonathan Cape, 1963).
16. *Ibid.*, 136–7.
17. For a discussion of borrowing see R. Wollheim, *Painting as an Art* (London: Thames & Hudson, 1987), lecture IV. Wollheim makes much of the psychological content of borrowing. For my purposes the concept is used to show how artists borrow from previous artists to aesthetic end.
18. See www.tate.org.uk/context-comment/video/tateshots-nick-serota-dexter-dalwood-on-patrick-caulfield (accessed 13 September 2013).
19. See www.tate.org.uk/context-comment/video/meet-artist-dexter-dalwood (accessed 13 September 2013).
20. *Ibid.*
21. Quoted in D. Lopes, *Understanding Pictures* (Oxford: Oxford University Press, 1996), 226.
22. T. S. Eliot, "Tradition and the Individual Talent", *Selected Prose of T. S Eliot*, F. Kermode (ed.) (London: Faber, 1975).
23. M. Archer, "The Figure in Painting", *Dexter Dalwood*, exhibition catalogue (Biel: CentrePasquArt, 2013).
24. R. Wollheim, "The Work of Art as Object", in his *On Art and the Mind*, 127–8 (London: Allen Lane, 1973).

4. At the still point of the turning world: Two Quartets by Tom de Freston

1. D. Hume, *Of the Standard of Taste and Other Essays*, J. W. Lenz (ed.) (New York: Bobbs-Merrill, 1965).
2. Cf. Donald Kuspit's foreword to D. A. Flanary, *Champfleury: The Realist Writer and Art Critic*, vii–xi (Ann Arbor, MI: UMI Research Press, 1980).
3. On the concept of *ekphrasis*, see L. Goehr, "How to Do More with Words: Two Views of (Musical) Ekphrasis", *British Journal of Aesthetics* 50(4) (2010), 389–410.
4. J. W. Goethe, *Elective Affinities*, R. Hollingdale (trans.) (Harmondsworth: Penguin, 1971), 56.
5. *Ibid.*
6. T. S. Eliot, "Burnt Norton", from *The Four Quartets*, in his *The Complete Poems and Plays* (London: Faber, 1969), 173.
7. T. de Freston, "Modern Pathos", *Topman* (2012), http://magazine.topman.com/category/culture/tom-de-freston-modern-pathos (accessed 19 February 2014).
8. T. de Freston, "On Falling", *Dazed Digital* (2011), www.dazeddigital.com/artsandculture/article/11403/1/tom-de-freston-on-falling (accessed 19 February 2014).
9. A. Sinclair, "Angus Sinclair reviews 'House of the Deaf Man' by Porter and de Freston", *ink, sweat and tears* (2012), www.inksweatandtears.co.uk/pages/?p=3244 (accessed 7 November 2013).
10. S. Beckett, *Collected Shorter Plays of Samuel Beckett* (London: Faber, 1984).
11. Cf. C. Ackerley, "Samuel Beckett and Mathematics", www.uca.edu.ar/uca/common/grupo17/files/mathem.pdf, 18 (accessed 7 November 2013).
12. Beckett, *Collected Shorter Plays*, 293, and BFI description at http://ftvdb.bfi.org.uk/sift/title/326964 (accessed 19 February 2014).
13. W. Benjamin, "On the Concept of History", *Walter Benjamin: Selected Writings*, M. W. Jennings (ed.) (Cambridge MA: Harvard University Press, 2003), 389.
14. J.-J. Rousseau, *Dictionniare de Musique* (Paris: Duchesne, 1768), 394.

15. J. Derrida, *The Truth in Painting*, G. Bennington & I. McLeod (trans.) (Chicago, IL: University of Chicago Press, 1987), 37–8.

5. Being ironic with style

1. S. Alpers, "Style is What You Make It: The Visual Arts Once Again", *The Concept of Style*, rev. edn, B. Lang (ed.), 137–62 (Ithaca, NY: Cornell University Press, 1987), 137. More recent art historical discussions of the issue are J. Elkins, "Style", *The Dictionary of Art*, J. Turner (ed.), vol. 29, 876–83 (London: Macmillan, 1996), where it is argued that the unexamined reliance on style might actually be the best way to treat it; J. Elsner, "Style", in *Critical Terms for Art History*, 2nd edn, R. S. Nelson & R. Shiff (eds), 98–109 (Chicago, IL: University of Chicago Press, 2003); R. Neer, "Connoisseurship and the Stakes of Style", *Critical Inquiry* 32 (2005), 1–26; and W. Davis, *A General Theory of Visual Culture* (Princeton, NJ: Princeton University Press, 2011), 75–119. As Elsner put it, "For nearly the whole of the twentieth century, style art history has been the indisputable king of the discipline, but since the revolution of the seventies and eighties the king has been dead" (Elsner, "Style", 98). The classic earlier, more optimistic, art historical accounts of style are: M. Schapiro, "Style", in his *Theory and Philosophy of Art: Style, Artist, and Society*, 51–102 (New York: George Braziller, 1994); J. Ackerman, "A Theory of Style", *Journal of Aesthetics and Art Criticism* 20 (1962), 227–37; E. H. Gombrich, "Style", *International Encyclopedia of the Social Sciences*, vol. 15, D. L. Sills (ed.), 353–61 (New York: Macmillan, 1968).
2. A. C. Danto, *The Transfiguration of the Commonplace* (Cambridge, MA: Harvard University Press, 1981), 136–208; R. Wollheim, "Pictorial Style: Two Views", in Lang, *The Concept of Style*, 183–202; R. Wollheim, *Painting as an Art* (Princeton, NJ: Princeton University Press, 1988), 25–36; R. Wollheim, "Style in Painting", *The Question of Style in Philosophy and the Arts*, C. van Eck, J. McAllister , & R. van de Vall (eds), 37–49 (Cambridge: Cambridge University Press, 1995). The lack of favour is clear in the essays, roundtable discussions and critical responses in J. Elkins (ed.), *The State of Art Criticism* (New York: Routledge, 2008). Among many references to writing style in the book, almost the only mention of pictorial style comes when the art critic Gemma Tipton complains that "so much of aesthetics has been concerned with looking at works of art – at style" (Elkins, *The State of Art Criticism*, 179).
3. The suspicion about the subjectivity of these categories has been widely registered. Classic critiques of the whole idea of "general" style, and of Wölfflin's categories in particular, are Wollheim's two essays on style referenced above, and M. Brown, "The Classic Is the Baroque: On the Principle of Wölfflin's Art History", *Critical Inquiry* 9 (1982), 379–404. A particularly interesting exploration of narratives of general and individual style is given by J. Gilmore, *The Life of a Style: Beginnings and Endings in the Narrative History of Art* (Ithaca, NY: Cornell University Press, 2000). A number of art historians would now want to argue that the conditions of Western modernity and the avant-garde artistic movements that it generated render "period style" a redundant concept for art made after the end of the eighteenth century; see, for example, D. Craven, "Art History and the Challenge of Postcolonial Modernism", *Third Text* 16 (2002): 309–13, esp. 311.
4. B. Lang, "Style", *The Encyclopedia of Aesthetics*, vol. 4, M. Kelly (ed.), 321 (New York: Oxford University Press, 1998).
5. This view and its problems have been succinctly discussed by D. Carrier, "How Can Art History Use Its History?", *History and Theory* 46 (2007): 472–5. For a more detailed defence of connoisseurship, drawing on Goodman's classic discussions of identification, see Neer, "Connoisseurship and the Stakes of Style".

6. J. Gaiger, *Aesthetics and Painting* (London: Continuum, 2008), 91–2. Gaiger's actual chapter on style as a whole, it should be said, is far more inclusive than this passage might suggest.
7. N. Goodman, "The Status of Style", *Ways of Worldmaking* (Indianapolis, IN: Hackett, 1978), 27, 35.
8. *Ibid.*, 23.
9. *Ibid.*, 23–33.
10. Wollheim, "Style in Painting", 43–4.
11. D. Jacquette, "Nelson Goodman on the Concept of Style", *British Journal of Aesthetics* 40 (2000), 452–67.
12. Jacquette, "Nelson Goodman on the Concept of Style", 460–61. For a discussion of a similar approach, acknowledged by Jacquette, see K. L. Walton, "Style and the Products and Processes of Art", in Lang, *The Concept of Style*, 72–103.
13. Jacquette, "Nelson Goodman on the Concept of Style", 461. This feature of style is also briefly discussed by N. Goodman, *Of Mind and Other Matters* (Cambridge, MA: Harvard University Press, 1987), 132–4.
14. Jacquette, "Nelson Goodman on the Concept of Style", 463.
15. *Ibid.*, 464.
16. *Ibid.*
17. *Ibid.*, 465.
18. G. Currie, "The Irony in Pictures", *British Journal of Aesthetics* 51 (2011), 149–58.
19. *Ibid.*, 149–50.
20. *Ibid.*, 151–5.
21. *Ibid.*, 150-51. For a discussion and critique of the old kind of irony, see A. Nehamas, *The Art of Living: Socratic Reflections from Plato to Foucault* (Berkeley, CA: University of California Press, 1998), 51–69.
22. Currie has discussed the pretence theory more generally, including a critique of the rival "echoic" theory of irony; G. Currie, G., "Why Irony is Pretence", *The Architecture of the Imagination: New Essays on Pretence, Possibility, and Fiction*, S. Nichols (ed.), 111–33 (Oxford: Oxford University Press, 2006).
23. Currie, "The Irony in Pictures", 157. There are conflicting views on the extent to which irony in pictures can properly be described as intentional; see, for example, S. Davies, "Authors' Intentions, Literary Interpretation, and Literary Value", *British Journal of Aesthetics* 46 (2006), 233–5, esp. 234, n. 19. All I will say here, with the pragmatic approach shared by Walton and Jacquette in mind, is that the account I give below of de Freston's practice is intended to provide knowledge that will better explain elements that are, ultimately, apparent to any viewer of the finished work.
24. Currie, "The Irony in Pictures", 155.
25. D. J. Enright, *The Alluring Problem: An Essay on Irony* (New York: Oxford University Press, 1986), 6. This passage is quoted by Alexander Nehamas, whose general discussion of this deep form of irony (which he links to Socrates and his legacy) I have drawn on here; see Nehamas, *The Art of Living*, 19–98.
26. It could be argued that what distinguishes such irony from outright confusion is the simple confidence of assertion that accompanies it – the appearance of a belief shoring up the verbal or pictorial communication that there is some unifying and definite meaning, personality or style that lies behind. Nehamas links this to the superior attitude of the ironist, who does not openly reveal their own uncertainty (Nehamas, *The Art of Living*, 62–3).
27. For a more general discussion, see W. Saurländer, "From Stilus to Style: Reflections on the Fate of a Notion", *Art History* 6 (1983), 253–70.
28. Elkins, "Style", 881.
29. Wollheim, "Pictorial Style: Two Views", 193; Wollheim, "Style in Painting", 49.

30. Elkins, "Style", 881.
31. *Ibid.*

6. The radioactive wolf, pieing, and the goddess "Fashion"

1. "Dada heißt im Rumänischen Ja Ja, im Französischen Hotto- und Steckenpferd. Für Deutsche ist es ein Signum alberner Naivität und zeugungsfroher Verbundenheit mit dem Kinderwagen." H. Ball, *Die Flucht aus der Zeit* (Munich: Duncker & Humblot, 1927), cited in K. Riha (ed.), *Dada in Zürich* (Stuttgart: Reclam, 1994), 14.
2. Riha, *Dada in Zürich*, 30.
3. "Addio, steigt mir, bitte, den Rücken runter, auf Wiedersehn ein ander Mal!"
4. Riha, *Dada in Zürich*, 30.
5. T. Tzara, *Sept manifestes DADA* (Geneva: Société Nouvelle des Èdition Pauvert, 1979), 41.
6. Riha, *Dada in Zürich*, 12.
7. On the modern as the "ephemeral", see C. Baudelaire, "Peintre de la vie moderne", in his *Ècrits sur l'art* (Paris: Gallimard, 1971), vol. 2, 133–93.
8. Ball is wrong; it was Spiegelgasse 14.
9. "Während wir in Zürich, Spiegelgasse 1, das Kabarett hatten, wohnte uns gegenüber in derselben Spielgelgasse, Nr. 6, wenn ich nicht irre, HerrUlianow-Lenin ... Ist der Dadaismus wohl als Zeichen und Geste das Gegenspiel zum Bolschewismus? Stellt er der Destruktion und vollendeten Berechnung die völlig donchichottische, zweckwidrige und unfaßbare Seite der Welt gegenüber?" (Riha, *Dada in Zürich*, 25).
10. "Dada ist die willentliche Zersetzung der bürgerlichen Begriffswelt. Dada steht auf der Seite des revolutionären Proletariats"; "Dilettanten erhebt euch gegen die Kunst"; and "Dada ist politisch".
11. Dom O'Mahony suggests to me that perhaps the wolf has just urinated on the painting as part of his habit of marking territory that he is claiming as "his", and this urine has caused the painting to run.
12. W. Benjamin, *Illuminationen* (Frankfurt: Suhrkamp, 1977), 136–69.
13. *Ibid.*, 184.
14. Riha, *Dada in Zürich*, 20–21.
15. "Dada means nothing".
16. "das bedeutende Nichts an dem Nichts etwas bedeutet".
17. Riha, *Dada in Zürich*.
18. *Preussischer Erzengel.*
19. This is a biblical text used in a well-known German Christmas carol.
20. Riha, *Dada in Zürich*, 14–15; see D. Graeber, *Direct Action* (Edinburgh: AK Press, 2009) for a discussion of the contemporary political use and significance of puppets.
21. Riha, *Dada in Zürich*, 33.
22. "Ich hoffe, daß Ihnen kein körperliches Unheil widerfahren wird, aber was wir Ihnen jetzt zu sagen haben, wird Sie wie eine Kugel treffen."
23. Riha, *Dada in Zürich*, 29.
24. See J. Bakan, *The Corporation* (London: Random House, 2003).
25. Brecht would ask, "Did he do it *all by himself?*" ("Frage eines lesenden Arbeiters").
26. G. E. Lessing, Zerstreute Anmerkungen über das Epigramm und einige der vornehmsten Epigrammatisten", in his *Werke* (Vienna: Bensinger, n.d.), vol. 5, 42–89.
27. See J. Berger, *Ways of Seeing* (London: Penguin 1972).
28. A. Nehamas, *Only a Promise of Happiness* (Princeton, NJ: Princeton University Press, 2007).
29. "[L]ocated between the salon where conversation reigns and the bedroom where love reigns, the

'*boudoir*' symbolizes the locus of union of philosophy and love" (Y. Belaval, "Préface", *La philoso-phie dans le boudoir*, D. A. F. de Sade, 7–8 [Paris: Gallimard, 1976]).

30. T. Friedman, *The World is Flat* (New York: Farrar, Straus & Giroux, 2005).
31. D. Bell, *The End of Ideology* (Glencoe, IL: Free Press, 1960); F. Fukuyama, *The End of History and the Last Man* (Glencoe, IL: Free Press, 1992).
32. H. Marcuse, *One-Dimensional Man* (Boston, MA: Beacon Press, 1965).
33. "Wir wollen die Welt mit Nichts verändern … wir wollen den Krieg mit Nichts zu Ende bringen" (Riha, *Dada in Zürich*, 29).

7. Confinement, apathy, indifference

1. T. Aquinas, *Summa Theologiae* (Notre Dame, IN: Ave Maria Press, 1989), 365.
2. *Ibid.*
3. A. Smith, *A Theory of Moral Sentiments*, K. Haakonsen (ed.) (Cambridge: Cambridge University Press, 2002), 19.
4. *Ibid.*, 42.
5. M. P. Golding, "On the Idea of Moral Pathology", *Echoes from the Holocaust: Philosophical Reflections on a Dark Time*, A. Rosenberg & G. E. Myers (eds), 128–48 (Philadelphia, PA: Temple University Press, 1988), 137.
6. E. Wiesel, *Night* (Harmondsworth: Penguin, 2006), 98.
7. A. Solzhenitsyn, *The Gulag Archipelago 1918–1956: An Experiment in Literary Investigation* (New York: Harper Perennial, 2007), 396.
8. A. Camus, *The Plague*, (Harmondsworth: Penguin, 2002).

8. Thinking outside the frame: Plato, Quinn and Artaud on representation and thought

1. Claude Lorrain, *Landscape with Abraham Expelling Hagar and Ishmael*, c.1665–8, oil on canvas. Collection Alte Pinakothek, Munich; a drawing (in which the subject is reversed) is held in the Fitzwilliam Museum, Cambridge.
2. Compare the *Fall of Icarus* attributed to Pieter Brueghel (Koninklijke Musea voor Schone Kunsten van België), apparently a copy of a Brueghel original. One of the most ancient versions of the story can be found in Ovid, *Metamorphoses* 8.183–259: here the moralizing comes from Daedalus, who urges his foolish son to "take the middle way".
3. Thucydides, *Histories* 1.22.
4. Plato, *Meno* 97d, *Euthyphro* 11b, makes much of the contrast between Daedalus' skill and the way-wardness of his creations. For a good translation of all the dialogues see *Plato: Complete Works*, J. M. Cooper & D. S. Hutchinson (eds) (Indianapolis, IN: Hackett, 1997); the page and section references are standard across editions and translations.
5. The language of representation, both in discussions of perception and of aesthetic representa-tion, tends to shift between these two versions of representation: on the one hand, how an image represents what it is of; and on the other how we, in seeing an image, represent to ourselves what we see there. In what follows I shall argue that this contrast – between the representation's object and the subject to whom it appears – is exploited in the Platonic account, and possibly also in Quinn and Artaud.

6. Compare the complex framings in Magritte – for example, *The Human Condition* (National Gallery of Art, Washington, DC).

7. Some might disagree, of course; I leave this worrying issue on one side here; but compare G. Priest, *Beyond the Limits of Thought* (Cambridge: Cambridge University Press, 1995) with R. M. Sainsbury, *Paradoxes* (Cambridge: Cambridge University Press, 1995).

8. There is a complex question here about where seeing ends and thought begins. Briefly, I take it that in cases such as this (and perhaps in all cases), there is no first-impression brute "seeing" of the painting, which is then overlain by a whole series of more or less metaphorical "seeings", infused with more and more judgemental content. Instead, I think that all of these seeings and seeings-as, both at first and later on, are cognitively complex; none of them is brute.

9. *Republic* 598–602 seems to complain that images seen in a mirror or represented by a painter fail to show themselves *as representations*. The same thought is central to the image of the Cave at 514–18. The point about persuasion is central to Socrates' complaints about rhetoric in the *Gorgias*.

10. He is not, in quite the same way, worried about the sort of representation that is given in language, although, as I shall suggest, he finds some aspect of language pretty tricky as well. On this see V. Harte, "Language in the Cave", *Maieusis*, D. Scott (ed.), 195–215 (Oxford: Oxford University Press, 2007).

11. For Plato's celebrated image of the Cave, see *Republic* 515–18. There are as many interpretations of this image as there are interpreters; here I offer some aspects of my own.

12. Recall Quine's thought experiment to establish the indeterminacy of translation in *Word and Object* (Cambridge, MA: Harvard University Press, 1960), ch. 2.

13. *Republic* 515a. I argue for the significance of this point in "From the Cradle to the Cave" in *Platonic Conversations*, M. M. McCabe (Oxford: Oxford University Press, forthcoming), ch. 11.

14. There is comic genius (the opening of the *Charmides*, the last pages of the *Symposium*) and tragic genius (the end of the *Phaedo*, the last pages of the *Symposium*, in which there is a debate about the coincidence of tragic and comic expertise); and yet there is an attack on comedy at *Philebus* 48–50 and on tragedy at *Republic* 380.

15. Think for example, of Socrates' arguments against Thrasymachus in *Republic* 1; or the much-maligned affinity argument at *Phaedo* 78–81; or the notorious Third Man arguments of *Parmenides* 132–3.

16. An obvious example would be the elaborate settings of some dialogues, e.g. *Symposium* or *Parmenides*. Even these have a philosophical contribution to make, as I argue elsewhere; see "Unity in the *Parmenides*: The Unity of the *Parmenides*", *Form and Argument in Late Plato*, C. Gill & M. M. McCabe (eds), 5–48 (Oxford: Oxford University Press).

17. M. M. McCabe, *Plato and his Predecessors: The Dramatization of Reason* (Cambridge: Cambridge University Press, 2000).

18. Notice the way in which the frame dialogue interrupts at *Euthydemus* 290e, for example, to comment on what has been going on in the framed discussion.

19. The elaborate frame of the *Parmenides* is strikingly dropped by the end.

20. They are not, as Lindsay Judson notably said once in oral discussion, Hansard reports of Socrates' day-to-day exchanges. On the contrary, the dialogues are philosophical fiction.

21. To repeat: I take the seeing here to be richly informed, not brute.

22. The second and third pieces of information are given in the Saatchi Gallery artistic biography of Quinn; so indirectly by the painter himself: see www.saatchigallery.com/artists/ged_quinn.htm (accessed 31 January 2014).

23. A. Artaud, *The Theatre and its Double*, M. C. Richards (trans.) (New York: Grove Press, 1958), ch. 2. Notice throughout this passage its realism, deliberate or otherwise: "it realizes"; "a sense of real humor"; "a true image"; "realistically materialized".

24. *Republic* 515c–d.
25. *Ibid.*, 10.
26. *Phaedrus* 275a, my translation. On the intricacies of this passage, see notably G. R. F. Ferrari, *Listening to the Cicadas* (Cambridge: Cambridge University Press, 1990); or – for a more extreme take – J. Derrida, "La pharmacie de Platon", in his *La Dissémination*, 77–214 (Paris: Éditions du Seuil 1972).
27. See McCabe, *Platonic Conversations*, ch. 1.
28. Compare, for example, the thoroughgoing puzzles generated by the impasses at the end of the so-called "Socratic" dialogues (a good and complex example is the *Protagoras*); or the more elaborate impasses to be found in the "critical" dialogues, such as *Theaetetus* or *Parmenides*. If this is right, then we should avoid the easy assumption that Plato was just a dogmatic idealist.
29. Artaud, *The Theatre and its Double*, ch 7.
30. See, for example, *Republic* 389e.
31. W. H. Auden, "Musée des Beaux Arts", in his *Collected Poems*, 179 (London: Faber, 1976). William Carlos Williams makes much the same point in "Landscape with the fall of Icarus", in his *Pictures from Brueghel and Other Poems*, 4 (New York: New Directions Books, 1962).

9. Nature, life and spirit: a Hegelian reading of Quinn's vanitas art

1. "Interview with Artist Ged Quinn at Frieze Art Fair 2012", London, 15 October 2012, http://vernissage.tv/blog/2012/10/15/interview-with-artist-ged-quinn-at-frieze-art-fair-2012 (accessed 30 October 2013).
2. "Vanitas", *Encyclopaedia Britannica*, www.britannica.com/EBchecked/topic/623056/vanitas (accessed 30 October 2013).
3. The German Romantics before Hegel also saw art as able to reveal truths about the nature of reality, even truths that philosophy itself could not reveal, but Hegel is perhaps the first who sees art as a different medium for revealing what philosophy itself uncovers. See A. Bowie, "German Idealism and the Arts", *The Cambridge Companion to German Idealism*, K. Ameriks (ed.), 239–57 (Cambridge: Cambridge University Press, 2000) for a more detailed account of the differences between Hegel and the German Romantics regarding the relationship between art and philosophy.
4. G. W. F. Hegel, *Aesthetics: Lectures on Fine Art*, T. M. Knox (trans.) (Oxford: Oxford University Press, 1975), vol. I, 111.
5. *Spirit* is a technical term in Hegel's philosophy. Very roughly, according to some of the more recent interpretations (e.g. Robert Pippin's and Terry Pinkard's), *spirit* represents a collective, social mindedness embodied in our form of life: our practices and institutions, including, for example, the institution of science, of the family, of the state, and so on. This collective mindedness – *spirit* – emerges out of a struggle to determine what counts as an authoritative reason for forming beliefs and for acting in particular ways; in other words, *spirit* is the collection of norms that shape our lives as they develop through history.
6. The *Idea* is the last category in the *Science of Logic*, and is, according to Hegel's philosophy, the ultimate concept through which reality is comprehensible. According to one reading, the *Idea* is not really so much a new concept as the collection of all fundamental concepts of thought, and it stands for intelligibility as broadly construed as possible: that which can be comprehended in thought.
7. R. Pippin, "The Absence of Aesthetics in Hegel's Aesthetics", in *The Cambridge Companion to Hegel and Nineteenth-Century Philosophy*, C. Beiser (ed.), 394–418 (Cambridge: Cambridge University Press, 2008), 398.

8. Of the practical approach, Hegel says the following: "The practical approach to nature is, in general, determined by appetite, which is self-seeking; need impels us to use nature for our own advantage, to wear her out, to wear her down, in short to annihilate her. And here, two characteristics at once stand out. (a) The practical approach is concerned only with individual products of nature, or with individual aspects of those parts ... (b) The other characteristic of the practical approach is that, since it is our end which is paramount, not natural things themselves, we convert the latter into means, the destiny of which is determined by us, not by the things themselves" (G. W. F. Hegel, *Philosophy of Nature: Part Two of the Encyclopaedia of the Philosophical Sciences (1830)*, A. V. Miller [trans.], from Nicolin and Poggeler's 1959 edition and from the Zusatze in Michelet's 1847 text [Oxford: Oxford University Press, 1970], §245 Zusatz, 5).

9. *Ibid.*, §246 Zusatz, 7.

10. This is an argument that Hegel expounds in more detail in the "Sense-Certainty" section of *Phenomenology of Spirit*, A. V. Miller (trans.) (Oxford: Oxford University Press, 1977).

11. Hegel, *Philosophy of Nature*, §246 Zusatz, 7.

12. *Ibid.*, §246, 8.

13. Hegel, *Phenomenology of Spirit*, §159, 97–8.

14. See W. Sellars, "Philosophy and the Scientific Image of Man", in *In the Space of Reasons: Selected Essays of Wilfrid Sellars*, K. Sharp & R. Brandom (eds), (Cambridge, MA: Harvard University Press, 2007).

15. "Interview with Artist Ged Quinn at Frieze Art Fair 2012".

16. Quinn is clearly interested more generally in the idea of context providing the meaning of an image, as he also mentions in his interview how he is fascinated by the way certain images, originally found in vanitas paintings and which would have had a well-known coded meaning (e.g. the snake symbolizing sin; the butterfly, the soul) when seen in a contemporary painting have lost that original meaning, they are now just an image.

17. As I will explain, the analogy isn't perfect, since in the case of the film the purpose of the film is given externally, from the filmmaker, whereas, in the case of the animal organism, the end is given from within the organism itself. In both cases, however, a reference to the purpose of the whole is necessary in order to explain the function of the parts.

18. Although in this case, the home movie was probably filmed with the intention of placing it within the larger film, so its meaning is already determined by the context and its place within it.

19. Aristotle, *On the Soul*, J. A. Smith (trans.), *The Complete Works of Aristotle: The Revised Oxford Translation*, J. Barnes (ed.) (Princeton, NJ: Princeton University Press, 1984), vol. II, 1, 412b, 10–24.

20. R. Wicks, "Hegel's Aesthetics: An Overview", *The Cambridge Companion to Hegel*, F. Beiser (ed.), 348–77 (Cambridge: Cambridge University Press, 1992), 367–8.

21. Immanent teleology is to be distinguished from external teleology. An entity exhibits a teleological structure of the external kind if its parts are only intelligible through the purpose of the whole, but that purpose is externally imposed rather than generated from within the entity itself. Human artefacts, like films for example, exhibit this kind of teleological structure: the parts of the film can indeed only be understood by reference to the whole, but the purpose of the whole film is something given to it from without, namely from the film-maker. In the case of beings intelligible though internal teleology, however, the purpose of the being in question is given from within the being itself. For Kant, as well as Hegel, alive organisms (life), were the paradigm beings that seemed to exhibit such a teleological structure. Of course Kant notoriously did not commit to the claim that organisms really were intelligible only through teleology, and only suggested the attraction of the idea that nature as a whole exhibits a teleological structure.

22. G. W. F. Hegel, *Science of Logic*, A. V. Miller (trans.) (Amherst, NY: Humanity Books, 1969), 737.

23. A. Stone, "German Romantic and Idealist Conceptions of Nature", *International Yearbook of German Idealism*, vol. 6, J. Stolzenberg, K. Ameriks & F. Rush (eds), (Berlin: De Gruyter, 2009), 94.

24. Hegel, *Philosophy of Nature*, §376 Zusatz: 443.
25. The different levels of nature form a kind of hierarchy, with each level of nature corresponding to a higher level of intelligibility. Material inorganic nature, for example, is intelligible through mechanism, the lowest form of intelligibility present in nature, whereas animals, as we have already seen, are intelligible through teleology, the highest form of intelligibility found in nature. Hegel thinks of mechanism as a lower form of intelligibility because it can only explain the behaviour of matter externally, that is, only in reference to how other matter acts on it (e.g. through gravity). Mechanism, then, is a form of explanation that is lacking, according to Hegel, since an explanation of something can never be complete if that explanation only references things external to the *explanandum*. Teleology, on the other hand, is a higher form of intelligibility because it can explain the behaviour of animals according to their own internal purposes (e.g. according to the animal's struggle for self-preservation and procreation). Teleology then is a more complete form of explanation because it offers explanations according to principles of the *explanandum* itself, namely its purpose. At the ontological level, this means that animals as beings are more "rational": they exhibit a higher level of intelligibility, than mere inorganic matter.
26. In connection with the discussion of life and organic unity, we can say that *spirit*, like animal organisms, exhibits a lifelike logic of internal teleology, albeit in a more perfect way than that of animal organisms. *Spirit* is organized through the logic of internal teleology, but the principles of self-organization exhibit a higher degree of freedom than those of animals. The principles that organize *spirit* are principles of reason that it has to work out and develop for itself throughout history, rather than finding them ready-made in nature, as animals do.
27. "Estranged from the Idea, Nature is only the corpse of the Understanding. Nature is, however, only implicitly the Idea, and Schelling therefore called her a petrified intelligence... Since Nature is the Idea in the form of otherness, the Idea, comfortable to its Notion, is not present in Nature as it is in and for itself, although nevertheless, Nature is one of the ways in which the Idea manifests itself, and is a necessary mode of the Idea" (Hegel, *Philosophy of Nature*, §247 Zusatz).
28. G. W. F. Hegel, *Hegel's Philosophy of Subjective Spirit*, M. Petry (ed. & trans.) (Dordrecht: Riedel, 1978), vol. I, 6.
29. "Nature as such in its self-internalizing does not attain to this being-for-self, to the consciousness of itself; the animal, the most complete form of this internalization, exhibits only the spiritless dialectic of transition from one individual sensation filling up its whole soul to another individual sensation which equally exclusively dominates it; it is man who first raises himself above the individuality of sensation to the universality of thought, to awareness of himself, to the grasp of his subjectivity, of his I – in a word, it is only man who is thinking mind and by this, and by this alone, is essentially distinguished from nature" (G. W. F. Hegel, *Philosophy of Mind: Part Three of the Encyclopaedia of the Philosophical Sciences (1830)*, W. Wallace [trans.], with the Zusatz, M. Inwood [rev.] [Oxford: Oxford University Press, 2007], §381 Zusatz).
30. Of course, according to Hegel, one cannot simply choose who one is, one cannot define oneself simply according to one's self-conception. The latter has to become recognized by others also capable of having a self-conception by being incorporated into a system of norms that are recognized as valid. For example, I cannot simply define myself as a professor of philosophy; even if I see myself as one, I first need to fulfil certain conditions that others will recognize as sufficient in order actually to be one. This is, very crudely, one of the lessons of the "Self-Consciousness" chapter in the *Phenomenology*.
31. This way of reading the image, in relation to the meaning of the painting as a whole (i.e. relying on the content of the film and not only its form), as well as the context of this scene in particular, can perhaps be seen to be in tension with the previous reading of the image as dead (i.e. as completely separated from its original context). However, it is not impossible to think that the image in question might have a dual role and meaning in the painting, one in which what matters is purely

formal (the fact that it clashes with the rest of the painting and that it is severed from its original organic unity), and one in which the original context of the image is what is important.

32. "Interview with Artist Ged Quinn at Frieze Art Fair 2012".
33. For example, in the very first chapter of the *Phenomenology*, sense-certainty's claim that immediate sense perception provides us with the ultimate knowledge of reality, seems, by the end of the chapter, as a completely absurd claim, one that could not possibly have been true, by the very standards of sense-certainty itself.
34. See for example T. Pinkard, *Hegel's Phenomenology: The Sociality of Reason* (Cambridge: Cambridge University Press, 1996).
35. See Stern's discussion for why this is the wrong way to understand Hegel's reading of the play in *Hegel and the Phenomenology of Spirit* (London: Routledge, 2002), 139–45.
36. This image of *spirit* guiding historical progression can be easily misunderstood, but as Terry Pinkard makes clear, there needn't be any mystery here: "Hegel's frequently misunderstood talk of the 'world spirit's' directing history for 'its own ends' is not a nod on his part to some metaphysical supervisor directing the entire drama of history from off stage. The 'world spirit' is just the human community taken as a whole, seen from the standpoint of humanity's gradually coming to terms with itself through its developing sets of social and political institutions which in retrospect can be reconstructed as gradual developments of a kind of rational understanding of what is essentially involved in social and political life" (Pinkard, *Hegel's Phenomenology*, 335).
37. Sometimes Hegel is interpreted as having believed that this final stage of history had already been reached by the time he was writing his philosophical works. However, as Pinkard correctly puts it: "Hegel's claim about the final stage of history is thus neither metaphysical nor a theological, quasi-eschatological thesis. It is rather the view that insofar as the conceptualization of freedom is concerned, European modern life has reached a point at which there seems to be nothing left to be developed. A modern constitutional state with representative political institutions, based on a market society with the appropriate mediating institutions and a compationate familial structure embodies for political communities what the Phenomenology of Spirit promised: a ... reconciled form of life" (*ibid.*, 336). What Hegel seems to be saying, therefore, is that we have reached the point in history when we have all the available concepts and institutions needed in order to shape a life that is at home with itself, at our disposal. We have cracked the conceptual problem, but that does not mean that we have also managed to actually bring about such a form of life into existence.
38. "Interview with Artist Ged Quinn at Frieze Art Fair 2012".

10. Of war and madness

1. F. Goya, *Los Caprichos* (New York: Dover, [1799] 1969).
2. S. Freud, *The Interpretation of Dreams*, A. A. Brill (trans.) (New York: Macmillan, 1900). See also R. Wollheim, *Freud*, Fontana Modern Masters (London: Collins, 1971).
3. For recent work on disgust, see D. Kelly, *Yuck! The Nature and Moral Significance of Disgust* (Cambridge, MA: MIT Press, 2011). For a discussion of the relation of disgust to art, see N. Carroll, *The Philosophy of Horror, or Paradoxes of the Heart* (New York: Routledge, 1990).

11. Showing us how it is

1. J. Ruskin, *The Stones of Venice* (Boston, MA: Estes & Lauriat, 1894), vol. III, ch. 2, para 8, 39.

2. T. Wolfe, *The Painted Word* (New York: Farrar, Straus & Giroux, 1975).
3. R. Kraut, "The Metaphysics of Artistic Expression: a Case Study in Projectivism", *Mind, Metaphysics and Morality: Themes from the Philosophy of Simon Blackburn*, R. Johnson & M. Smith (eds) (Oxford: Oxford University Press, forthcoming).
4. R. G. Collingwood, *The Idea of History* (Oxford: Oxford University Press, 1946), 193.
5. S. Fish, *Is there a Text in this Class? The Authority of the Interpretive Community* (Cambridge, MA: Harvard University Press, 1982).
6. Quoted from a speech in the House of Lords, as reported in the *Guardian* (30 July 2013).
7. "Non ignara mali, miseris succurrere disco".
8. J.-J. Rousseau, *Émile*, B. Foxley (trans.) (London: Everyman Books, 1972), 185.
9. P. Larkin, "I Remember, I Remember", in his *Collected Poems*, A. Thwaite (ed.), 81–2 (London: Faber, 1988).

12. Paintings, photographs, titles

1. See R. Barthes, *Camera Lucida: Reflections on Photography* (New York: Hill & Wang, 1981); S. Sontag, *On Photography* (New York: Farrar, Straus & Giroux, 1977); R. Scruton, "Photography and Representation", *Critical Inquiry* 7 (1981): 577–603; K. Walton, "Transparent Pictures: On the Nature of Photographic Realism", *Critical Inquiry* 11 (1984): 246–77; J. Friday, *Aesthetics and Photography* (Farnham: Ashgate, 2003).
2. See J. Levinson, "Titles", *Music, Art, and Metaphysics*, 159–78 (Ithaca, NY: Cornell University Press, 1990).
3. See J. Levinson, "Intention and Interpretation in Literature", in his *The Pleasures of Aesthetics*, 175–213 (Ithaca, NY: Cornell University Press, 1996).
4. See A. Danto, "The Artworld", *Journal of Philosophy* 61 (1964): 571–84.
5. See M. Baxandall, *Painting and Experience in Fifteenth Century Italy* (Oxford: Oxford University Press, 1972); R. Wollheim, *Painting as an Art* (Princeton, NJ: Princeton University Press, 1987).

13. The laughter behind the painted smile

1. Associating Yue Minjun with cynical realism is a relatively common move. See, for example, A. Solomon, "Their Irony, Humor (and Art) Can Save China", *The New York Times* (19 December 1993), www.nytimes.com/1993/12/19/magazine/their-irony-humor-and-art-can-save-china.html?pagewanted=all&src=pm (accessed 5 December 2013); "Cynical Realism", www.artspeak-china.org/mediawiki/Cynical_Realism_%E7%8E%A9%E4%B8%96%E7%8E%B0%E5%AE%9E%E4%B8%BB%E4%B9%89 (accessed 5 December 2013); A. Daniels, "Yue Minjun's Haunting Laugher", *New Criterion* 31(10) (2013), 31–3; and A. Cohen, "The Shadow of Laughter: Yue Minjun", *ArtAsiaPacific*, 84 (2013), http://artasiapacific.com/Magazine/84/YueMinjun (accessed 1 December 2013).
2. "Bold New Expressions: China Makes its Mark Felt in the World of Modern Art", http://macau-closer.com/magazine/bold-new-expressions (accessed 6 December 2013).
3. K. Smith, "Interview with Yue Minjun", *Yishu* 7(2) (2008), 25–36, esp. 29.
4. *Ibid*, 27.
5. E. Tsui, "Yue Minjun: Behind the Painted Smile", *Financial Times* (2 November 2012), www.ft.com/cms/s/2/d15b7a5a-23b0-11e2-a46b-00144feabdc0.html (accessed 3 December 2012).

| Bibliography

Ackerley, C. "Samuel Beckett and Mathematics". www.uca.edu.ar/uca/common/grupo17/files/ mathem.pdf (accessed 7 November 2013).

Ackerman, J. "A Theory of Style". *Journal of Aesthetics and Art Criticism* 20 (1962): 227–37.

Alpers, S. "Style is What You Make It: The Visual Arts Once Again". In *The Concept of Style*, rev. edn, B. Lang (ed.), 137–62 (Ithaca, NY: Cornell University Press, 1987).

Aquinas, Saint T. *Summa Theologiae* (Notre Dame, IN: Ave Maria Press, 1989).

Archer, M. "The Figure in Painting". In *Dexter Dalwood*, exhibition catalogue (Biel: CentrePasquArt, 2013).

Aristotle. *De Anima*, H. Lawson-Tancred (trans.) (Harmondsworth: Penguin, 1986).

Aristotle. *On the Soul*, J. A. Smith (trans.), *The Complete Works of Aristotle: The Revised Oxford Translation*, J. Barnes (ed.) (Princeton, NJ: Princeton University Press, 1984).

Artaud, A. *The Theatre and its Double*, M. C. Richards (trans.) (New York: Grove, 1958).

Auden, W. H. *Collected Poems* (London: Faber, 1976).

Bakan, J. *The Corporation* (London: Random House, 2003).

Ball, H. *Die Flucht aus der Zeit* (Munich: Duncker & Humblot, 1927).

Barthes, R. *Camera Lucida: Reflections on Photography* (New York: Hill & Wang, 1981).

Baudelaire, C. "Peintre de la vie modern". In his *Ècrits sur l'art*, vol. 2, 133–93 (Paris: Gallimard, 1971).

Baxandall, M. *Painting and Experience in Fifteenth Century Italy* (Oxford: Oxford University Press, 1972).

Belaval, Y. "Préface". In *La philosophie dans le boudoir*, D. A. F. de Sade, 7–8 (Paris: Gallimard, 1976).

Bell, D. *The End of Ideology* (Glencoe: Free Press, 1960).

Benjamin, W. *Illuminationen* (Frankfurt: Suhrkamp, 1977).

Benjamin, W. "On the Concept of History". In *Walter Benjamin: Selected Writings*, M. W. Jennings (ed.), 389 (Cambridge, MA: Harvard University Press, 2003).

Berger, J. *Ways of Seeing* (Harmondsworth: Penguin 1972).

Bowie, A. "German Idealism and the Arts". In *The Cambridge Companion to German Idealism*, K. Ameriks (ed.), 239–57 (Cambridge: Cambridge University Press, 2000).

Brown, M. "The Classic Is the Baroque: On the Principle of Wölfflin's Art History". *Critical Inquiry* 9 (1982): 379–404.

Bruno, A. "Punk Rock Romeo and Juliet: Sid Vicious and Nancy Spungen". www.trutv.com/library/crime/notorious_murders/celebrity/sid_vicious/3b.html (accessed 13 September 2013).

Budd, M. *Values of Art* (London: Allen Lane, 1995).

Camus, A. *The Plague* (Harmondsworth: Penguin, 2002).

Carrier, D. "How Can Art History Use Its History?". *History and Theory* 46 (2007): 472–5.

Carroll, N. & J. Gibson (eds). *Narrative, Emotion, and Insight* (University Park, PA: Pennsylvania State University Press, 2011).

Carroll, N. *The Philosophy of Horror, or Paradoxes of the Heart* (New York: Routledge, 1990).

Carse, A. L. "Pornography: An Uncivil Liberty?" *Hypatia* 10 (1995): 155–82.

Cohen, A. "The Shadow of Laughter: Yue Minjun". *ArtAsiaPacific* 84 (2013): http://artasiapacific.com/Magazine/84/YueMinjun (accessed 1 December 2013).

Cohen, L. *The Favourite Game* (London: Cape, 1963).

Collingwood, R. G. *The Idea of History* (Oxford: Oxford University Press, 1946).

Collingwood, R. G. *The Principles of Art* (Oxford: Clarendon Press, 1938).

Craven, D. "Art History and the Challenge of Postcolonial Modernism". *Third Text* 16 (2002): 309–13.

Currie, G. "The Irony in Pictures". *British Journal of Aesthetics* 51 (2011): 149–58.

Currie, G. "Why Irony is Pretence". In *The Architecture of the Imagination: New Essays on Pretence, Possibility, and Fiction*, S. Nichols (ed.), 111–33 (Oxford: Oxford University Press, 2006).

Daniels, A. "Yue Minjun's Haunting Laugher". *New Criterion* 31(10) (2013): 31–3.

Danto, A. "The Artworld". *Journal of Philosophy* 61 (1964): 571–84.

Danto, A. *The Transfiguration of the Commonplace* (Cambridge, MA: Harvard University Press, 1981).

Davies, S. "Authors' Intentions, Literary Interpretation, and Literary Value". *British Journal of Aesthetics* 46 (2006): 233–5.

Davis, W. *A General Theory of Visual Culture* (Princeton, NJ: Princeton University Press, 2011).

Derrida, J. "La pharmacie de Platon". In his *La Dissémination*, 77–214 (Paris: Éditions du Seuil, 1972).

Derrida, J. *The Truth in Painting*, G. Bennington & I. McLeod (trans.) (Chicago, IL: University of Chicago Press, 1987).

Dworkin, A. & C. MacKinnon. *Pornography and Civil Rights* (Minnesota, MN: Organizing Against Pornography, 1988).

Eliot, T. S. "Shakespeare and the Stoicism of Seneca". In his *Selected Essays, 1917–1932*, 107–20 (London: Faber, 1932).

Eliot, T. S. "Tradition and the Individual Talent". In his *Selected Prose of T. S. Eliot*, F. Kermode (ed.), 37–44 (London: Faber, 1975).

Elkins, J. (ed.). *The State of Art Criticism* (New York: Routledge, 2008).

Elkins, J. "Style". In *The Dictionary of Art*, J. Turner (ed.), vol. 29, 876–83 (London: Macmillan, 1996).

Elsner, J. "Style". In *Critical Terms for Art History*, 2nd edn, R. S. Nelson & R. Shiff (eds), 98–109 (Chicago, IL: University of Chicago Press, 2003).

Enright, D. J. *The Alluring Problem: An Essay on Irony* (New York: Oxford University Press, 1986).

Ferrari, G. R. F. *Listening to the Cicadas* (Cambridge: Cambridge University Press, 1990).

Fish, S. *Is there a Text in this Class? The Authority of the Interpretive Community* (Cambridge, MA: Harvard University Press, 1982).

Flanary, D. A. *Champfleurt: The Realist Writer and Art Critic* (Ann Arbor, MI: UMI Research Press, 1980).

Freud, S. *The Interpretation of Dreams*, A. A. Brill (trans.) (New York: Macmillan, 1900).

Friday, J. *Aesthetics and Photography* (Farnham: Ashgate, 2003).

Friedman, T. *The World is Flat* (New York: Farrar, Straus, Giroux, 2005).

Fukuyama, F. *The End of History and the Last Man* (Glencoe: Free Press, 1992).

Gaiger, J. *Aesthetics and Painting* (London: Continuum, 2008).

Gilmore, J. *The Life of a Style: Beginnings and Endings in the Narrative History of Art* (Ithaca, NY: Cornell University Press, 2000).

Goehr, L. "How to Do More with Words: Two Views of (Musical) Ekphrasis". *British Journal of Aesthetics* 50 (2010): 389–410.

Goethe, J. W. *Elective Affinities*, R. Hollingdale (trans.) (Harmondsworth: Penguin, 1971).

Golding, M. P. "On the Idea of Moral Pathology". In *Echoes from the Holocaust: Philosophical Reflections on a Dark Time*, A. Rosenberg & G. E. Myers (eds), 128–48 (Philadelphia, PA: Temple University Press, 1988).

Gombrich, E. H. "Style". In *International Encyclopedia of the Social Sciences*, D. L. Sills (ed.), vol. 15, 353–61 (New York: Macmillan, 1968).

Goodman, N. *Of Mind and Other Matters* (Cambridge, MA: Harvard University Press, 1987).

Goodman, N. "The Status of Style". In his *Ways of Worldmaking*, 23–40 (Indianapolis, IN: Hackett, 1978).

Goya, F. *Los Caprichos* (New York: Dover, [1799] 1969).

Graeber, D. *Direct Action* (Edinburgh: AK Press, 2009).

Harte, V. "Language in the Cave". In *Maieusis*, D. Scott (ed), 195–215 (Oxford: Oxford University Press, 2007).

Hegel, G. W. F. *Aesthetics: Lectures on Fine Art*, T. M. Knox (trans.) (Oxford: Oxford University Press, 1975).

Hegel, G. W. F. *Hegel's Philosophy of Subjective Spirit*, M. Petry (ed., trans.) (Dordrecht: Riedel, 1978).

Hegel, G. W. F. *Phenomenology of Spirit*, A. V. Miller (trans.) (Oxford: Oxford University Press, 1977).

Hegel, G. W. F. *Philosophy of Mind: Part Three of the Encyclopaedia of the Philosophical Sciences (1830)*, W. Wallace (trans.), M. Inwood (rev.) (Oxford: Oxford University Press, 2007).

Hegel, G. W. F. *Philosophy of Nature: Part Two of the Encyclopaedia of the Philosophical Sciences (1830)*, A. V. Miller (trans.), (Oxford: Oxford University Press, 1970).

Hegel, G. W. F. *Science of Logic*, A. V. Miller (trans.) (Amherst, NY: Humanity Books, 1969).

Hume, D. *Of the Standard of Taste and Other Essays*, J. W. Lenz (ed.) (New York: Bobbs-Merrill, 1965).

Ishiguro, H. "Imagination". *Proceedings of the Aristotelian Society* supplementary volume (1967): 50.

Jacquette, D. "Nelson Goodman on the Concept of Style". *British Journal of Aesthetics* 40 (2000): 452–67.

Kelly, D. *Yuck! The Nature and Moral Significance of Disgust* (Cambridge, MA: MIT Press, 2011).

Kraut, R. "The Metaphysics of Artistic Expression: A Case Study in Projectivism". In *Mind,*

Metaphysics and Morality: Themes from the Philosophy of Simon Blackburn, R. Johnson & M. Smith (eds) (Oxford: Oxford University Press, forthcoming).

Lang, B. "Style". In *The Encyclopedia of Aesthetics*, M. Kelly (ed.), vol. 4, 321 (New York: Oxford University Press, 1998).

Larkin, P. *Collected Poems*, A. Thwaite (ed.) (London: Faber, 1988).

LeMoncheck, L. *Dehumanizing Women: Treating Persons as Sex Objects* (Totowa, NJ: Rowman & Allenheld, 1985).

Lessing, G. E. "Zerstreute Anmerkungen über das Epigramm und einige der vornehmsten Epigrammatisten". In his *Werke*, vol. 5, 42–89 (Vienna: Bensinger, n.d.).

Levinson, J. "Erotic Art and Pornographic Pictures". *Philosophy and Literature* 29 (2005): 228–40.

Levinson, J. "Intention and Interpretation in Literature" in his *The Pleasures of Aesthetics*, 175–213 (Ithaca, NY: Cornell University Press, 1996).

Levinson, J. "Titles". In his *Music, Art, and Metaphysics*, 159–78 (Ithaca, NY: Cornell University Press, 1990).

Longino, H. "What is Pornography". In *Take Back the Night: Women on Pornography*, L. Lederer (ed.), 40–54 (New York: William Morrow, 1980).

Lopes, D. *Understanding Pictures* (Oxford: Oxford University Press, 1996).

Lorde, A. *The Uses of the Erotic: The Erotic as Power* (Trumansburg, NY: Crossing Press, 1978).

Lunn, F. "Foreword". In *Dexter Dalwood*, exhibition catalogue (Biel: CentrePasquArt, 2013).

Marcuse, H. *One-Dimensional Man* (Boston, MA: Beacon Press, 1965).

McCabe, M. M. *Plato and His Predecessors: The Dramatization of Reason* (Cambridge: Cambridge University Press, 2000).

McCabe, M. M. *Platonic Conversations* (Oxford: Oxford University Press, forthcoming).

McCabe, M. M. "Unity in the *Parmenides*: The Unity of the *Parmenides*". In *Form and Argument in Late Plato*, C. Gill & M. M. McCabe (eds), 5–48 (Oxford: Oxford University Press).

McGinn, C. *Mindsight* (Cambridge, MA: Harvard University Press, 2004).

Neer, R. "Connoisseurship and the Stakes of Style". *Critical Inquiry* 32 (2005): 1–26.

Nehamas, A. *The Art of Living: Socratic Reflections from Plato to Foucault* (Berkeley, CA: University of California Press, 1998).

Nehamas, A. *Only a Promise of Happiness* (Princeton, NJ: Princeton University Press, 2007).

Newman, B, "The Sublime is Now". In *Barnett Newman: Selected Writings and Interviews*, J. P. O'Neill (ed.), 171–3 (Berkeley, CA: University of California Press, 1992).

Pinkard, T. *Hegel's Phenomenology, The Sociality of Reason* (Cambridge: Cambridge University Press, 1996).

Pippin, R. "The Absence of Aesthetics in Hegel's Aesthetics". In *The Cambridge Companion to Hegel and Nineteenth-Century Philosophy*, C. Beiser (ed), 394–418 (Cambridge: Cambridge University Press, 2008).

Plato, *Complete Works*, J. M. Cooper & D. S. Hutchinson (eds) (Indianapolis: Hackett, 1997).

Priest, G. *Beyond the Limits of Thought* (Cambridge: Cambridge University Press, 1995).

Quine, W. van O. *Word and Object* (Cambridge, MA: Harvard University Press, 1960).

Rae, M. "What is Pornography?". *Nous* 35 (2001): 118–45.

Riha, K. (ed.). *Dada in Zürich* (Stuttgart: Reclam, 1994).

Rosenberg, H. "The American Action Painters". In his *The Tradition of the New*, 23–39 (New York: Horizon Press, 1960).

Rosenberg, K. "Influences: John Currin". *New York Magazine* 39(42) (2006): 134.

Rousseau, J.-J. *Dictionniare de Musique* (Paris: Duchesne, 1768).

Rousseau, J.-J. *Émile*, B. Foxley (trans.) (London: Everyman, 1972).

Ruskin, J. *The Stones of Venice* (Boston, MA: Estes & Lauriat, 1894).

Sainsbury, R. M. *Paradoxes* (Cambridge: Cambridge University Press, 1995).

Sartre, J.-P. *The Psychology of Imagination*, B. Frechtman (trans.) (New York: Washington Square Press, 1966).

Schapiro, M. "Style". In his *Theory and Philosophy of Art: Style, Artist, and Society*, 51–102 (New York: George Braziller, 1994).

Scruton, R. *Art and Imagination* (London: Methuen, 1974).

Scruton, R. "Photography and Representation". *Critical Inquiry* 7 (1981): 577–603.

Sellars, W. "Philosophy and the Scientific Image of Man". In *In the Space of Reasons: Selected Essays of Wilfrid Sellars*, K. Sharp & R. Brandom (eds), 369–408 (Cambridge, MA: Harvard University Press, 2007).

Shakespeare, W. *Macbeth*, A. P. Riemer (ed.) (Sydney: Sydney University Press, 1980).

Sinclair, A. "Angus Sinclair reviews 'House of the Deaf Man' by Porter and de Freston". *ink, sweat and tears* (2012): www.inksweatandtears.co.uk/pages/?p=3244 (accessed 7 November 2013).

Smith, A. *A Theory of Moral Sentiments*, K. Haakonsen (ed.) (Cambridge: Cambridge University Press, 2002).

Smith, C. "Dexter Dalwood: Interview". *Kaleidoscope Magazine* 8 (2010): kaleidoscope-press.com/issue-contents/dexter-dalwood-interview-by-cherry-smith (accessed 12 December 2013).

Smith, K. "Interview with Yue Minjun". *Yishu* 7(2) (2008): 25–36.

Solomon, A. "Their Irony, Humor (and Art) Can Save China". *The New York Times* (19 December 1993): www.nytimes.com/1993/12/19/magazine/their-irony-humor-and-art-can-save-china.html?pagewanted=all&src=pm (accessed 5 December 2013)

Solzhenitsyn, A. *The Gulag Archipelago 1918–1956: An Experiment in Literary Investigation* (New York: Harper Perennial, 2007).

Sontag, S. *On Photography* (New York: Farrar, Straus & Giroux, 1977).

Stern, R. *Hegel and the Phenomenology of Spirit* (London: Routledge, 2002).

Stone, A. "German Romantic and Idealist Conceptions of Nature". In *International Yearbook of German Idealism*, J. Stolzenberg, K. Ameriks & F. Rush (eds), vol. 6, 80–101 (Berlin: De Gruyter, 2009).

Tsui, E. "Yue Minjun: Behind the Painted Smile". *Financial Times* (2 November 2012): www.ft.com/cms/s/2/d15b7a5a-23b0-11e2-a46b-00144feabdc0.html (accessed 3 December 2012).

Tzara, T. *Sept manifestes DADA* (Geneva: Société Nouvelle des Èdition Pauvert, 1979).

Walton, K. L. "Style and the Products and Processes of Art". In *The Concept of Style*, rev. edn, B. Lang (ed.), 72–103 (Ithaca, NY: Cornell University Press, 1987).

Walton, K. "Transparent Pictures: On the Nature of Photographic Realism". *Critical Inquiry* 11 (1984): 246–77.

Wicks, R. "Hegel's Aesthetics: An Overview". In *The Cambridge Companion to Hegel*, F. Beiser (ed.), 348–77 (Cambridge: Cambridge University Press, 1992).

Wiesel, E. *Night* (Harmondsworth: Penguin, 2006).

Williams, W. C. *Pictures from Brueghel and Other Poems* (New York: New Directions, 1962).

Wittgenstein, L. *Philosophical Investigations*, G. E. M. Anscombe (trans.) (Oxford: Blackwell, 1953).

Wittgenstein, L. *Remarks on the Philosophy of Psychology*, G. H. von Wright & Heikki Nyman (eds), C. G. Luckhardt & M. A. E. Aue (trans.) (Oxford: Blackwell, 1980).

Wolfe, T. *The Painted Word* (New York: Farrar, Straus & Giroux, 1975).

Wollheim, R. "Pictorial Style: Two Views". In *The Concept of Style*, rev. edn, B. Lang (ed.), 183–202 (Ithaca, NY: Cornell University Press, 1987).

Wollheim, R. "Style in Painting". In *The Question of Style in Philosophy and the Arts*, C. van Eck, J.McAllister and R.van de Vall (eds), 37–49 (Cambridge: Cambridge University Press, 1995).

Wollheim, R. "The Work of Art as Object". In his *On Art and the Mind* (London: Allen Lane, 1973).

Wollheim, R. *Freud* (London: Fontana, 1971).

Wollheim, R. *Painting as an Art* (London: Thames & Hudson, 1987).

| Index